DRAWING SHORTCUTS

DRAWING SHORTCUTS

SHORTCUTS

Developing Quick Drawing Skills Using Today's Technology

JIM LEGGITT, AIA

RNL DESIGN

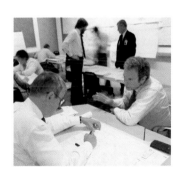

JOHN WILEY & SONS, INC.

Library of Congress Cataloging-in-Publication Data:

Leggitt, Jim.
 Drawing shortcuts : developing quick drawing skills using today's technology / by Jim Leggitt.
 p. cm.
 ISBN 0-471-07549-3
 1. Drawing—Technique. I. Title.

 NC730 .L44 2002
 741.2—dc21

Printed in the United States of America.

10 9 8 7 6 5

To Jon Gnagy, my first drawing teacher,
who in 1955 taught me to draw through the wondrous new
technology of television and my five-year-old imagination

CONTENTS

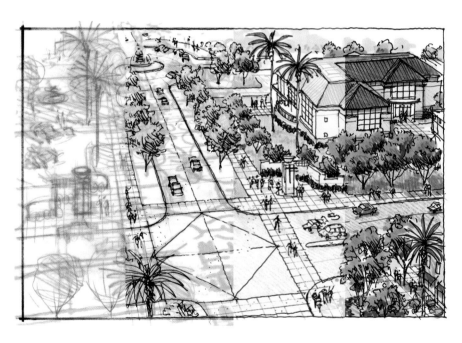

PREFACE

> *"Every child is an artist.*
> *The problem is how to remain an artist*
> *once he grows up."*
>
> ~ Pablo Picasso

I took my first drawing lessons when I was five years old, courtesy of TV. There was a television program in the 1950s called *Learn to Draw,* hosted by Jon Gnagy. Every Saturday, I faithfully set up my *Learn to Draw* kit in front of the black-and-white screen—and then fought with my twin brother over who got to trace the televised drawings with our pencils. This cutting-edge combination of technology and hand drawing was a great idea. We even watched another program called *Winky Dink,* that involved drawing on a clear vinyl sheet placed directly onto the screen. I believe it was America's first interactive television show! Forty-five years later, I'm still working with machines to create drawings, and I'm still having just as much fun. Sometimes I draw for pure pleasure, the way I did when I was five, although most of my drawings these days are done as part of my professional architecture and urban design practice.

I first began thinking about this book more than twenty-five years ago, when I was in architectural design school—because I sure could have used something like it then! In an intensive design school environment, nobody escapes the need for time management, meeting multiple project deadlines, and producing great work with minimal time and little or no money. It's the same today in any professional design practice, and getting more so all the time. These shortcuts and design tips are the ones I use, and I've put them in this book for the benefit of art students, design professionals, and anyone else who needs to be able to communicate creative ideas through effective drawings and graphics in a fast-paced modern world.

Fig. P.1 Reproduced in the 1973 Rhode Island School of Design Yearbook, this drawing compared the architectural graduate Jim Leggitt with the stereotypical architect of earlier times.

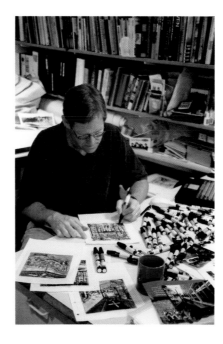

Fig. P.2 A recent photograph of Jim Leggitt working on a drawing project in his home studio (Figs. 2.59 and 2.68).

The Need for Drawing Shortcuts

Over the past decade, there have been incredible advances in computer hardware, software, and other high-tech equipment. Good old-fashioned hand drawing, however, has suffered. No computer rendering can communicate the way a real drawing can, but many of us have lost—or never developed—the ability to draw by hand. This book shows that you can have the best of both worlds. You can put technology to work for you, creating accurate computerized perspective backgrounds to use in drawings, using photographs to make the basis for illustrations, exploiting the amazing abilities of copiers, and finding the right tools to make your drawing process faster and your drawings more effective. By utilizing technology on your own terms, you can improve your drawing skills and even bring back the magic of drawing in the process!

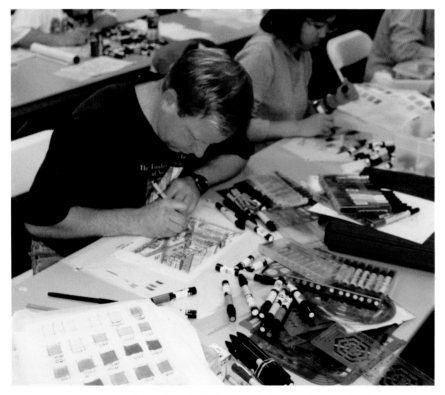

Fig. P.3 Developing hand-drawing skills. Surrounded by markers, color charts, and drawing tools, a student in a Drawing Shortcuts class works on an isometric drawing.

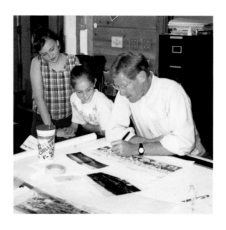

Fig. P.4 Drawing is for all ages. During a community planning workshop, Jim Leggitt shows neighborhood school children how to draw from photographs enlarged with a standard office copier.

Why This Book Is Important

This book is about putting your design ideas on paper, so that others can see what you visualize. It is just as important as ever—maybe even more important in this age of computers—to be able to capture creative ideas in the form of confident, believable hand drawings and sketches. But there are often barriers between creative ideas and the drawings that communicate them. The obstacles are most often fear of drawing, over-reliance on technology, lack of training and practice, low self-confidence, and shortage of time. Overcoming these creativity roadblocks can seem like trying to cross a bottomless abyss, but the next seven chapters will show you how to make the leap. In the words of Thomas Edison, "genius is one percent inspiration and ninety-nine percent perspiration." This book will show you how to manage the necessary ninety-nine so that the vital one isn't lost for lack of trying.

How This Book Is Organized

Drawing Shortcuts has seven chapters, all about drawings that can be generated quickly, how to start and finish them with ease, and what to do with them when you're done. Chapter 1 "The Rules Have Changed," reviews the conditions that currently influence drawing and introduces you to new drawing attitudes. Chapter 2, "Basic Drawing Types," explains how to choose among different line techniques and drawing styles to communicate your ideas. Chapter 3, "Start Your Drawing," introduces you to different

drawing approaches. Chapter 4, "Learning Your CCCs," shows how cameras, copiers, and computers can help you generate drawing data. Chapter 5, "Tools of the Trade," covers a wide variety of easily available drawing tools and materials. Chapter 6, "The Success of Color," gives advice on getting the best use out of color when drawing. Finally, Chapter 7, "Your Completed Drawing," discusses drawing management, or how to save, reproduce, and present your drawings.

The Creative Artist in You

Everyone is born with the ability to communicate creative ideas with drawings. Some of the best and most effective drawings come from children, before their creative spirit is damaged by the "but I can't draw" attitude that affects so many adults. Children's drawings are simple, lively, quick, and communicate only the basic concept of their vision—in short, the kind of drawings that I've been trying to recreate for years. Simplicity, character, speed, effectiveness, and ease of drawing are what this book is all about. Kids can do it, students in my drawing seminars can do it—and so can you!

Fig. P.5 Having fun drawing. These architects in a Drawing Shortcuts class finish a large drawing of the White House turned into a themed water park. A postcard was copied onto clear acetate, enlarged with an overhead projector, drawn with felt-tip pens on vellum, and colored with Chartpak AD markers directly on the original artwork.

Acknowledgments

This book project could never have materialized without the support of my family, friends, and a team of professional colleagues working behind the scenes to review, critique, and guide the process. My "front line" of inspiration and encouragement is my wife, Janice, who has elevated the definition of patience and support. I'm indebted to my twin brother, John, for giving me creative energy and an entrepreneurial attitude. I thank my children, Hunter, Gretchen, and my stepdaughter Kelsey, for giving me the space and time to work. My wonderful copy editors, Francis Kruger and Joyce McDonald, were imaginative and always offering new ideas. Special thanks to my parents, Jennie and Leo, for raising a very creative family and encouraging me to develop my drawing talent. I'm grateful to each of you for keeping me pointed in the right direction.

Most of the drawings in this book were produced for architectural and urban planning purposes. The majority of work originated in proposals, interviews, conceptual and schematic designs, and formal documentation for projects with RNL Design, one of the largest architectural/engineering firms in the Rocky Mountains. Scores of individuals have generously offered their time and expertise during all phases of this project. I am grateful to Jesse Adkins, Dick Anderson, Matthew Beehler, Trent Cito, Jana Coons, Pat Dawe, Larry Doane, Martin Eiss, Lisa Marie Eytcheson, Kent Freed, Phil Goedert, Josh Gould, Heather Gregg, Brian Harder, Dan Kessler, Shirley King, David Klages, Mary Lemmer, Tony Mazzeo, Ed Montoya, David Morris, Steve Newman, Roy Newton, Parke Nimmons, Debra Rinde, Todd Risch, John Rogers, Dick Shiffer, Doug Spuler, David Stone, Marc Stutzman, Richard von Luhrte, Steven Walsh, and Judy Werner.

I am indebted to a growing list of professional friends and clients, who have influenced many of the projects seen in this book. My thanks go to Brent Anderson, Leslie Bethel, Dana Crawford, John Decker, Sherry Dorward, Chris Duerksen, Mark Falcone, Will Fleissig, Bill and Judy Fleming, David Frieder, Paul Haack, Paul Jeselnick, Marjorie Leggitt, Merritt Malin, Ron Mason, Heather Mourer, Jean Robbins, Mark Sawyer, Bruno Schloffel, Chris Shears, Rick Werpel, and John Wolfmeyer.

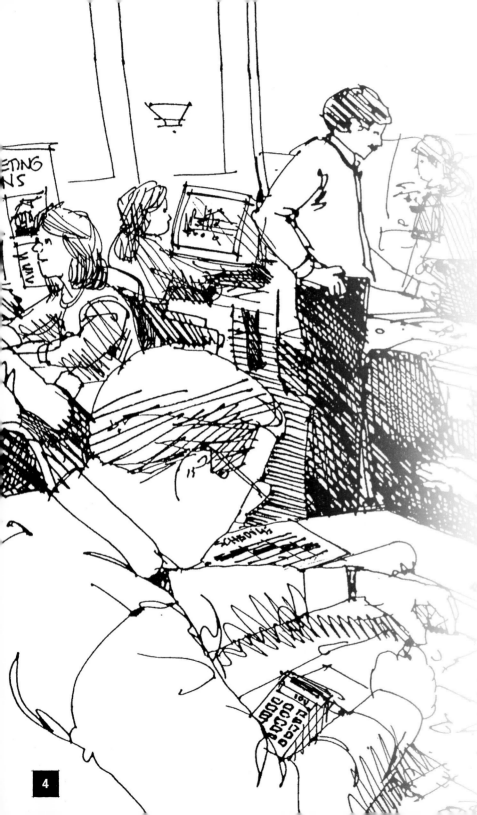

1

THE RULES HAVE CHANGED

The near universal availability of desktop publishing technologies has affected every publication, menu, magazine, school report, greeting card, design document, real estate brochure, and cereal box you see. Graphs, charts, color sketches, and illustrations are standard ingredients in almost any presentation. Everyone from elementary school students to corporate giants uses these methods. The kinds of drawings and techniques in this book are geared to the demands—and opportunities—of the modern world.

Client Expectations

Trends in design presentation are very different than they were twenty years ago. Clients once paid large sums of money for beautifully crafted perspective drawings of their unbuilt projects. Today, construction schedules are so demanding, budgets so tight, and design changes so frequent that an investment in a detailed perspective drawing early in the process is usually seen as an unwarranted risk. Clients are getting smarter and are relying on quick, inexpensive drawings for the early visioning and promotion of projects.

Compressed Schedules

Who has time for anything anymore? Even television commercials, reflecting our fast-paced times, talk about "buying time." Expectations at home, in school, and in business are higher than they were years ago. With all this speedy equipment at our fingertips, we're being asked to produce more in less time. Even the creative process and design communication aren't immune. If we can deliver packages overnight from coast to coast, then why can't we design a building with the same efficiency? But don't panic—the shortcuts and design tips in this book will help you cope.

Fig. 1.2 Ideas sometimes begin on napkins. There is something very friendly about drawing on napkins. These are "napkin sketches" done by architects who attended a recent Drawing Shortcuts seminar. Next time you visit a restaurant with paper tablecloths or paper napkins, try your hand at drawing what you see around you. Don't forget to keep your drawings!

Tighter Budgets, Thinner Wallets

There's never enough money, of course, but lack of money shouldn't be an excuse for not being able to communicate your ideas. Remember, children can tell fabulous stories with just newsprint and poster paint! There are many ways to create drawings that don't require expensive markers, technical pens, or exotic materials. Even documenting your work can be economical. A portfolio made up of high-resolution color copies and computer-printed text costs a fraction of what it took to produce color photographs and elaborate typesetting in the 1970s.

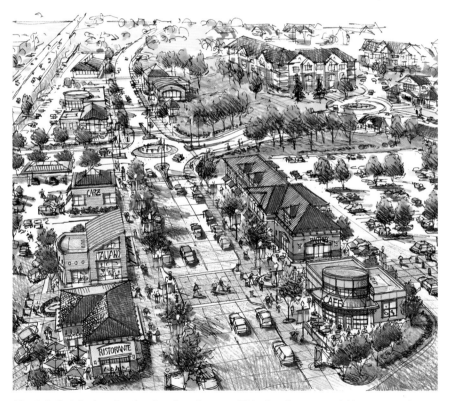

Fig. 1.1 Quick visualization for city planners. This drawing was quickly generated in two days for presentation to a local planning department interested in reviewing ideas for developing a commercial site. The original 18 x 24" line drawing was reduced to 11 x 17" and then colored with markers and colored pencils. The drawing was then scanned and plotted at a poster size for the presentation.

"Time is the greatest innovator."

~ *Francis Bacon*

Fig. 1.3 Quick perspective with a computer wireframe. The transparency and overlapping lines of this 9 x 22" wireframe makes the building walls and planes very difficult to understand. A hidden line wireframe would have been better to use. The basic massing and perspective was traced from this wireframe and used to create the final drawing (Fig. 1.4). *Computer model by Jesse Adkins.*

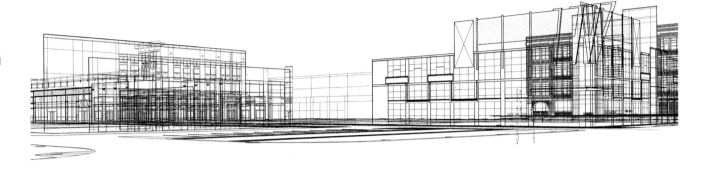

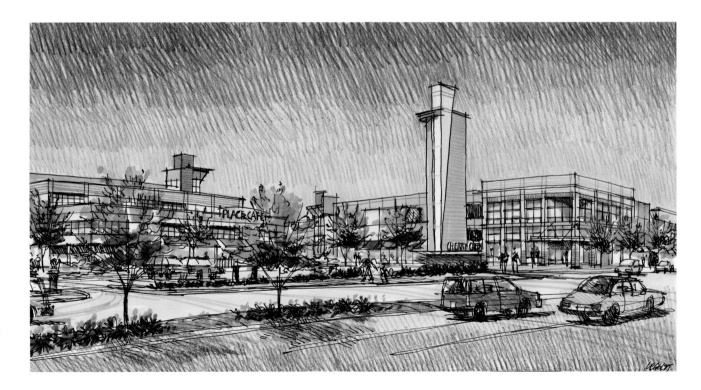

Fig. 1.4 Add people, cars, and trees for scale. The eye-level perspective required adding landscaping and activity to the foreground of the drawing. Cars were drawn, flowerbeds and trees added, and a few people sketched into the drawing to add character and a sense of scale to the scene.

ORNAMENTAL TREES.

Fig. 1.5 Practice drawing trees. These ornamental tree sketches were drawn during a Drawing Shortcuts workshop (Fig. 1.6). Different linework, color combinations, and shapes were explored in the 15-minute exercise. 7 x 10" felt-tip pen on trace with AD markers applied directly to the original artwork.

Fig. 1.6 Have an "in-house" drawing session with other creative people. Drawing techniques and creative visualization ideas can be learned from others in your school or office. Organize a drawing workshop and practice some basic drawing techniques using different papers, pens, pencils, and markers.

Computer Skills versus Drawing Skills

The average fifteen-year-old spends more time in front of a computer monitor than watching TV. By the time they graduate from college, most architecture and graphic design students have learned computer skills that rival those of experienced professionals. We have CDs, DVDs, multimedia, worldwide web sites, Internet learning, 3-D imaging, custom software, ergonomically designed keyboards, custom screensavers, more power, greater memory, and much, much more. What's wrong with this picture? Nothing!

Computers are wonderful tools and everyone should know how to use them. At the same time, we need to be careful not to lose sight of creativity, imagination, and visual communication skills. Recent college graduates in design fields can't draw as well as they could years ago. Perhaps they simply aren't being taught or allowed to develop their ability to draw! Many people are scared to draw, fearing disastrous results and failure:

> *"The people I draw look like trolls."*
> *"My cars look like shoe boxes."*
> *"I'm creative, but I can't draw."*
> *"I just don't have the time to learn to draw."*
> *"I haven't a clue about how to draw in perspective."*
> *"I don't have enough money for expensive drawing materials."*

Sound familiar? You could probably add a few of your own to this list!

Erase Your Drawing Fears

The right shortcuts and design tips can eliminate almost any excuse for not drawing. Chapter 4, "Learning your CCCs," will add the words *camera*, *copier*, and *computer* to your drawing vocabulary. Chapter 5, "Tools of the Trade," covers topics such as which combinations of materials to use so you won't have problems with smearing, and those materials to use so that you can erase mistakes if they do happen. *Remember, most mistakes can be prevented or fixed.*

Communicating design ideas with drawings is actually easier than it was even a decade ago, because of the equipment and services that are now available. Cameras are getting less expensive and easier to use, images are sharper all the time, and photofinishing is available in almost every grocery store and shopping mall. You can even have photos back in an hour! Digital

Fig. 1.7 Step 1: Take a photograph of your subject. This interior scene (people posed for the picture) was photographed from many different angles with a standard 35mm camera, wide-angle lens on color print film. This view was selected because it best represented the overall room layout. 3¹/₂ x 5" standard color print.

Fig. 1.8 Step 2: Trace the image from the photograph. The photograph was enlarged with an opaque projector (Fig. 3.38) and traced onto standard bond paper with a felt-tip pen. In this case, no changes were made to the interior space compared with the photograph. But if you choose to, this is the time in the drawing process when you can add new furniture, plants, people, lighting, and any other interior modification. 5 x 8" ink on bond paper.

Fig. 1.9 Step 3: Color the final drawing. A standard (same size) black-and-white copy was made from the original artwork and colored with Prismacolor pencils. Some of the drawing was left uncolored to de-emphasize certain elements of the interior space. 5 x 8" colored pencil on a bond copy.

cameras and computer-based processors can deliver color prints in less than a minute. These are all steps in the right direction, because *photography is one of the best drawing shortcuts you could ever learn.*

Color copiers are getting so accurate that an original drawing and its copy appear almost identical. Copy machines are even merging with other technologies to become all-in-one packages—phone, fax, copy, print, and other options all in a single machine! Grocery stores, 24-hour copy centers, malls, and libraries all have copiers you can use, which is great because *using a copier is a good time-saving drawing secret.*

No computer program can replicate the wonderful character of a hand drawing, although some new software is closing the gap somewhat. Computer-aided drafting (CAD) programs allow you to construct perspective views of buildings. Additional software can transform mechanical linework into a series of squiggley lines that give the appearance of a drawing done by hand. But you can also use computer-generated images as templates for hand drawings, complete with character and life. *Your communication skills and hand-drawing options are infinitely expanded with computers.*

A Three-Step Program

Every drawing is a three-step process. First, you must gather the *data,* or visual information, that you need. Then you *construct* the perspective and the basic framework of the drawing. Once you're comfortable with the size, layout, look, and feel of the drawing, it's time to *illustrate* the final drawing with linework, textures, tone, and color.

Remember coloring books? The images are collected for you, the drawing is already constructed, and the fun illustrative part is left up to you. Once you know how to quickly collect data and accurately construct the framework of a drawing, all that's left is the fun of illustrating the final drawing.

Let Technology Do Your Dirty Work

Everyone has an individual style of drawing and design, a "drawing identity." A roomful of kids coloring the exact same page of a lesson book will have a wide range of unique results. But although the results are different,

Fig. 1.10 Drawing from a projected 35mm slide. These architectural students are finishing a 30-minute drawing that originated with a 35mm color slide projected onto the wall of their studio. Once the basic information from the slide was traced onto vellum, they taped the paper down to a table surface and completed the drawing.

Fig. 1.11 Computer images often lack detail and character. The gray cars, colorless buildings, lack of people, leafless trees, monotone sky, and material colors all miss creating the character that is needed to communicate the streetscape improvements in this design. Although the perspective is accurate, the unfriendly computer rendering fails to capture the personality of the place. *Computer model by Trent Cito.*

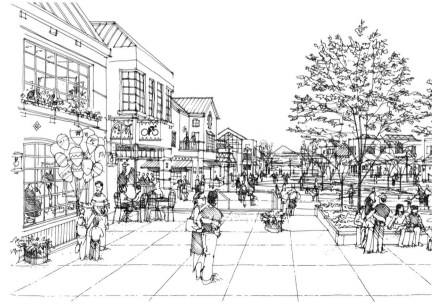

Fig. 1.12 Streetscape drawing that tells the story of an active place. This drawing captures the street activities, variety of storefronts, landscaping, signage, and many other elements that communicate the overall streetscape design. Imagine how much better the drawing might be if color were added to identify differences in building materials and landscaping. 16 x 30" permanent ink on Mylar.

the basic information—or data—in each drawing is the same. The data that you use to construct a drawing should be as accurate as possible. Technology lends itself beautifully to this task. Computers can construct perspectives, a camera can record details that you want to use, and a copier can enlarge or reduce images for you to trace.

"There is real magic in enthusiasm. It spells the difference between mediocrity and accomplishment..."

~*Norman Vincent Peale*

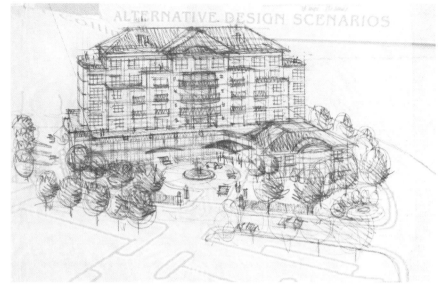

Fig. 1.14 Step 2: Construct the basic drawing framework. The floor plan of the building, street layout, and landscaping were correctly placed in perspective with the digital image. Using a red pencil on trace, the building was then drawn in proportion to the scale of the site plan. People, cars, and trees were added to the drawing mock-up.

Fig. 1.13 Step 1: Gather data for the drawing. The use of a digital camera quickly generated the basic perspective for this drawing. Several view angles of the site plan were photographed, downloaded into a computer, and printed in black and white on an 11 x 17" office laser printer.

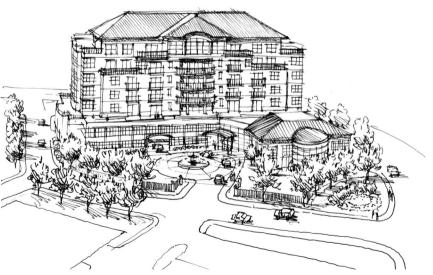

Fig. 1.15 Step 3: Illustrate the final drawing. The final black-and-white line drawing was traced over the red pencil mock-up using a felt-tip pen on trace. A minor amount of shade and shadow was added to the linework.

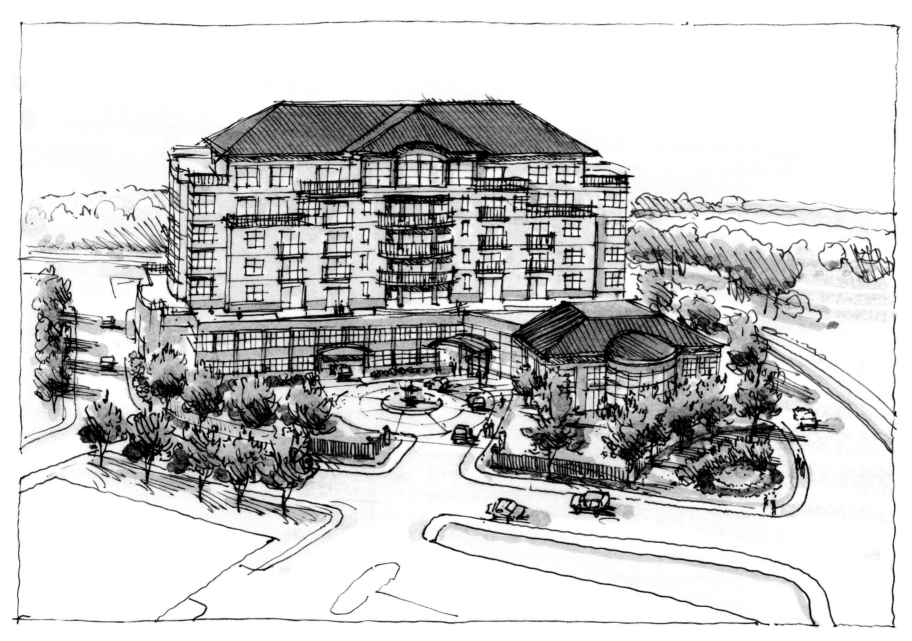

Fig. 1.16 Add color to the drawing with computer help. A computer was used again for the coloring process of the drawing. The black-and-white linework (Fig. 1.15) was scanned with an 11 x 17" scanner, slightly modified and resized using Photoshop, and then printed onto 8 1/2 x 11" vellum using a standard DeskJet printer. The vellum image was then colored on the front and reverse side with Chartpak AD markers.

Fig. 1.17 Photography as a base for a new drawing. This promotional photograph of a design charette was used for the base of a drawing. More people were added in the final drawing and changes were made to the desktops and perimeter walls. Computer equipment was also incorporated into the image.

Fig. 1.18 Add variety to the people you draw. When you draw people, be careful to add differences in body type, age, race, and gender. This $7^1/2 \times 7^1/2$" colored image was generated from a scan of the original artwork, printed onto vellum with a DeskJet printer, and colored with Chartpak AD markers and Prismacolor pencils.

Fig. 1.17 Fig. 1.18

Fig. 1.19 Create a mobile drawing attitude. This photograph of Jim Leggitt was taken during a rural community planning workshop in which a portable digital desktop system was utilized. Photographs of the neighborhoods were taken with a digital camera, downloaded, and printed using a laptop computer and lightweight color printer. Quick sketches were then generated during the public meeting, showing different planning scenarios based on individual homeowner feedback.

Fig. 1.20 Have a fun drawing attitude!

Make the Best of What's Available

This book covers the basics about doing your best drawings with limited resources. Take a good look around your home, school, office, art supply store, and town. Figure out what drawing materials are easily available, and the copy and photofinishing services that are nearby. Do you have access to computer equipment? Make your drawing decisions based on the tools and services you have at hand. There's no need to commit to brand-name colored markers if the only art supply store in town doesn't carry them. Instead, focus on alternative methods of coloring your drawings, such as colored pencils. I recently gave a design workshop in a rural town. Since there wasn't any photo service capable of developing color slides locally, I photographed with color print film. I had prints back in an hour, and projected color negatives instead of slides to create drawings. It worked fine!

You're in the Drawing Seat

Experiment with your own drawing identity. You may have a natural talent for pencil drawing, but never feel comfortable with ink. Try using minimal detail and no color on your next drawing. Practice several different line styles, drawn at different speeds. See what kind of drawing you come up with if you work on it for half a day. Then try it again in half the time. Don't be afraid to make a mistake. Remember to play to your drawing strengths, and develop the parts of the drawing that are the most exciting to you. Have some fun! It's all in your attitude—once you know some good shortcuts and design tips.

"Genius is the ability to put into effect what is in your mind."

~F. Scott Fitzgerald

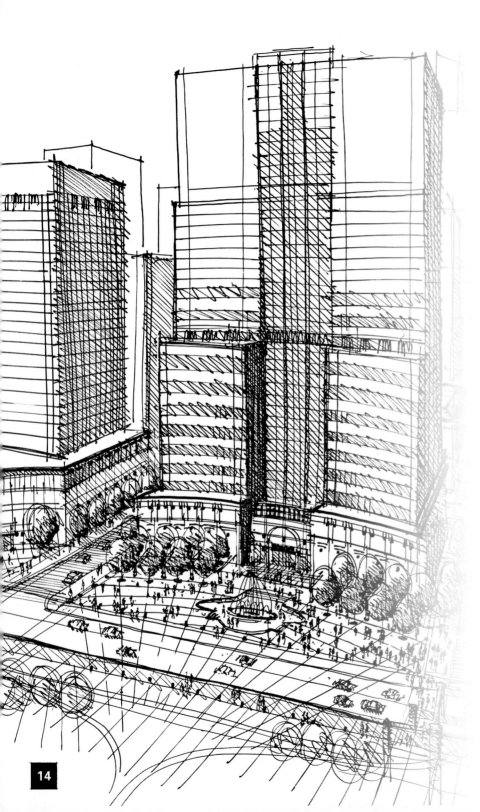

2

BASIC
DRAWING
TYPES

The look of a drawing—and the amount of time it takes you to do it—depends a great deal on the linework technique you use. Scribble lines are the fastest and sketchiest. Most drawings are done with a casual or informal line style, but occasionally a more formal technique is called for. Most design drawings fall into one of four categories: *thumbnail drawings, concept drawings, perspective drawings,* and *paraline drawings.* The vast majority of design drawings are concept drawings. Remember, the most successful drawing may not be the largest, the most detailed, the most colorful, or the most difficult to do.

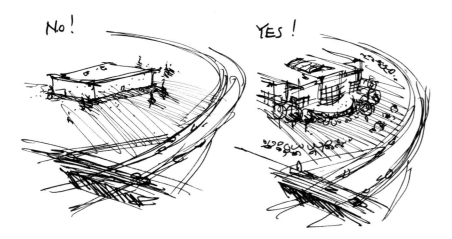

Fig. 2.1 Thumbnail drawing. This quick 2-minute pair of sketches simply captures an idea of landscaping the highway edge of a building. The sketch was later developed into a more detailed drawing for a planning project. 2 x 4" felt-tip pen on vellum.

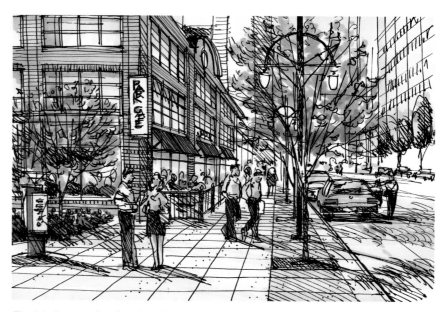

Fig. 2.3 Perspective drawing. This one-point eye-level perspective was effective in showing a downtown streetscape. The foreground objects are detailed and the distant objects are no more than rough shapes to reinforce the depth of the view. 6 x 9" ink on vellum, color marker on a digital print.

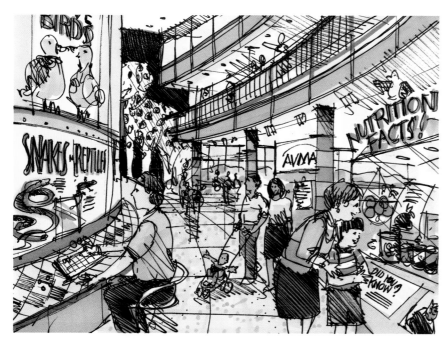

Fig. 2.2 Concept drawing. This 7½ x 10" drawing illustrates many different design ideas for a museum about animals. The multilevel character of the interior space, visitor circulation, color, and graphics collectively tell the story of how a visitor might experience the exhibits. Ink on vellum, color marker on a digital print.

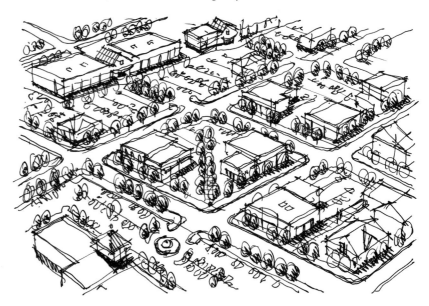

Fig. 2.4 Paraline drawing. This type of drawing technique is used when looking down on a subject, such as this aerial view of a downtown neighborhood. An isometric view was used in this freehand sketch, which was first blocked out in pencil, then traced over with felt-tip pen on vellum.

BASIC DRAWING TYPES **15**

Linework and Shading Techniques

A *scribble line* drawing is a "cocktail napkin" type of drawing. Lines overlap each other and individual shapes are created by repeating lines on top of each other. Extremely loose and noncommittal, scribble line drawings show no design detail. This technique is extremely appropriate for thumbnail drawings, for loose concept drawings, and for working out size and space relationships. It works best in small formats. The scribble technique lets you generate lots of visual ideas quickly, using simple shapes and forms, when you're in the planning stage of a drawing. Shading and shadows are drawn with continuous back-and-forth motions of the hand (Figs. 2.5–2.7).

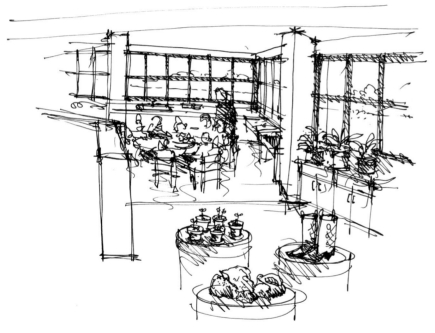

Fig. 2.6 Walk through downtown. This series of images were based on Polaroid photographs taken at different locations. The severe scribble technique enabled each segment to be drawn in about 10 minutes, showing basic massing and movement, without any detail. 18 x 18" permanent ink on Mylar.

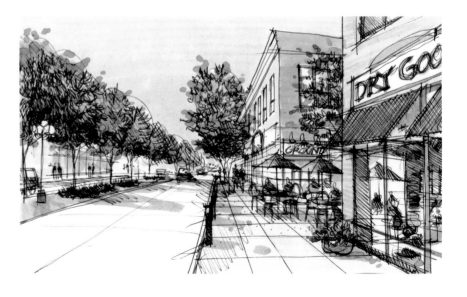

Fig. 2.5 Ghosted detail of a daycare room. The objects in this interior sketch are scribbled with just enough form and detail to distinguish between plants and people. The 15-minute drawing shows worktables, counters, objects on pedestals, and basic architectural components. 7 x 9" felt-tip pen on vellum.

Fig. 2.7 Outdoor sidewalk café. This 9 1/2 x 16" drawing blends scribble line-work for the landscaping, furniture, and people with more carefully drawn buildings and sidewalks. Color markers are applied with the same spontaneous character as the lines to reinforce the early phase of the design process. Felt-tip pen on vellum with Chartpak AD markers applied directly to the original sketch.

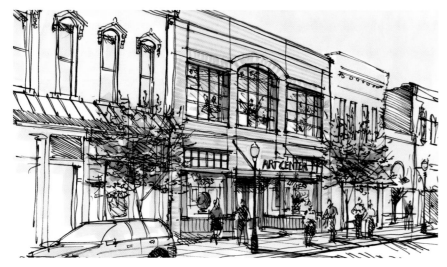

Fig. 2.8 Architectural character without the detail. This downtown scene is drawn with enough care to accurately represent building type and window proportions. Trees, lights, cars, and people add scale and activity to the street. 9 x 15" felt-tip pen on vellum with Chartpak AD marker color on the original drawing.

Most of the drawings in this book are done using *casual line* techniques. Casual linework lets you communicate information without spending too much time in the process. Lines may not be perfectly straight, corners may overlap, and the amount of detail may be consciously held back. This technique is very successful in the early phases of a design, and reflects the freehand nature of developing ideas. There is a spontaneous character to casual linework, and casual drawings tend to look friendly. Slight variations in perspective or proportions are less noticeable, and accuracy is not a high priority. One great advantage of this line technique is the amount of time saved over a more formal approach. Notice that shading and shadows are more carefully drawn with disconnected lines parallel with each other (Figs. 2.8–2.10).

Fig. 2.9 Simple shade and shadow technique. This 8 1/2 x 14" ink on Mylar drawing was first outlined and then shadowed with diagonal lines parallel to each other. Windows are filled in black for contrast.

Fig. 2.10 Relaxed pencil lines. The linework and shading characteristics of pencil can create a softer look than an ink pen. This drawing was one of 12 done with similar pencil technique and color. 7 1/2 x 10" pencil on vellum, Chartpak AD markers on a digital print.

If you commit to precisely crafting a drawing, you need to make an accurate statement with each and every line. This requires a *formal line technique,* in which lines are drawn with a straightedge, proportions are exact, and the entire drawing is very realistic and accurate. Drawings of this nature can be very beautiful, but the time invested may be so great that you could have produced several casual line drawings in the same time it took to create a single formal drawing. Unless you are specifically asked to create a drawing with this amount of detail, try to stay with casual line drawings.

Adding *tone and shading* to a drawing can also be done loosely, moderately, or in great detail. You can get a continuous gray tone by using pencil. When working with ink, you have to build the shading with multiple lines or line hatching. A loose hatching technique may involve a series of rough z-lines.

Fig. 2.11 Formal lines take too much time. All of the straight lines in this drawing were carefully drawn with a straightedge. Objects were drawn with enough detail that they could be recognized and people were accurately rendered with specific clothing and expressions. This drawing took well over two days to create. 13 x 24" technical ink pen on Mylar.

Fig. 2.12

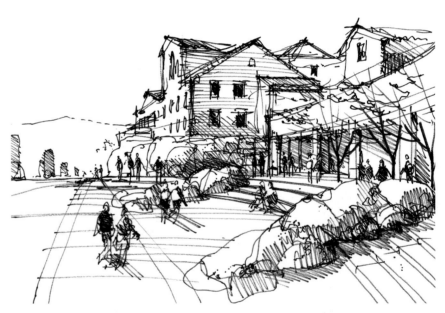

Fig. 2.12 Extreme detail, maximum time. Both drawings were developed for publication and required accurate detail and shading. The 10 x 14" illustrations were drawn with a technical ink pen on cold-pressed art board. This drawing was far too detailed and time-consuming to create.

Fig. 2.13 Loose hatching pattern. This 10-minute 8 x 10" sketch of an outdoor plaza is drawn with minimum detail. Shading was done almost entirely with continuous z-lines. Felt-tip pen on vellum.

Moderate hatching creates the shading by adding freehand lines on top of each other in various patterns. Tight hatching is usually done with a straight-edge and is laborious and time-consuming. You can also add tone with dots. This is called stippling, and takes a lot of time to create. Scientific illustrators regularly use the stipple method with their highly technical and accurate line drawings.

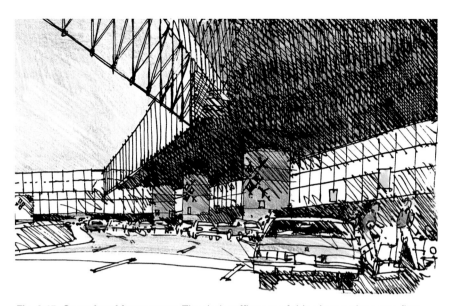

Fig. 2.15 Cross-hatching pattern. The dark soffit area of this airport plaza was first drawn with vertical hatching, then layered with diagonal hatching. Lines were drawn closer together at the darkest areas of the roof. 4 1/2 x 7" felt-tip pen on vellum, colored pencil on standard bond copy.

Fig. 2.14 Tight hatching pattern. Most of the hatching in this series of architectural drawings was done with lines carefully drawn parallel with each other. Darker shadows were created with additional layers of hatching. 13 x 17" permanent ink on Mylar, traced from photographs.

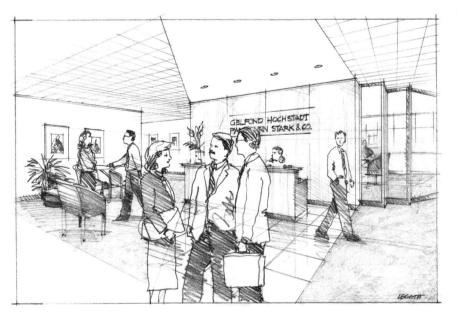

Fig. 2.16 Pencil hatching variety. Drawing with pencil can create many different shadowing effects. The carpet has a continuous tone hatching, while the clothing is drawn with different densities of diagonal hatching. Varying the pressure of the pencil on the paper controls light and dark hatching. 9 x 14" graphite pencil on vellum.

Thumbnail Drawings

Keep It Small

Thumbnail drawings are the smallest and easiest drawings to create. Because of their tiny, stamplike size, detail has to be kept to a minimum. They tend to be pure line drawings, very simple, without color or even much variation in tone. They're often used in the margins of reports to help readers visualize. Sometimes they illustrate objects or icons, and they can be used like clip-art to embellish word documents. In early design phases of projects, thumbnail drawings help "storyboard" multiple ideas that later can develop into more refined drawings.

Fig. 2.18 One-minute vignettes. These thumbnail sketches identify different streetscape elements during the concept development of a project. The ideas were easy to sketch and allowed the client to visualize the many alternatives that could be integrated into the building. Felt-tip pen on trace.

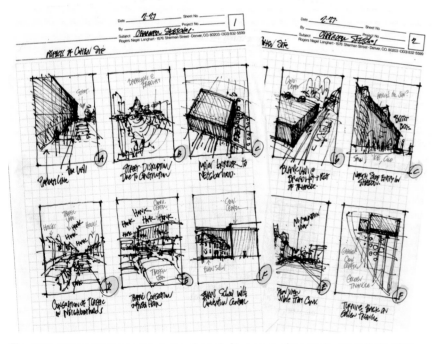

Fig. 2.17 Urban design concept storyboard. Six pages of 2 x 3" thumbnail sketches were developed to illustrate different impacts a large convention center might have on its neighborhood. From the 36 sketches, 12 were selected and drawn at a larger scale with more detail. Felt-tip pen on bond paper.

Fig. 2.19 Five-minute vignettes. These thumbnail sketches are similar to those in Fig. 2.18 but were drawn in more detail. Permanent ink pen on vellum.

When to Use Thumbnail Drawings

Either as a single image or in a series of multiple images, thumbnail drawings are best used to support text documents. Imagine a book report or a newsletter. Text alone is dull and unimaginative, but often limited layout space doesn't allow for large drawings. Perhaps the printing process precludes photographs. One good solution is to incorporate thumbnail drawings that break up the text and add a personal touch to the document.

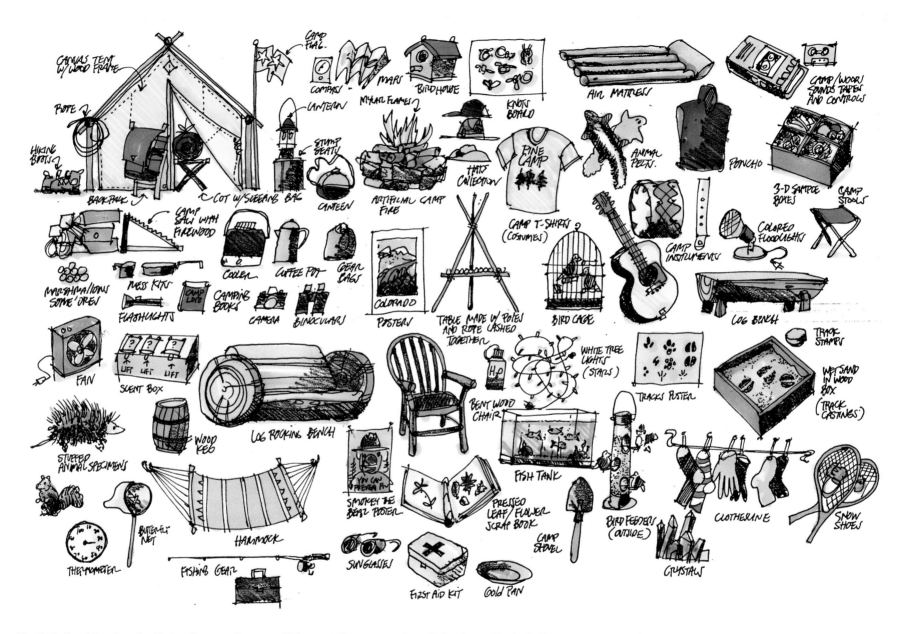

Fig. 2.20 Combine thumbnail sketches to tell a story. This 11 x 17" montage of small sketches collectively illustrate the theme for an exhibit about summer camps. Each element was drawn with just enough detail and labeled to identify its use. Permanent ink on Mylar with pencil tone, marker color on an OCE digital print.

How Much Time?

Try to keep your drawing time on thumbnails to a minimum. Thumbnail drawings aren't supposed to be information-rich; they just support the text and add character to the document. Try not to spend any more than 15 minutes on each thumbnail. Remember, less is more!

The Best Thumbnail Sizes

The best size for a thumbnail drawing is 3 x 3" or less; any larger and you need more detail and drawing time. Thumbnails can be reproduced even smaller. If you reduce the image by 50%, it will be sharper and be easier to fit on the page. Use ink linework, because you won't get a good reduction with color or pencil tones on the drawing. A great shortcut for making thumbnail drawings is to keep a file copy of every drawing you create, and reuse portions of those images in new thumbnail drawings. When you copy and modify existing work, you save a tremendous amount of drawing effort.

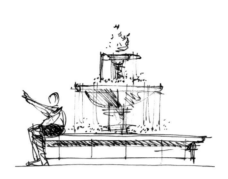

Fig. 2.22

Fig. 2.24

Fig. 2.21–2.24 Ink drawings reduce well in documents. The various thumbnail sketches on this page were each drawn less than 3 x 5" and with an ink pen. Notice how many images are cropped and how the detail and hatching varies.

Fig. 2.23

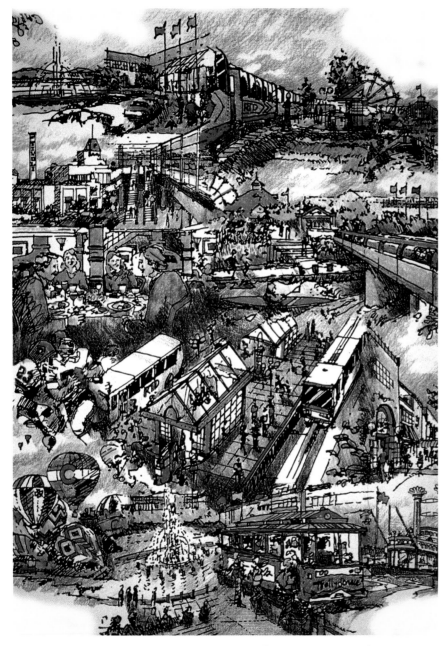

Fig. 2.25 Combine and color thumbnail sketches. This 8½ x 11" cover for a report combines 14 separate thumbnail sketches, many of which can be found on page 73. Copies of each original were pasted together and the edges were blended with white correction fluid and additional linework. A final copy was made and colored with Prismacolor pencils.

QuickTips *Thumbnail Drawing*

- Label a 9 x 12" envelope THUMB-NAIL DRAWING EXAMPLES FILE and begin filling it with examples of thumbnail drawings you find in magazines and newspapers. Use these examples for reference when you begin new thumbnail drawings.

- Tape or spray mount your thumbnail drawings on 8½ x 11" bond paper so you can copy them easily and keep them filed.

- Unlike larger drawings with many images that can tell several different stories, a thumbnail drawing should have a simple, singular message. Don't try to show too much information.

- If you're creating a series of thumbnail drawings that will be presented together, determine a similar size for all of the images and draw them in an identical style. The drawings will provide a consistent design theme and help reinforce each other.

- Due to the small size of these drawings, try to keep the amount of time you spend on the drawing to a minimum. Work quickly and limit the amount of detail.

- Adding color to a thumbnail drawing sometimes enhances what would normally be very sketchlike and difficult to understand.

- Crop your image area and draw only the most important information. Figure out what is not essential to your story, and leave that information off the drawing.

- Work in black-and-white linework only. Avoid using gray tones, because they're difficult to reproduce at such a small scale.

- Create the thumbnail at twice the size you want the final to be. Reduce the drawing 50% on a copier for the final reproduction.

- Always keep a black-and-white copy of your initial line drawing before you add any shading or texture. That record of the drawing in its simple form can provide useful information to trace from for future drawings. It's harder to trace information after shading and textures have been added, and the black-and-white version of the drawing is also easier to reproduce in a newspaper or newsletter.

Concept Drawings

Visualize the Concept

A concept drawing is an illustrative representation of a design direction, motif, or theme. Concept drawings have a broad range of applications, from design presentations to reports and publications. A concept drawing can portray the spirit of an urban space, evoke the excitement of an interior, or tell the story of your landscape design idea. Because of the standard glass size of copy machines and computer scanners, concept drawings should be drawn at 11 x 17" or smaller. Unlike sketchy, black-and-white thumbnail drawings, concept drawings begin to define materials and include some detail as well as people and objects that are more carefully drawn. Concept drawings are almost always colored with markers or pencils.

Each concept drawing is a unique drawing solution to a design problem. It's always a good idea to discuss your drawing concept beforehand with others involved with the project—such as your teacher, client, boss, or coworker—to be sure that your idea communicates the right message.

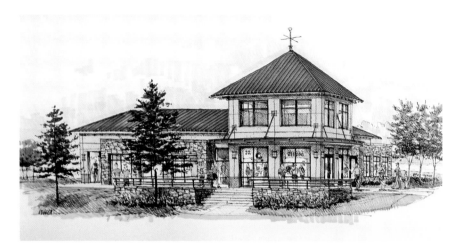

Fig. 2.27 Oversized to show detail. This 12 x 24" visitors center drawing was slightly larger than most concept drawings because of the detail needed in the landscaping, stone walls, and roof. The original drawing was created with permanent ink on Mylar, traced over an enlarged photograph of a physical model. An OCE digital print was made and colored with Chartpak AD markers and colored pencils.

Two Concept Drawing Approaches

There are two basic ways to complete a concept drawing, each leading to similar results. The fastest drawing method involves *coloring the original artwork.* The original drawing is created with felt-tip pen on vellum or lighter-weight trace. When the linework is completed, color markers and/or colored pencils are applied directly to the original artwork. Figure 2.28 is an example of this process. The advantage of this approach is that the final color drawing can be completed in minimal time without any reprographic interim steps. Be aware that this method involves some risks, such as the potential of ruining the original drawing if the coloring is poorly done, or losing it if the final drawing is given away before a record scan or photograph can be taken. The second drawing method involves *coloring a print.* Once the original black-and-white drawing is completed, a copy of the artwork is made and color markers and/or colored pencils are applied to the copy, not the original artwork. This approach adds a reprographic step between drawing and coloring, but saves the original black-and-white artwork. If there are good reprographic machines or services nearby, this option is safer, even if it adds time to the drawing process. Figures 2.26 and 2.27 are colored prints.

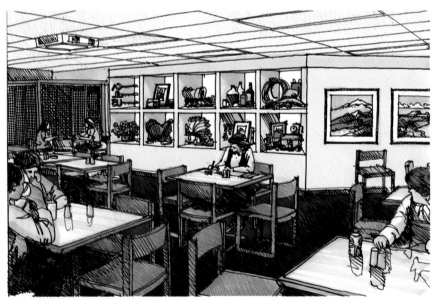

Fig. 2.26 Cafeteria exhibit wall. This 10 x 14" concept drawing highlights an exhibit wall with western artifacts displayed in a series of niches. The basic perspective and foreground information originated from a reference photograph. The original drawing was created with a permanent ink pen on Mylar. An OCE digital print was made from the original artwork and colored with Chartpak AD markers.

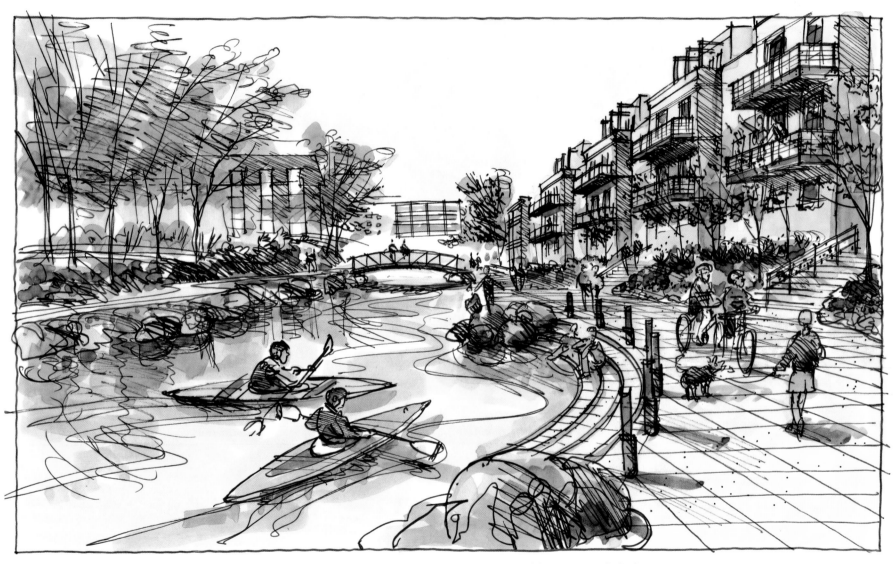

Fig. 2.28 Ideal scanning format. The 9 ½ x 16" size of this drawing was set in order to scan the original with an 11 x 17" flatbed scanner. The drawing was colored with Chartpak AD markers directly on the original felt-tip pen drawing on vellum. The drawing was trimmed and taped to an 11 x 17" bond paper carrier sheet for easy copying and storage.

Concept Drawing
Step by Step

Fig. 2.29 Step 1: Gather the drawing data. The original 4 x 6" photograph was enlarged 150% on a copier. A computer wireframe was created that roughly blocked out a second-floor addition. The sheet of tracing images included people, cars, and trees. A sheet of vellum was then placed over the enlarged photograph and both were taped to the table surface.

Fig. 2.30 Step 2: Place and trace the objects. A felt-tip pen frame was drawn around the outer edge of the photo. Using a red pencil, the building outline and computer wireframe were added, followed by tracings of the car, people, and trees.

Fig. 2.31 Step 3: Complete the redline mock-up. The building roof form, windows, outdoor dining area, level-two terrace, stairs, and sidewalk were all roughed in with red pencil. The photograph was removed and a second piece of vellum was then taped over the mock-up.

Fig. 2.32 Step 4: First trace the foreground. Using a felt-tip pen, objects in the foreground were outlined first. Shading and shadow were not added until tracing of the entire image was completed.

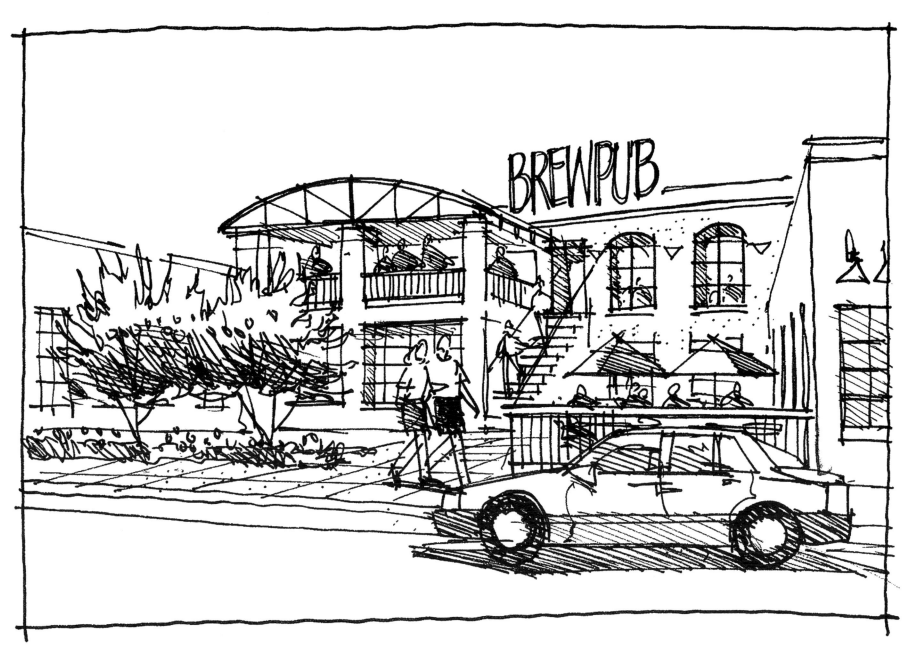

Fig. 2.33 Step 5: Complete the concept drawing. Completing the final 6 x 9" drawing involved adding hatching patterns to the window surfaces, shadows beneath the car, trees, and people, and stipple pattern on the sidewalk and building exterior.

Concept Drawing in Series

You'll save the greatest amount of time if you can communicate your design idea with a single drawing, but sometimes you need a series of drawings to tell a more complete story. Occasionally, the planning or design issues are so numerous that a series of six to ten concept drawings is necessary to fully illustrate the design ideas. Shown below and opposite are three drawings from a series of seven created to visualize many ideas about a new museum devoted to pets. Figure 2.2 is also from that series. Each drawing of a series should be similar in size, format, drawing style, and coloring technique to give the overall series a consistent appearance and quality. In the example of the Pet Museum, each drawing illustrated different interior and exterior program spaces of the building—exhibition halls, main entrance, interpretive exhibit rooms, retail spaces, and other amenities.

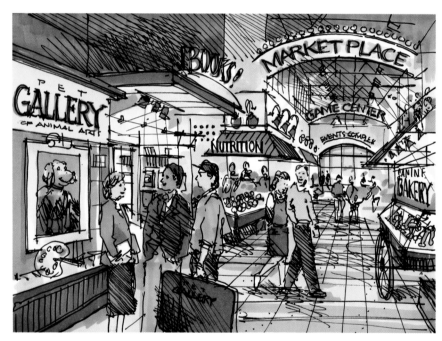

Fig. 2.34 Signage identifies the retail space. This one-point perspective clearly identifies the retail uses by including seven different signs. The perspective emphasizes the corridor connecting to an events complex. People and objects in the foreground are carefully drawn, while those in the background are "ghosted" images. All of the 7 1/2 x 10" drawings were sized to fit on a standard flatbed scanner. Each was drawn with a felt-tip pen on vellum, reproduced on presentation bond with a digital copier, and colored with Chartpak AD markers.

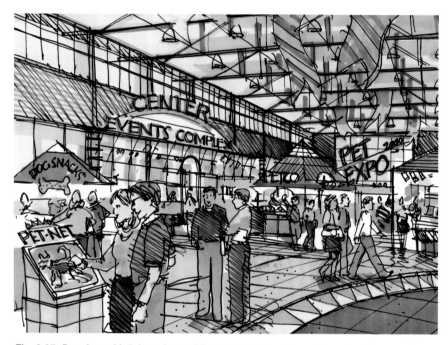

Fig. 2.35 People and bright colors add energy. In this concept drawing, the events center hall has many brightly colored kiosks with graphics. Over 18 people drawn in the foreground and background give the appearance of a well-attended event. Imagine how lifeless this drawing might look if only a couple of people had been drawn.

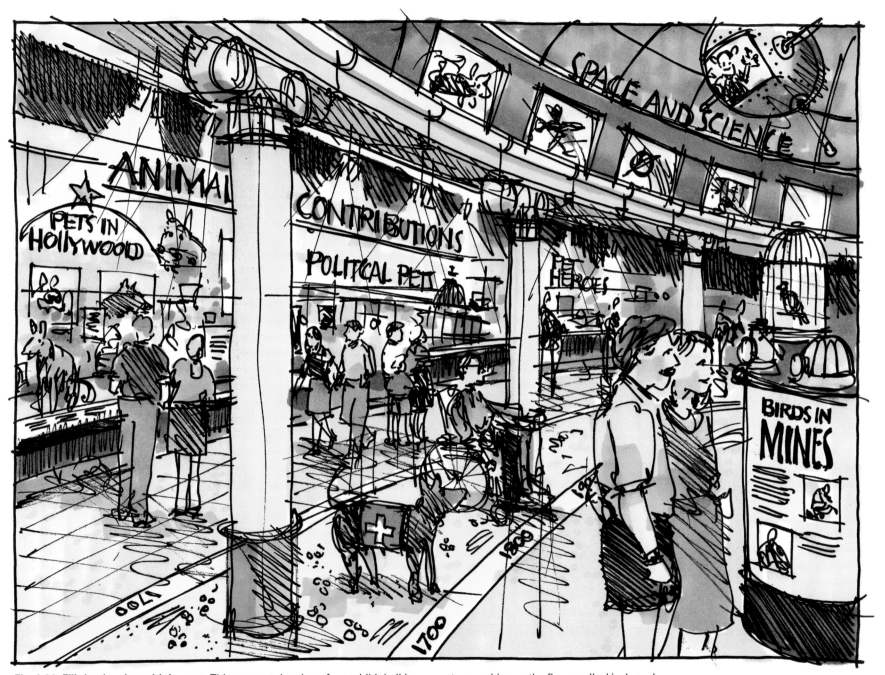

Fig. 2.36 Fill the drawing with images. This concept drawing of an exhibit hall incorporates graphics on the floor, walls, kiosk, and ceiling. Detail is purposely minimal but the many different shapes and colors give the impression of a large collection of artifacts. Don't be afraid to include people in wheelchairs in drawings. Drawing cone shapes below the fixtures, colored in with yellow, creates spotlights. Shading is kept away from the lights.

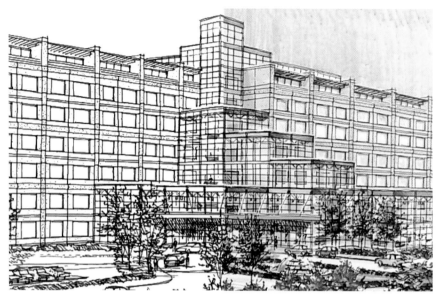

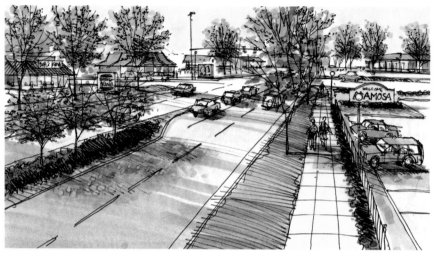

Fig. 2.37 Materials are not clearly identified. Tree types and building surfaces shown in this black-and-white portion of the drawing are difficult to identify. There isn't a clear distinction between the sidewalk and grass areas. As is, the drawing is unsuccessful in communicating basic design information.

Fig. 2.38 Color differentiates materials. With color markers and pencils, the different glass types are highlighted, ornamental trees and shade trees are identified, and numerous other materials are clearly shown. 14 x 32" permanent ink on Mylar, digital print on presentation bond and colored with both markers and pencils.

Fig. 2.39 Color-enhanced trees. The street trees in this drawing are lightly drawn with branches and scattered dots representing leaves. Dabbing three different markers at each tree creates the canopy of foliage. The treetops have yellow highlights to represent reflecting sun, light-green leaves, and dark-green shadowed areas. The ornamental trees combine brown and purple colors. 9 x 16" felt-tip pen on vellum with markers applied directly to the original drawing.

Color or Black-and-White?

The choice to use or not use color should be made during the initial planning stage of a drawing. That decision will set you up to make other choices regarding drawing size and materials, amount of detail and texture, and reproduction options. For example, if a landscape drawing will be black-and-white, tree branches and leaves should be more carefully drawn in with linework. If the same drawing was planned for color, you could use color techniques to illustrate the foliage. This kind of simple drawing decision can amount to big shortcuts in the amount of time and effort you invest in a drawing.

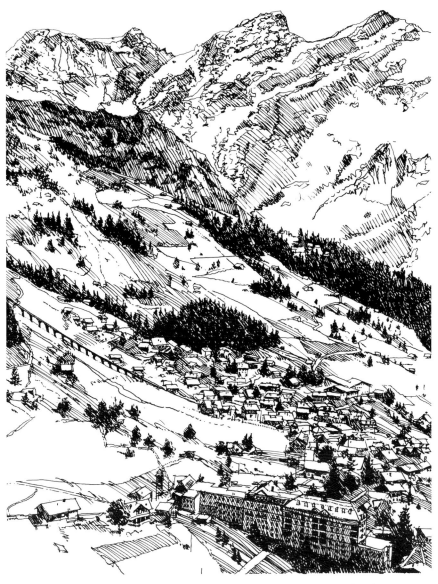

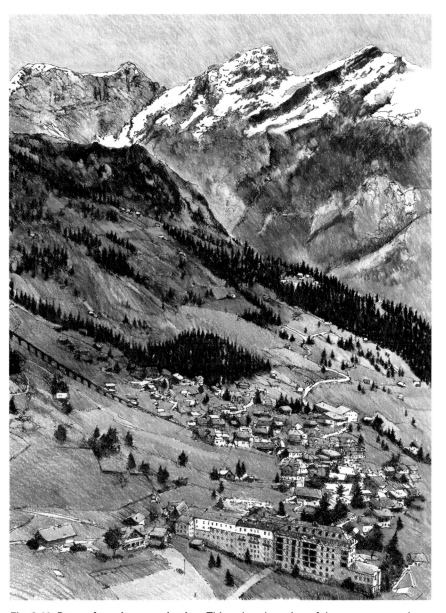

Fig. 2.40 Drawn for black-and-white reproduction. This 12 x 16" line drawing was delineated specifically for reproduction in a book. Hatching patterns help define building shadows and variations in the terrain. Darkest areas represent pine forests surrounding this alpine resort village. With the amount of detail in buildings, it was necessary to leave the hillside and mountain slopes somewhat free of detail to avoid overwhelming the image. Permanent ink pen on Mylar.

Fig. 2.41 Drawn for color reproduction. This colored version of the same mountain village clearly shows the red and white color palette of the architecture and the lush green vegetation. Giving the mountain a blue-purple tone creates depth. A dark shadow on the hillside above town draws more attention to the village and less to the background. The Prismacolor pencils were applied in thick layers and blended with a white pencil to create a soft, mistlike character to the lower portion of the mountain. 12 x 16" permanent ink pen on illustration board with colored pencil.

Selecting the Right View

Selecting the right viewing angle for a drawing is a matter of answering two basic questions: "How close should I be to get the best view of the subject?" and "How high off the ground should I be when looking at the subject?" You should also include some environmental context in your drawing. Adding objects to the foreground can accentuate the three-dimensional depth of the drawing and help frame the image. Most concept drawings are drawn from one of three viewpoints: (1) *eye-level view*, with the scene viewed from 5 to 10 feet above the ground, (2) *bridge-level view*, as if you were looking from a bridge, a treetop, or roof, and (3) *aerial view*, a bird's-eye view from far above the ground. Look at the different drawings in this book and determine which of the three view categories they represent.

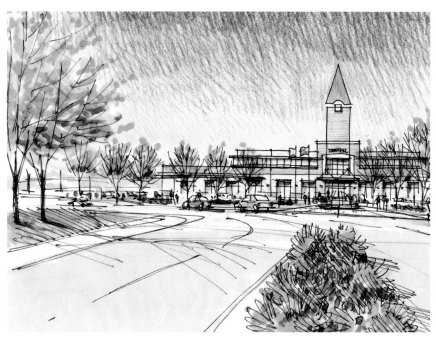

Fig. 2.42 Eye-level view. The ground level view is the most natural and realistic orientation for portraying a building design concept. Most of our interaction with architecture is from eye level, and it is the preferred viewpoint for the majority of drawings. The focus of this 8 x 14" drawing is the building entry and tower. Minimizing the foreground and edge detail emphasizes the entry plaza. Felt-tip pen on vellum with marker applied directly to the original.

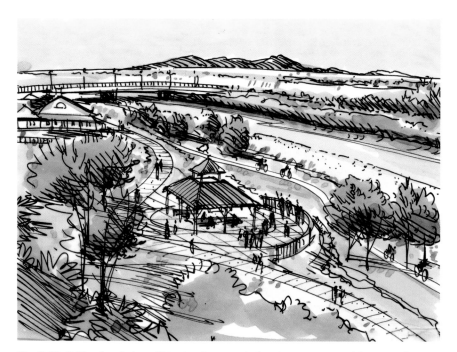

Fig. 2.43 Bridge-level view. This riverfront park drawing was created from a reference photograph taken from a bridge crossing the river. The view from above allows the viewer to see more of the site context, meandering trails, central picnic pavilion, and distant structures. 6 x 8" felt-tip pen on vellum with marker directly applied to the original artwork.

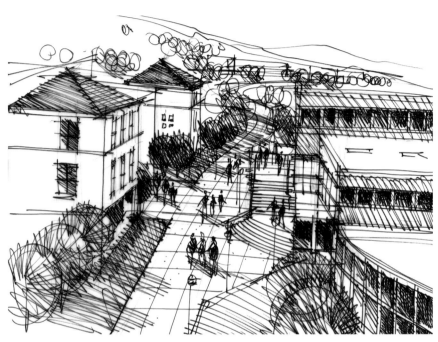

Fig. 2.44 Campus view from a rooftop. The circulation patterns and interconnecting plazas of the school were best illustrated from this vantage point. The quickly drawn sketch shows building facades, massing, landscaping, paving patterns and steps, and people. 7 1/2 x 10" permanent ink on Mylar.

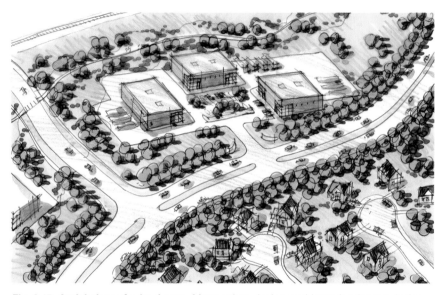

Fig. 2.45 Aerial view of mixed uses. Many urban design and large landscape design projects require drawings that visualize more land area. This 2-hour 10 x 16" drawing is a bird's-eye look at a neighborhood in which single-family residences and office warehouses are split with a landscaped boulevard. Detail is minimal due to the distance from the objects and early conceptual phase of the project. Felt-tip pen on trace with Chartpak AD markers directly applied to the original artwork.

The Best Concept Drawing Size

As a rule, concept drawings should never be drawn any larger than 11 x 17". Drawing originals at 8½ x 11" makes for easy copying, scanning, and record keeping. At these small sizes, you can have standard high-resolution color copies made of your drawings instead of paying for expensive color photographs or large-format color scans.

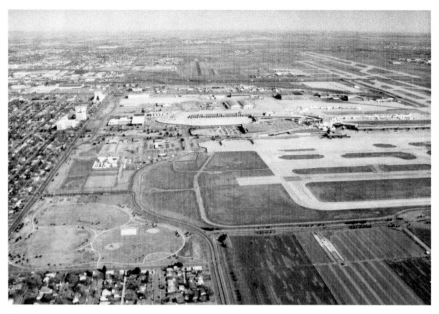

Fig. 2.46 Development site for NCAA headquarters. When starting any design and visualization project, gather site information from both ground level and from above. You can hire a local pilot and photograph the site from a small plane. Your pictures might be used as an accurate base for an aerial perspective of the project. This image was taken with a standard 35mm camera, high-speed print film at about 750–1000 feet above the ground.

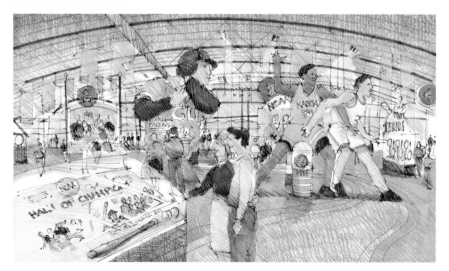

Fig. 2.47 Eye-level concept drawing. The interior views of the NCAA exhibits and public spaces were drawn at ground level to show maximum detail and visitor interaction with the displays. 7 1/2 x 13" permanent ink pen on Mylar, diazo printed on brownline paper and colored with Chartpak AD markers and Prismacolor pencils.

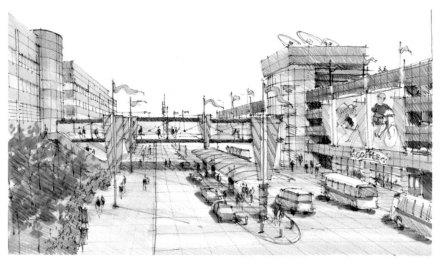

Fig. 2.48 Bridge-level concept drawing. This elevated view of the main entry plaza shows more of the circulation relationships between pedestrians and cars and transit. The view has a realistic look, as if one were walking across a second bridge connecting the parking structure and the headquarters building. 7 1/2 x 13" permanent ink pen on Mylar, diazo printed on brownline paper and colored with Chartpak AD markers and Prismacolor pencils.

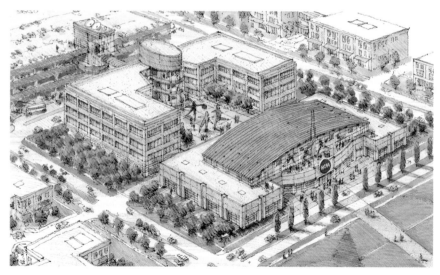

Fig. 2.49 Aerial view concept drawing. The series of drawings needed to visualize the overall development included two aerial views of the headquarters building and surrounding areas. The aerial view can illustrate the architecture, landscape design, circulation patterns, and amenities in a single drawing. Aerial views tend to be larger than most concept drawings because of the amount of detail required to show all of the elements. This 18 x 26" drawing was generated from a projected slide taken of the architectural site plan.

QuickTips *Concept Drawing*

- Label a 9 x 12" envelope CONCEPT DRAWING EXAMPLES FILE and store all your smaller concept drawings in it. Create larger files for the 11 x 17" drawings. This keeps your work flat and away from damaging sunlight.

- If you are developing a series of concept drawings around a single theme, create variety among the views and try to avoid repeating the same elements, such as traced people, plants, graphics, and other objects. Repeated objects diminish the realism of the drawings.

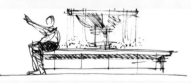

- Always add elements in your drawing that will help give it scale. For example, if you're drawing a landscape, try to include people, birds, plants, furniture, signs, lighting, or any other appropriate objects that will enhance the subject of the drawing.

- Avoid drawing sizes larger than 11 x 17".

- Don't hesitate to add wildlife to your drawing to help animate areas that otherwise would appear lifeless. Flying birds, geese on water, squirrels in grass, and dogs on a leash are good examples.

- If you add signage to a drawing, avoid using real names of businesses. Make up your own store titles and graphics to maintain the unique character of your drawing and avoid drawing attention to actual commercial names.

- Don't forget to add shadows to your drawings. An object will appear to float unless it has a shadow drawn beneath it. A soft shadow can suggest a diffused light source, while a hard shadow indicates an intense single light source, such as the sun.

- When adding shade to small areas of the drawing, you can accurately control the area of the shadow by using a triangle or straightedge to draw against.

- When having a diazo or digital print made from an original, don't assume that the print will come back to you perfectly exposed. Just like the "lighter –darker" setting on a copier, diazo and digital machines have variable settings that can make your print lighter and darker. Ask the reproduction company to make small test strips for you to review so you can pick which exposure is best for your drawing.

- Sign your name and the date in a lower corner on each of your drawings. It's a good idea in case your drawing gets misplaced. It's also great advertising for you as a designer.

- You can enhance the appearance of a small original drawing done on vellum simply by mounting it on a sheet of 11 x 17" white paper, using either clear tape or spray mount.

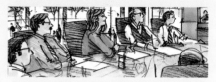

- If it's appropriate for the subject matter, incorporate people into your drawing. They always add character and scale to the image.

- For the purposes of making color or black-and-white copies, the optimum drawing size is 11 x 17". Make your image no bigger than 10 x 16" to allow for a border and white space between the image and the edge of the paper.

- When you draw people, place them in active situations, interacting with each other and having fun. Happy faces always enhance the image and make for a more friendly looking drawing.

Perspective Made Easy

What Is a Perspective Drawing?

Perspective means point of view. A perspective drawing shows how a three-dimensional object, such as a building or an interior space, looks to the human eye from a certain angle. In short, a perspective is the accurate rendering of a subject in three dimensions.

There are many detailed mechanical methods for creating perspectives, and entire books are devoted to step-by-step instructions and formulas. The purpose of this section is to give you an overview of different kinds of perspective drawings and to emphasize effective shortcuts in creating them. You can, for instance, use a camera to photograph buildings, study models, or floor plans—and then create perspectives by projecting the image on paper. You can purchase commercial perspective charts, and draw perspectives by overlay tracing. Wireframe perspectives can be generated on a computer, with the right software, and used as a base for drawing. A few designers are so experienced that they can freehand or "eyeball" a perspective, aiming for a sketch that falls within an acceptable range of accuracy.

Fig. 2.50 Freehand one-point perspective. The view of this signage is from beneath. Lines of the ceiling grid converge to a single point. 4 x 8" permanent ink pen on trace.

Perspectives fall into three categories: the easiest to draw *one-point perspective,* the most commonly drawn *two-point perspective,* and the seldom-used *three-point perspective.* Each is described on the following pages.

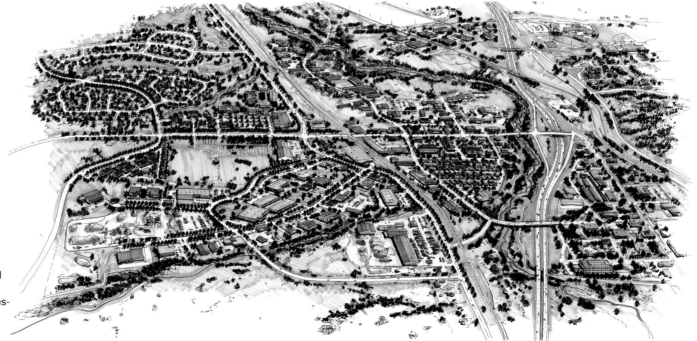

Fig. 2.51 Aerial perspective with no clear vanishing point. This 24 x 48" birds-eye view of a town originated from a reference photograph of the area. Establishing a vanishing point from the photograph was difficult and was further complicated by the curved streets. Establishing a true vanishing point in this type of drawing isn't necessary due to its large scale.

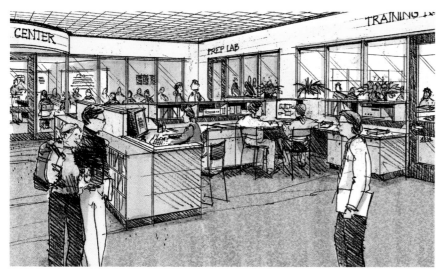

Fig. 2.52 Two-point perspective created with a chart. This interior drawing of a library was developed using a Lawson Perspective Chart to lay out the furniture, walls, and ceiling grid. Although accurate, these charts can be somewhat confusing to use and may not offer a great variety of viewing angles. Perspective charts were useful tools for generating perspective views prior to the proliferation of computers.

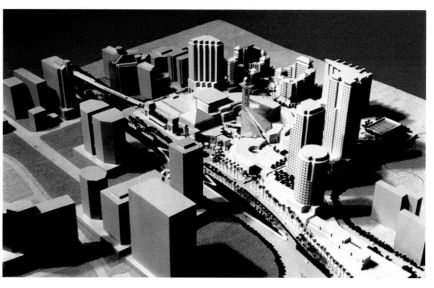

Fig. 2.54 Three-point perspective from a model photograph. The severe downward angle of the camera has created a three-point perspective of the city model. Notice how the vertical walls of the buildings flare outward from the center of the drawing. When a photograph such as this one is taken, certain adjustments can be made to the camera angle to reduce this type of distortion.

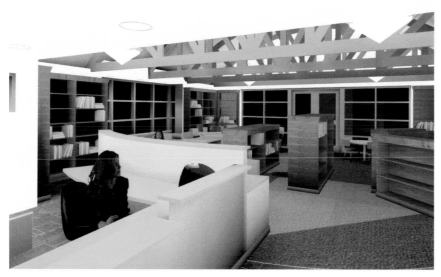

Fig. 2.53 Two-point perspective created by computer. This computer model of another library space was created with numerous software programs and complex steps. The original information was generated in AutoCAD, then rendered in 3D Studio Max. The image was then brought into another program named Lightscape and rendered with realistic lighting. The drawing took 2 days to create and an additional 2 days of computer "crunching" to process the image. *Computer model by David Stone.*

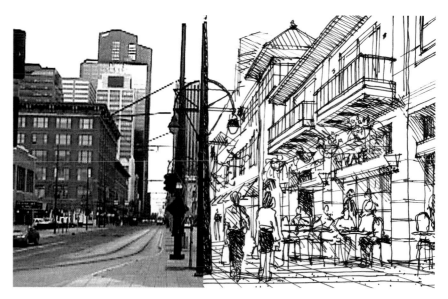

Fig. 2.55 and **Fig. 2.56 A single vanishing point.** Drawn from a digital photograph (Fig. 2.55, left), most lines of the sidewalk, balconies, and roofs converge in the distance to a single point located just to the right of the light rail train. The photograph already established the perspective. All of the buildings on the left existed, while all of the information on the right was new. 6 x 9" permanent ink on vellum.

Three Types of Perspectives

One-Point Perspective

One-point perspectives are the least complicated and quickest perspectives to draw. Imagine a box in which all the lines representing the box's width are called the *x*-lines. All lines representing the box's height are *y*-lines, and those representing the box's depth are called *z*-lines. Now imagine looking at a single spot on the horizon line beyond the box. All of the *z*-lines converge toward that one point, creating the one-point perspective (Fig. 2.57).

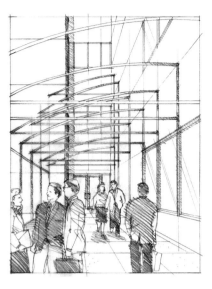

Fig. 2.58 Vanishing point centered on the doors. This drawing clearly illustrates the one-point perspective concept. All horizontal lines of the sidewalk and trellis (*x*-lines) are parallel with the bottom frame of the drawing. All vertical lines of the walls (*y*-lines) are parallel with the side frame of the drawing. All lines representing the length of the walk and wall (*z*-lines) converge to a single point near the door handles. 10 x 13" graphite pencil on vellum.

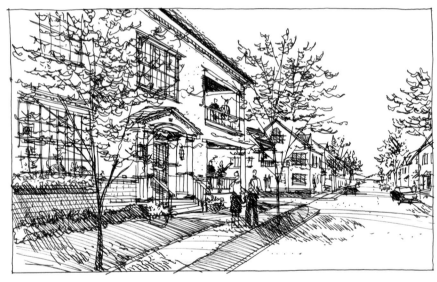

Fig. 2.57 Single vanishing point in the distance. Notice in this eye-level one-point perspective that the sidewalks, curbs, roof edges and house fronts converge to a single point in the distance that is centered in the street. Detail in the foreground is more carefully drawn than in the distance. This reinforces the depth of the street scene. 9 x 15" permanent ink on trace.

Fig. 2.59 Free-hand perspective. The floorboards, window mullions, and roof beams clearly point to the single vanishing point in this beachfront scene. 6 x 6" felt-tip pen on vellum with Chartpak AD marker.

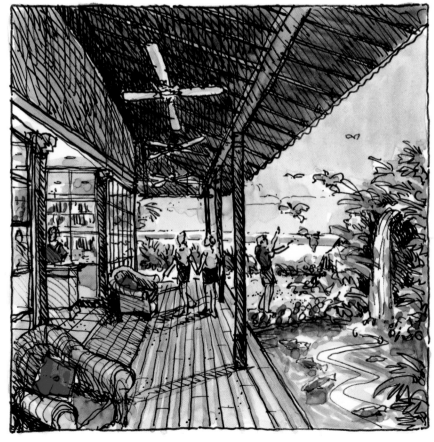

Fig. 2.60 Focus on the central plaza. This one-point perspective originated from a photograph taken from the center of the street. The central vanishing point was established by tracing the street curbs and edge of the building. The new building on the right was drawn to match similar historic alignments and materials. New storefronts were emphasized by purposely not drawing street trees in front of them. 12 x 24" permanent ink on Mylar, reduced to 8 x 15" and then colored with Prismacolor pencils. The reduction allowed the final color version to be color-copied on a standard machine.

One-Point Perspective Step by Step

This interior perspective was one in a series of drawings created for a proposal for a new NCAA headquarters (see Figs. 2.46–2.49). Reference material for the drawing came from magazines and an ad showing a large space in an airport.

Fig. 2.62

Figs. 2.61–2.63 Step 1: Gathering reference data. Images of sports figures were copied from magazines and a photograph of an interior space. The one-point perspective was established from the photograph. Each image was enlarged/reduced on a copier to fit into the final size of the drawing.

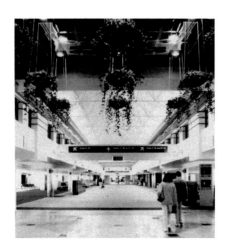

Fig. 2.63

Fig. 2.64 Step 2: Trace and block out the sketch. Most of the drawing decisions were made in this redline stage. The 7 1/2 x 13" size was framed, images were traced, new people and exhibits were added, and the overall signage was roughed in. The original square photograph of the interior room was extended to the right side of the drawing to increase the horizontal proportion of the drawing. Lines were simply extended back to the single vanishing point.

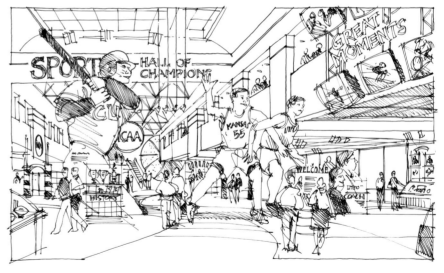

Fig. 2.65 Step 3: Overlay and trace the redline mock-up. A sheet of Mylar was taped over the redline mock-up and the images were traced with a permanent ink pen. Additional detail, people, graphics, and exhibits were added at this stage of the drawing. Compare the two images and see what other information was added.

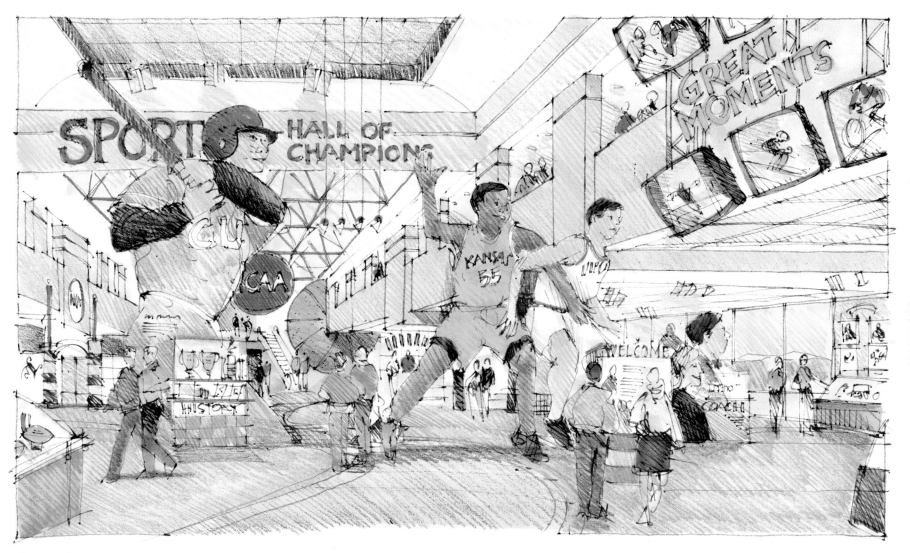

Fig. 2.66 Step 4: Diazo print and final color. All of the drawings in the NCAA series were diazo printed on heavyweight brownline paper to give a "warmer" appearance to the presentation. The drawing was first colored with Chartpak AD markers and then finished with colored pencil to add texture.

Fig. 2.67 Freehand mock-up of a two-point perspective. This perspective type allows you to view the room and furniture from a corner angle, seeing more of the front and sides of the objects. This 6 x 6" mock-up was sized small to prevent the artist from getting bogged down in drawing all of the detail. Red pencil on trace.

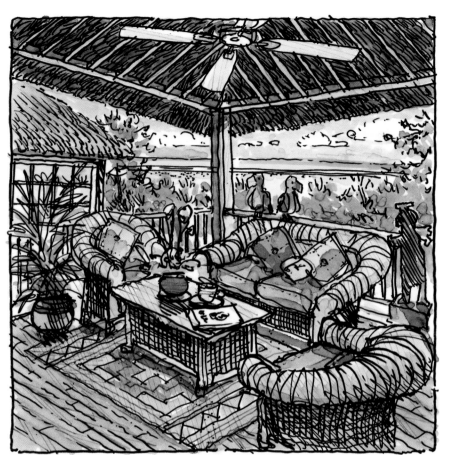

Fig. 2.68 Color right on the original artwork. The final drawing was a 30-minute trace over the redline mock-up. Coloring with Chartpak AD markers directly on the original artwork took another 30 minutes. Don't be afraid of making mistakes. As these small perspective drawings are so quick and casual, minor mistakes won't be noticed.

Two-Point Perspective

Imagine the same box again, then rotate it as if you are now looking at a corner. Now, establish a horizon line with two points at either end. Notice how the x-lines converge to one point and the z-lines converge to the other point. In a two-point perspective, the vertical y-line will always remain perpendicular to the horizon line. The room in Fig. 2.68 is a basic box shape in which the railings and beam converge to two different vanishing points and the column remains perpendicular to the horizon.

Fig. 2.69 Two-point perspective from above. This aerial perspective shows the development approached from the corner of the building. The perspective was created freehand and has enough detail to show the overall design concept. The great challenge with this small 5 x 7" drawing was sizing the buildings and parking areas accurately enough to look realistic. Permanent ink pen on trace.

Fig. 2.70 Use a perspective chart for larger drawings. This interior perspective has two vanishing points that can be found by extending lines to vanishing points from the tops of walls. The perspective layout was constructed using a perspective chart as a base for laying out the rooms. Charts are effective tools when drawings become large, as with this 15 x 22" view of a proposed workplace. Permanent ink pen on Mylar.

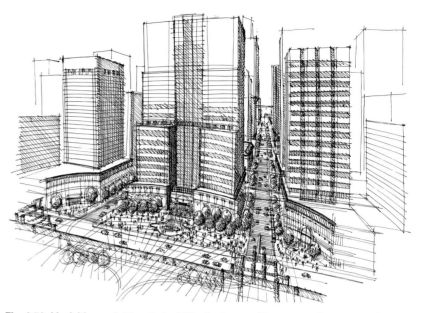

Fig. 2.72 Vanishing point located within the image. Most two-point perspectives have vanishing points located far from the actual image area (Figs. 2.68 to 2.71). This freehand perspective locates one of the vanishing points on center with a street, while the second vanishing point is located far to the left. The orientation of the perspective effectively communicated the primary street connection to the city and conceptual design of the main plaza in front of the proposed building. 12 x 16" permanent ink on Mylar.

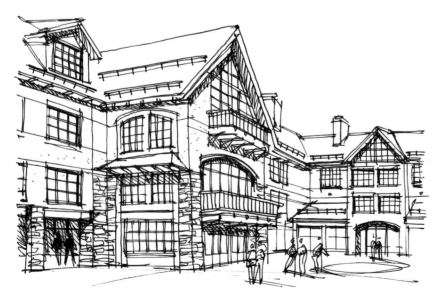

Fig. 2.71 Freehand perspective adds character. When drawings are small, such as this 6 x 9" view of a resort building, a two-point perspective can give the drawing a more believable look. Permanent ink on vellum.

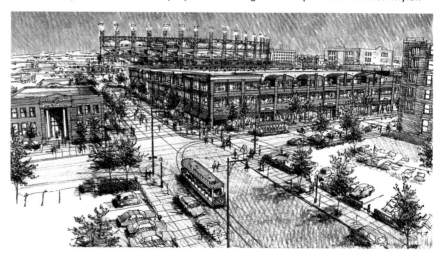

Fig. 2.73 Perspective created from a photograph. This rooftop perspective originated with a photograph taken from an adjacent building. The perspective in the photo established the vanishing points for adding the new building, which is centrally located in the drawing. This is an additional view of the same building in Fig. 2.60. 12 x 24" permanent ink on Mylar, reduced to 8 x 15" and then colored with Prismacolor pencils.

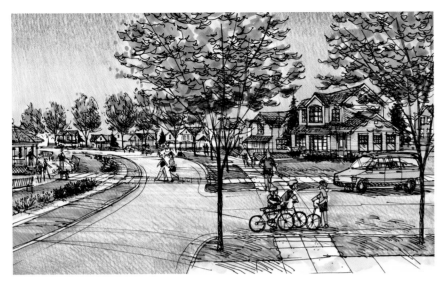

Fig. 2.74 Close-up of a residential neighborhood. This freehand sketch illustrated a cluster of homes surrounding a small park. Large foreground street trees and children playing in the street strengthen the parklike setting. 9 x 15" permanent ink on Mylar, digital print with marker and colored pencils.

Consider a Variety of Perspective Options

When you determine different options for visualizing a particular design concept, select a variety of views that show your subject in different ways. One drawing might present your subject up close at eye level, showing fine design detailing and character. Another drawing might have an aerial view, showing the context in which your subject is placed. The distance from your subject, the height of your viewpoint, the accuracy of your perspective layout, the tools you use to create the perspective, the level of detail you draw, and many other decisions are made before you ever start drawing. Always try to make choices that not only give you the best results, but also visualize your ideas as quickly as possible. The drawings on this page and opposite are from a series of images that were developed to study a new 600-acre mixed-use development.

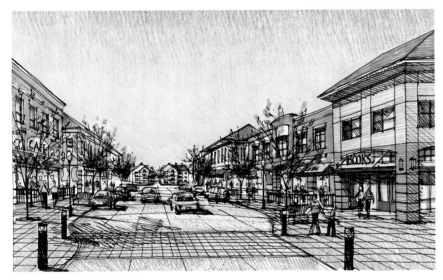

Fig. 2.75 Show more detail in the foreground. The central and distant portions of this drawing are filled with street activity such as outdoor cafes, lights, banners, cars, and trees. Unfortunately, the foreground portion of the drawing is lacking any detail other than paving pattern. Imagine how this drawing might be improved if additional landscaping, people, and furniture were drawn in front. 9 x 15" permanent ink on Mylar, digital print with marker and colored pencils.

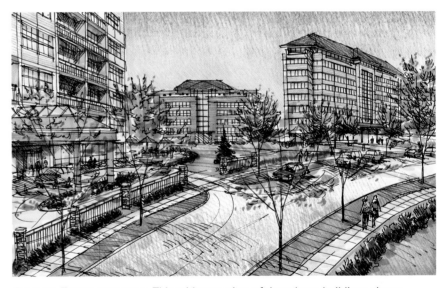

Fig. 2.76 Transparent trees. This midrange view of three large buildings shows enough architectural elements to understand entries and building features. Many of the trees are "ghosted in" with trunks and branches, but left transparent so that the information beyond can be seen.

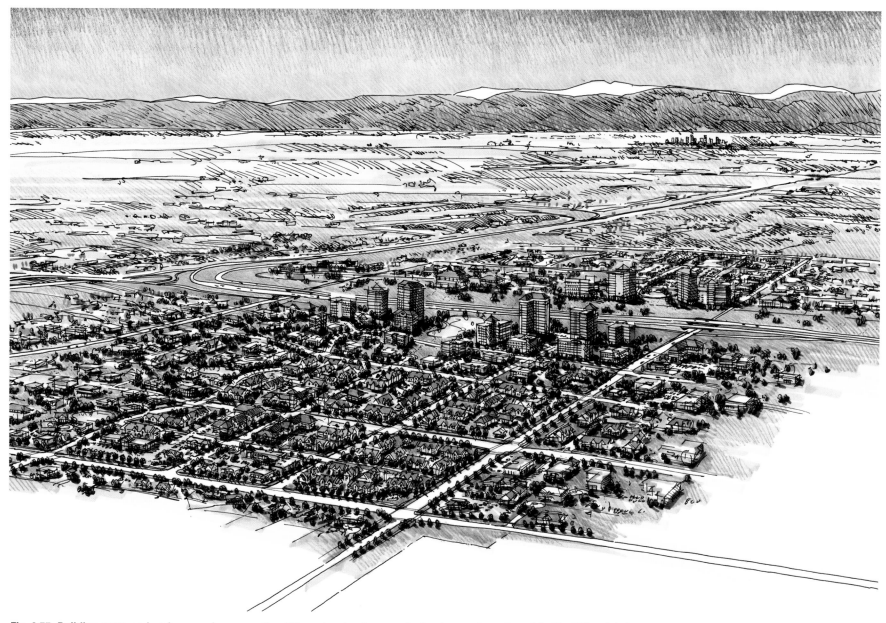

Fig. 2.77 Building patterns in a large-scale perspective. When drawing large-scale developments such as this 21 x 32" aerial view, draw simple building patterns to avoid overwhelming the drawing with "too much architecture" and taking too much of your time in the process. The buildings in this drawing are limited to repeated sloped roofs of residences, flat roofs of commercial buildings, and office towers. Buildings in the distance are nonrecognizable shapes and colors. The challenge with this type of aerial perspective is to show just enough information to communicate the concept without overdrawing and spending too much valuable time. The drawing originated from a reference photograph taken of the site. The image was blocked out in red pencil and traced on Mylar with a permanent ink pen. The drawing took 2–3 days to make and an additional day to color with markers and pencils on a digital print.

Three-Point Perspective

A third type of perspective involves three vanishing points, but it is extremely complex to draw and often gives marginal results. If you create sketches from photographs taken with wide-angle lenses, you will encounter three-point perspective. The vertical lines converge either upward or downward, depending on the angle of the photograph. This distortion never looks very realistic. When this happens, adjust the vertical lines at the time you block out the drawing in the redline stage. When generating computer wireframe perspectives, it is easy to fall into the trap of distorting the perspective view of the building (Fig. 2.80).

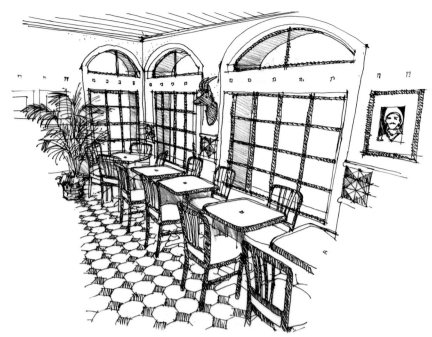

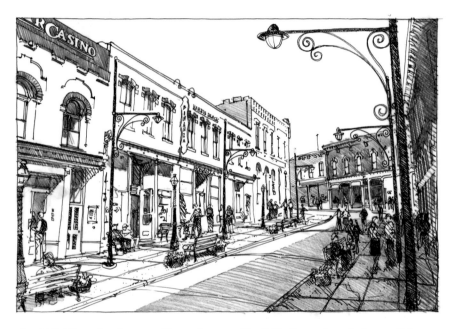

Fig. 2.79 Three vanishing points. If you trace the window and tile lines of this three-point perspective you can locate the three vanishing points of the drawing. The distortion of the vertical lines gives the drawing an unnatural appearance. This drawing would have been more effective as a two-point perspective, keeping all of the vertical elements parallel with each other. 7 x 9" permanent ink on Mylar with graphite pencil tone.

Fig. 2.78 Distortion from a wide-angle photograph. This streetscape view has enough distortion in the perspective to cause one to wonder whether the streetlights and buildings are tipping over. To correct this problem, adjust the vertical lines before drawing the final image. 9 x 14" permanent ink on Mylar with graphite pencil tone.

Fig. 2.80 Computer wireframe distortion. The perspective view created with this computer-generated wireframe is so distorted that the building appears cone shaped. The image would have been more realistic if the vertical lines were more parallel with each other. These perspective corrections can be easily made in the computer.
Computer model by Doug Spuler.

QuickTips *Perspective Drawing*

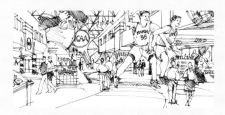

• The most realistic perspective view is from eye level. The fastest perspective to create is with a single vanishing point.

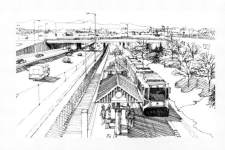

• Place larger objects in the foreground of a perspective to reinforce a sense of depth and distance. Try blocking out your perspective drawing with some foreground detail, a middle ground with the majority of your subject, and a lightly delineated background.

• Objects in the foreground should be colored much brighter than objects in the distance. The change in color intensity helps to reinforce the sense of depth in the drawing.

• Sometimes a vanishing point can be far off the edge of your drawing paper. Place a pushpin into the drawing table at the vanishing point and use a long straightedge to draw your perspective lines.

• Never go beyond a one-point perspective unless you must. Keeping it simple will save you a lot of time.

• If you're drawing a bridge-level perspective of a building, try not to establish your horizon line much higher than the parapet line. Any higher and you'll begin to show too much of the building's roof.

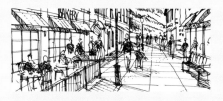

• Double-check the sizes of your people, vehicles, and other foreground objects to avoid proportional errors. Drawing these elements at incorrect sizes is an easy mistake when blocking out a perspective.

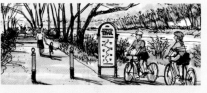

• When incorporating people into an eye-level perspective, place their heads at the same height as the horizon line. People in the distance are smaller than the people in the foreground, but their eyes are all at the same level.

• A fast and easy method of creating a perspective is to trace one that already exists, either in a photograph or in another drawing. Use the existing information as a layout tool to help you block out your drawing, then trace a new drawing from it.

Getting Technical

What Is a Paraline Drawing?

A *paraline drawing* is a three-dimensional representation of an object in which all of the lines are parallel with each other. There's no perspective, vanishing point, or horizon line in this type of drawing. Paraline drawings are always aerial views, and you need to have a floor or site plan to work from. Paraline drawings are a good choice when the floor plan information is complex, or when you don't have the time or tools to create a true perspective drawing. You need to be comfortable with the idea that an overhead view is the best way of visualizing your design, and you need to accept that paralines tend to look a little stiff and slightly unrealistic.

There are so many variations of paraline drawings that you can quickly get overwhelmed deciding between isometrics, dimetrics, trimetrics, axiometrics, axonometrics, plan obliques, elevation obliques, planometrics, exploded views, expanded views, and more! There are many technical books on the subject.

The shortcut through this confusing technical jungle is to simplify the choices to two basic types: the *axonometric drawing* and the *isometric drawing*.

The Axonometric Drawing

You probably have heard of a plan oblique drawing and might have tried drawing one in the past. The more commonly used name for this drawing is axonometric. Start with a floor or site plan, rotate it 30 degrees, and project vertical lines at the same scale as the base plan. It is easy to do, and the resulting bird's-eye view can be very effective. Think of it as a rotated plan with three dimensions. Sizes of "axos" can vary from small architectural facade studies (Fig. 2.83) to quite large urban design projects (Fig. 3.77). Experiment with varying the rotation angle and exaggerating the vertical proportions of the lines. There is no right or wrong axonometric drawing technique. If your drawing looks believable, then you've succeeded in communicating your design concept.

![Isometric drawing of a retail center](image placeholder)

Fig. 2.81 Isometric drawing. An isometric drawing has a lower viewing angle than the axonometric. Compare this retail center view with the axonometric drawing in Fig. 2.82 and notice the difference in height above ground. Isometric drawings tend to take longer to draw, but have a more natural and less mechanical appearance. 9 x 13" permanent ink pen on vellum with Chartpak AD markers applied on the reverse side of the vellum.

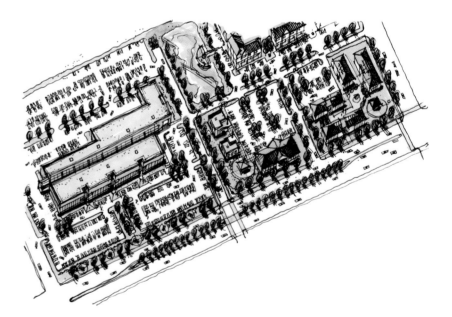

Fig. 2.82 Axonometric drawing. The bird's-eye view of this development reveals more of the site plan than might have been seen in a more "flattened" isometric drawing. The drawing was traced directly over a site plan that was rotated approximately 30 degrees. The drawing was created at a small 9 x 13" size to keep the detail to a minimum, shorten the drawing time and reduce well for publication in a report. Permanent ink pen on vellum with Chartpak AD markers applied on the reverse side.

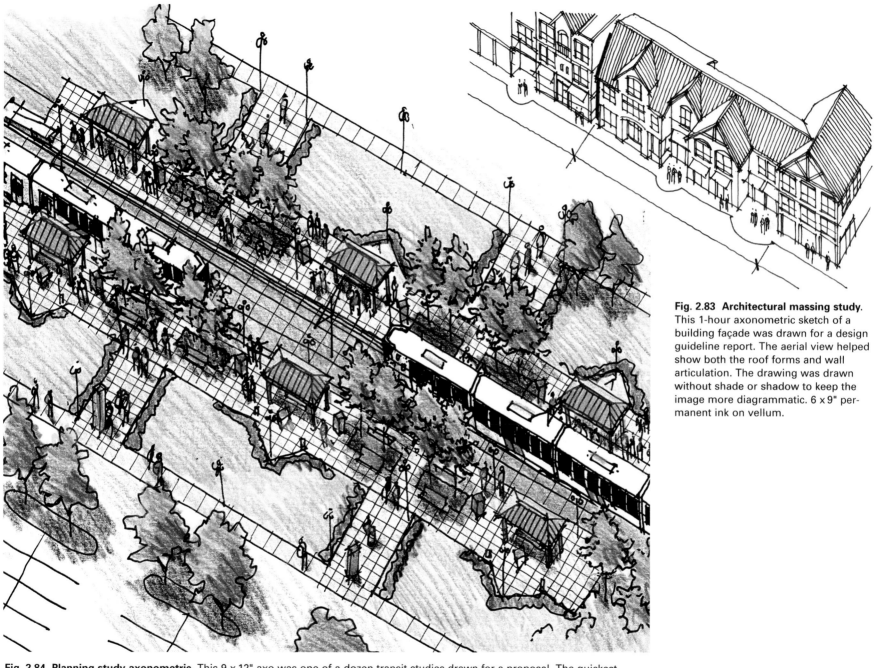

Fig. 2.83 Architectural massing study.
This 1-hour axonometric sketch of a building façade was drawn for a design guideline report. The aerial view helped show both the roof forms and wall articulation. The drawing was drawn without shade or shadow to keep the image more diagrammatic. 6 x 9" permanent ink on vellum.

Fig. 2.84 Planning study axonometric. This 9 x 12" axo was one of a dozen transit studies drawn for a proposal. The quickest method of visualizing each option was to trace over the conceptual site plans and create a three-dimensional axonometric sketch for each design. This view took about 2 hours to draw on Mylar, copy on bond paper, and color with Prismacolor pencils.

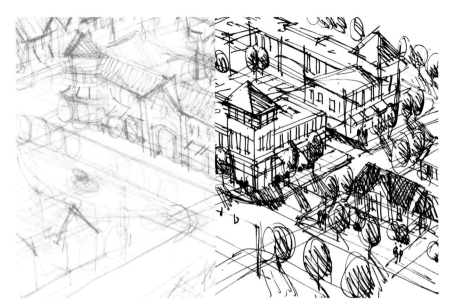

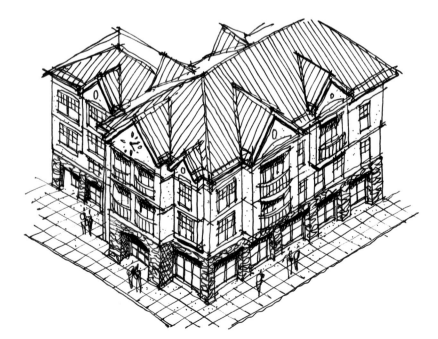

The Isometric Drawing

The alternative choice to an axonometric drawing is the isometric drawing. The floor plan is no longer represented in a true plan view, but is "flattened," giving a more balanced emphasis to the sides and top view of an object. Faces of objects are equally rotated 30 degrees to the horizontal plane. Most isometric drawings give the appearance of looking directly at the corner of an object.

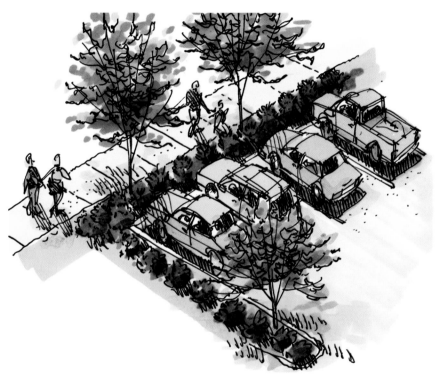

Fig. 2.85 Quick redline mock-up. The low angle of an isometric view was appropriate to visualize this small neighborhood infill project. The 15-minute block out established the general massing and view. 7 x 9 1/2" pencil on trace.

Fig. 2.86 Quick sketch. The final drawing took another 15 minutes to trace. Felt-tip pen on trace.

Fig. 2.87 Isometric view shows building massing. The front and side of this building are symmetrically drawn 30 degrees to the horizontal. All lines are parallel with each other. This 5 x 7" architectural study was drawn in 1 hour, looks accurate, and certainly took far less time to create than a perspective drawing. Permanent ink on vellum.

Fig. 2.88 Show landscaping in an isometric view. This quick sketch of a parking lot landscaped buffer was constructed as an isometric drawing, with the same 30-degree angles to sidewalk and parking spaces. 6 x 8" ink on vellum, digital print with marker color.

Fig. 2.89

Fig. 2.89–2.90 Isometric growth scenario. Both this drawing and Fig. 2.89 show how an area can develop over time. The isometric approach gave the drawings a low-level aerial view and a horizontal proportion, showing enough of the site plan information and architectural elevations. The scribble line technique of the drawings masked the lack of architectural detail and shortened the time spent on both drawings to 4 hours. 12 x 21" felt-tip pen on vellum with Chartpak AD markers applied directly to the artwork.

Fig. 2.91 Freehand isometric study. This 3 x 4" study for a model display is shown in an isometric view to best visualize the sides and top of the display in a single drawing. 1-minute felt-tip pen sketch on trace.

QuickTips
Paraline Drawing

- Although there are many different types of paraline drawings, you need to be familiar with only two: the axonometric drawing and the isometric drawing. These are the best paraline drawing choices and are worth trying.

- If important views or information are hidden behind wall planes, you can indicate those walls with linework, but make them transparent so you can see through them in your drawing.

- Exterior bird's-eye views are the most effective types of axonometric drawings. Interior views are more difficult to achieve with a rotated-plan drawing, because you are looking down through a roof and ceiling.

- Isometric drawings rely so much on 30-degree angles that it's a good idea to purchase a drafting triangle with 30- and 60-degree angles. It is much quicker to draw with a preset triangle!

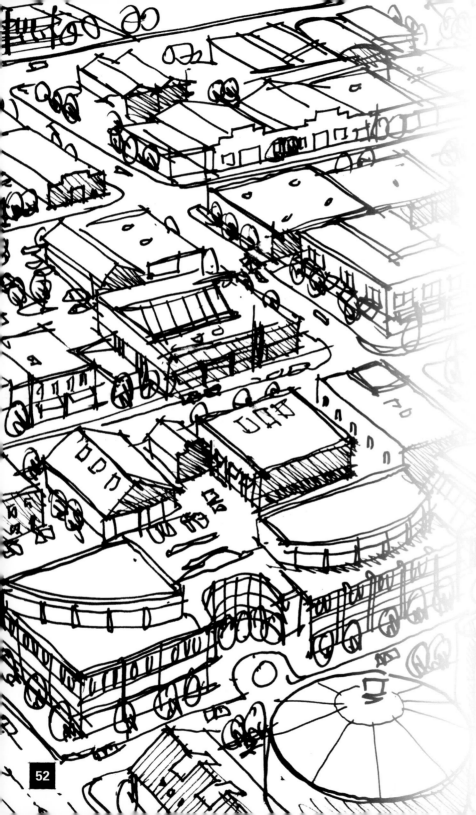

3
START YOUR DRAWING

This chapter covers techniques for using basic source materials for character sketches and constructing drawings. When there aren't any source materials available, you can always sketch from your *imagination*. This takes some prac-tice and confidence, but you can do good drawings without any refer-ences—cartoon illustrators do it everyday. Another method is *direct observa-tion*. It's much easier to draw what you see when you have something to look at! But you can't always be there to draw something in person. *Projection* of

Fig. 3.1 Use standard office projectors. Architects in a drawing class create large sketches from photographs copied onto clear acetate, then enlarged with standard overhead projectors.

photographic images is a very accurate and accessible technique. Last, but not least, is tracing. If an image exists in two dimensions, you can enlarge or shrink it, put translucent paper over it, and start *tracing and modifying.* Many drawings are created through a combination of these techniques. You might begin a drawing from a projection, trace in some additional elements, and then draw the rest from your imagination.

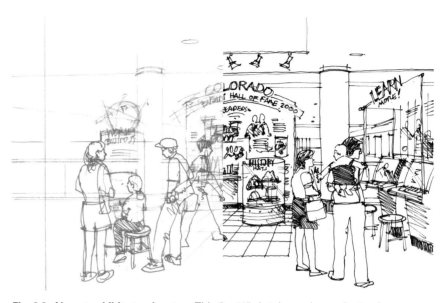

Fig. 3.3 Airport exhibit step by step. This 8 x 11" sketch was begun by tracing over a photograph of an interior space at an existing building. *Step 1.* Exhibit components, graphics, and people are added in a red pencil mock-up. *Step 2.* Final drawing created with a felt-tip pen on sheet vellum that was taped over the mock-up.

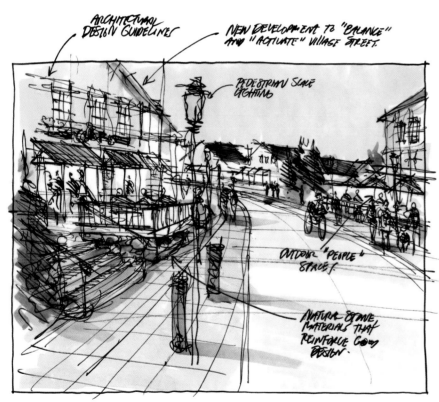

Fig. 3.2 Show elements that define the streetscape. Imagination sketch of a new village street with notes to help define the ideas. Felt-tip pen on vellum with marker color.

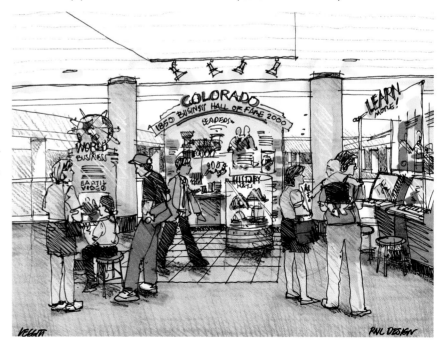

Fig. 3.4 Step 3. An OCE digital print on 30-lb paper was made and colored with Chartpak AD markers. Additional texture and tone was added with color pencils.

Fig. 3.5 Quick and loose perspective. 15-minute imagination sketch of an interior exhibit on future technology in the home. Felt-tip pen on bond paper. The rough forms of objects are drawn without any detail.

Fig. 3.6 Capture the idea. Imagination sketch of a central video control room with monitors overhead. Felt-tip pen on bond paper. Fig. 3.24 shows the final drawing of this concept.

Fig. 3.7 AIA picnic cartoon. Animated sketch used in a poster to advertise an AIA summer picnic. Combination drawing on Mylar using a permanent ink pen for outlines and a fine-point technical pen for shaded areas.

Use Your Imagination

Image drawings are created strictly from your imagination, with practically no visual references to draw from. This is often called "cartooning" or "storyboarding," and can be done quickly, without a lot of detail. Image drawings are often used for design feedback and to form the base information for more finished drawings. Image drawings don't have to be serious. You can have lots of fun sketching humorous situations and even cartoons. This "light" drawing technique is very effective in newsletters or presentations where you want an informal approach. School or office "get well" or "goodbye" cards are perfect applications for cartoon drawings, too.

During an early architectural charette for a new science museum, I storyboarded ideas on 8½ x 11" paper as we conceptualized the museum (Figs. 3.5 and 3.6). I produced over 15 sketches in the afternoon workshop. Although the drawings were extremely rough, they allowed everyone to clearly understand the design concepts, and later I was able to do the final drawings without additional input from the group. Depending on the complexity of the image, I might lightly block out the drawing with pencil and then put down a darker layer of pencil or ink for the final sketch.

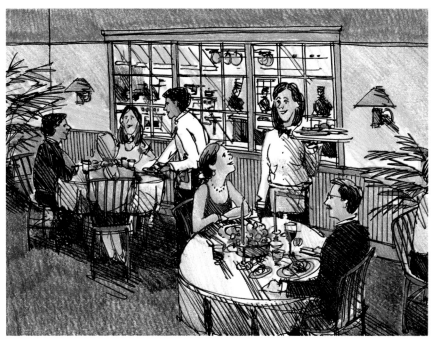

Fig. 3.9 Culinary school sketch. This concept drawing shows students preparing food, serving, and dining at a prototype space within a college. The 7 x 9½" sketch originated as a pencil drawing and was traced with a permanent ink pen on Mylar. A black-and-white copy was then made and colored with Prismacolor pencils.

Fig. 3.8 High-speed elevator cartoon. This view of an imaginary rocket-propelled elevator was drawn to humor an elevator consultant during a project. 10½ x 14" permanent ink pen on Mylar. Pencil guidelines on the Mylar were erased after the ink drawing was completed.

Fig. 3.10 Architect's Halloween party invite. Imagination sketch of a construction site with people carving a giant pumpkin from scaffolding. 5 x 7½" fine-point technical pen on vellum.

Fig. 3.11 Aquarium gift shop. The minimal detail of this 12 x 24" sketch is limited to the square shapes of millwork and circular shapes of gift items and people. Color varies from dark blue/greens to yellow/browns that describe different themed zones of the store. This felt-tip pen on vellum drawing was colored with AD Chartpak markers and generated in 30 minutes.

Be Aware of the Drawing Detail

When you draw from imagination, it's easy to get trapped into showing too much detail. If you need to communicate only a rough concept, then keep the drawing fairly undeveloped. Try to make it proportionally accurate, with a believable perspective view, but show as little detail as possible. An example of minimal detail is shown in the gift shop sketch (Fig. 3.11). There are other situations in which you may need to show more detail and commitment to the design, even though no concept direction has yet been established. The zoo kiosk sketch (Fig. 3.12) was one of many alternative ideas and needed more delineation of the roof truss and carefully drawn proportions. Both of these imagination drawing examples were used in formal client presentations.

Preferred Drawing Sizes

It's best to make image drawings no larger than 11 x 17". By keeping the image size to a minimum, you don't have to commit too much detail or time to the drawing. Two or three quick image drawings are generally more effective to help visualize a design idea than is a single, more detailed image that takes longer to draw. Figure 3.13 illustrates a prototype restaurant with different exterior regional styles applied to the same structure. Even without a floor plan, the side-by-side drawing comparison was effective in getting the client to understand the overall concept and begin developing the idea.

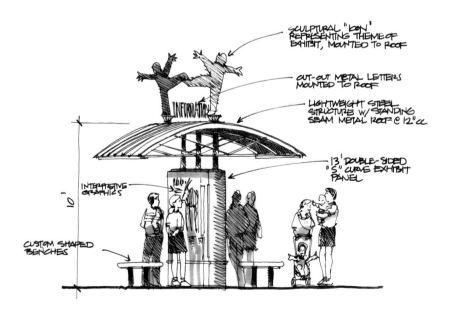

Fig. 3.12 Zoo kiosk design alternative. A moderate amount of detail was needed in this sketch to accurately communicate size and proportion of the exhibit structure. The drawing was one of five alternatives and began as a $1/2$ inch = 1 foot scale elevation. People in the foreground are carefully delineated while those in the rear are just rough shapes. Felt-tip pen on vellum with gray Chartpak AD marker shadows.

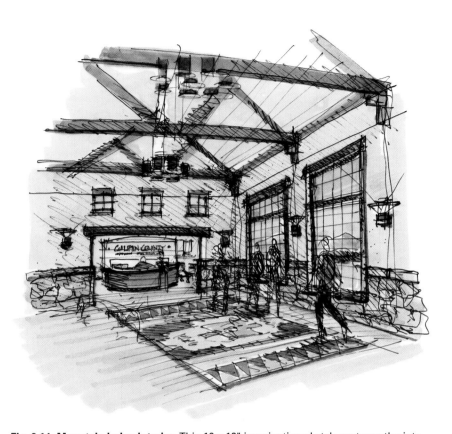

Fig. 3.13 Restaurant prototype. A building form was traced and modified to develop two different building facades of the same structure. Detail of the roofing and stone was time-consuming, but necessary to reflect the character of the different regional styles. The 6 x 9" size of the vellum drawing required a fine-point technical pen for detail.

Fig. 3.15

Fig. 3.16

Fig. 3.17

Fig. 3.18

Fig. 3.14 Mountain lodge interior. This 10 x 12" imagination sketch captures the interior volume, truss, and mountain views. People are dark masses without any detail. Color marker helps identify changes in materials. This felt-tip pen on vellum drawing is right on the edge of being too minimal for the amount of information it is representing.

Figs. 3.15 – 3.18 Cartoon storyboard.
This series of 3 x 5" sketches attempts to show maximum emotion with minimal detail. Similar to many newspaper cartoons, the images tell stories without words. Felt-tip pen on vellum.

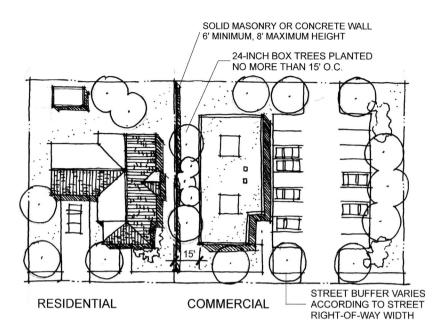

SOLID MASONRY OR CONCRETE WALL
6' MINIMUM, 8' MAXIMUM HEIGHT

24-INCH BOX TREES PLANTED
NO MORE THAN 15' O.C.

15'

RESIDENTIAL COMMERCIAL

STREET BUFFER VARIES
ACCORDING TO STREET
RIGHT-OF-WAY WIDTH

Fig. 3.19

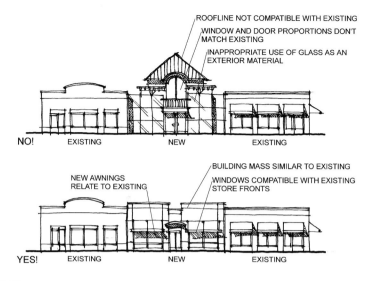

ROOFLINE NOT COMPATIBLE WITH EXISTING

WINDOW AND DOOR PROPORTIONS DON'T
MATCH EXISTING

INAPPROPRIATE USE OF GLASS AS AN
EXTERIOR MATERIAL

NO! EXISTING NEW EXISTING

NEW AWNINGS
RELATE TO EXISTING

BUILDING MASS SIMILAR TO EXISTING

WINDOWS COMPATIBLE WITH EXISTING
STORE FRONTS

YES! EXISTING NEW EXISTING

Fig. 3.21

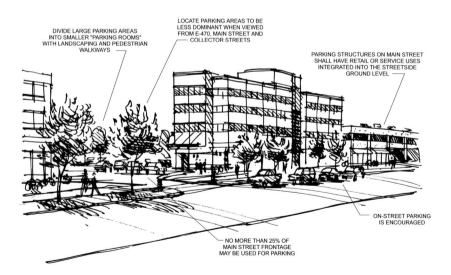

DIVIDE LARGE PARKING AREAS
INTO SMALLER "PARKING ROOMS"
WITH LANDSCAPING AND PEDESTRIAN
WALKWAYS

LOCATE PARKING AREAS TO BE
LESS DOMINANT WHEN VIEWED
FROM E-470, MAIN STREET AND
COLLECTOR STREETS

PARKING STRUCTURES ON MAIN STREET
SHALL HAVE RETAIL OR SERVICE USES
INTEGRATED INTO THE STREETSIDE
GROUND LEVEL

ON-STREET PARKING
IS ENCOURAGED

NO MORE THAN 25% OF
MAIN STREET FRONTAGE
MAY BE USED FOR PARKING

Fig. 3.20

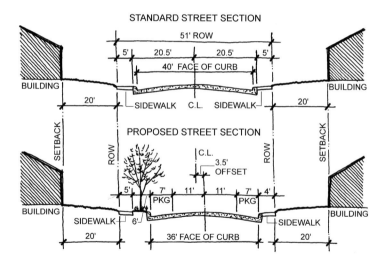

STANDARD STREET SECTION

51' ROW

5' 20.5' 20.5' 5'

40' FACE OF CURB

BUILDING BUILDING

20' 20'

SIDEWALK C.L. SIDEWALK

PROPOSED STREET SECTION

C.L.
3.5'
OFFSET

BUILDING BUILDING

5' 7' 11' 11' 7' 4'
PKG PKG

SIDEWALK 6' SIDEWALK

20' 36' FACE OF CURB 20'

SETBACK ROW ROW SETBACK

Fig. 3.19–3.22 Design guideline sketches. This series of sketches represents a category of imagination drawings that communicate various design guidelines and standards used in community planning. Because they are often printed at reduced size in planning reports, they are best drawn in ink, with moderate detail and shading. Guideline sketches are always combined with text descriptions and dimensions. The four sketches shown here (Figs. 3.19–3.22) reflect the basic groupings of plans, sections, elevations, and perspective drawings. They are even more effective when colored.

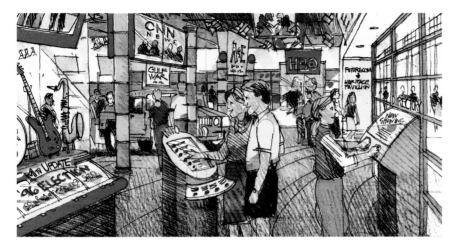

Fig. 3.23 Cable interactive exhibit. The foreground of this one-point perspective sketch details visitors with interactive kiosks while the background shows less detailed information and people. Large signs feature popular cable networks. This 7 x 11" pencil on vellum drawing was OCE printed on 30-lb paper and colored with Chartpak AD markers. Colored pencil added texture.

Fig. 3.24 Show detail only in the front. This 7 x 9 1/2" sketch shows faces and details of the foreground people and central control room. Notice how the people in the rear lack all detail. To emphasize the complex overhead video structure, the floor has no detail, even lacking shadows beneath the people. Permanent ink pen on Mylar with moderate hatching, since the drawing was not planned to be colored.

QuickTips *Imagination Drawing*

- If you want your drawing to fit on 11 x 17" or 8½ x 11" paper, but you're drawing the image on an oversized piece of Mylar or tracing paper, you can put "crop marks" on the larger sheet to represent the final page size. An accurate way to establish the location of the crop marks is to simply trace over a sheet of paper that matches the final dimensions.

- When drawing glass, the best way to indicate the transparency of the material is to draw objects on the other side of the glass. For example, if you're drawing a window, put plants or people on the other side of the glass to create a view through the glazing. You can also show reflections of nearby objects. Drawing diagonal lines across the glass also simulates reflections (Fig. 3.24).

- Add humor to your drawing. Don't be afraid to exaggerate key elements of the image. The benefit of making drawings from your imagination is that they don't have to be realistically accurate.

- With freehand drawings, it's very easy to accidentally make the vertical lines crooked, especially if you're drawing at a slight angle to the paper. Use a triangle or straightedge and lightly draw a few guidelines with a pencil. You can easily see any nonparallel lines by standing away from the drawing and looking squarely at the image.

- Working smaller and with less detail will save you time and still communicate your design idea.

- Add a finishing touch to your drawing by erasing your layout lines, eliminating any unsightly line overlaps and improving any areas of the drawing that you're not happy with. Be critical of your work and always try to improve your technique.

Fig. 3.25 Amalfi mill building sketch. A 7 x 10" sketchbook, soft pencil, 30 minutes, and a spectacular subject make a great combination. The pencil was a Mars Logograph 100 H on bond paper. The lighter face of the paper mill is contrasted against the darker canyon wall of the Italian hill town. Drawing cars in the street helps establish the scale of the building. The image is contained inside a frame.

Fig. 3.26

Draw What You See

Drawing from Real Life

Take a sketchbook outside some warm afternoon and start drawing! It's a lot of fun, and also provides you with drawing practice—which you can never have enough of. Wouldn't it be nice to get a group of creative friends together and all go to some interesting place to sketch for the afternoon? Do it! Then do it again. *Direct observation drawings* are made by simply looking at your subject and drawing it without using any tools other than your pencil or pen. The object you draw might be a great view you want to capture in your sketchbook, but may also be an architectural model or even a photograph that you use as reference.

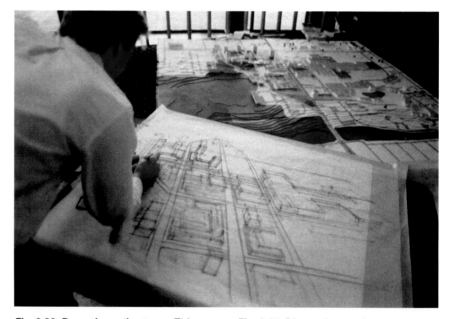

Fig. 3.26 Draw the entire town. This sketch took about an hour to make, using the same materials as in Fig. 3.25. The viewpoint was taken from the coastal town's pier. Complex building window patterns and white walls create an architectural texture that is contrasted with the dark and rough natural textures of the mountain above the town.

Fig. 3.27 Direct observation perspective sketch. A large study model of a regional mall, park, and civic center is being sketched directly from an angle that establishes the perspective and massing of the buildings. 30 x 40" felt-tip pen on vellum. This direct drawing technique may not be as accurate as sketching from an enlarged photograph, but it is quick and accurate enough for conceptual presentations.

Drawing from Photographs

Since you usually don't actually have the luxury of drawing from real life, take a picture instead! You can always grab a Polaroid, 35mm, or digital camera and take a series of reference photographs to draw from back in the studio. Study the photos and block out your drawing using the information that you see.

Figures 3.29, 3.31, and 3.33 were each drawn from direct observation of the photographs. The final drawings closely resemble the photos, but don't match the exact perspective or detail. The photos were intended only for general reference and not for accurate replication.

Fig. 3.28 Compose the photograph for your sketch. This picture was taken with a sketch in mind to show bike trails on each side of the water, connected by a pedestrian bridge.

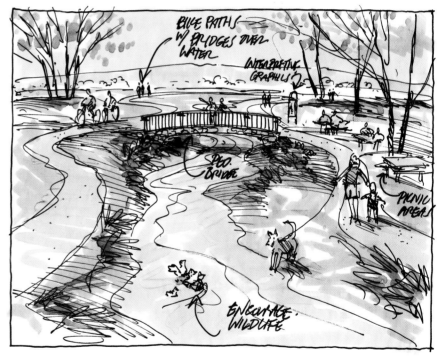

Fig. 3.29 Show activity in the drawing. This sketch was generated using the photograph (Fig. 3.28) as a general reference. The birds, pets, picnickers, pedestrians, and bikers all reinforce the concept of an active public recreation trail. Drawn 8 1/2 x 11" on vellum with felt-tip pen and colored directly with Chartpak AD markers. The notes add to the information and casual character of the drawing.

Fig. 3.32 Visualize a sketch when you take the picture. This building was a perfect subject for a sketch showing architectural and streetscape improvements. The photo was used as a reference to approximate the perspective and building proportions.

Fig. 3.30 Select the best photo viewpoint. The Polaroid picture was taken near water level to emphasize the river activity and not the street above.

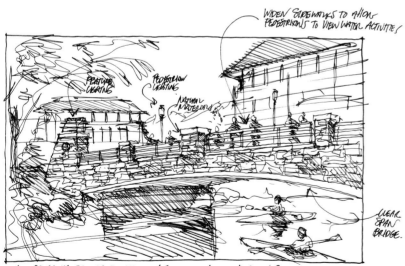

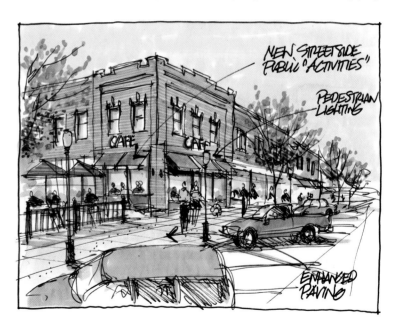

Fig. 3.31 Concept sketch of bridge replacement. Using the photograph in Fig. 3.30 as reference for the low-angle perspective, a new bridge was sketched with pedestrians and kayakers to promote the "people-friendly" character of the design. Buildings were ghosted in the background. 8 1/2 x 14" felt-tip pen on vellum.

Fig. 3.33 New uses for an old neighborhood. This sketch illustrates simple modifications to the sidewalk, graphics, storefront, side yard, and cars that communicate the potential of renovating the mixed-use street. Using the photo as reference for existing information added "believability" to the 8 1/2 x 11" drawing. Felt-tip pen on vellum with Chartpak AD marker color.

Figs. 3.34 – 3.35 Quick lunch hour sketches. I drew this pair of 5 x 6 1/2" sketches of a historic train station while eating lunch across the street. The small size and "scribble-sketch technique" of the drawings kept them quick and loose. Instead of including the entire building, these sketches show tightly cropped portions of the historic detail found on the building. Permanent ink pen on bond paper.

" LIONS OF UNION STATION "

" TRAVEL BY TRAIN "

Fig. 3.35

QuickTips *Direct Observation Drawing*

- If you're drawing outdoors, clip your paper to a piece of foam core or heavy cardboard so it can serve as a windproof drawing table.

- Don't overdraw your subject. Focus your drawing effort on visualizing the most important information, simplify and outline the less important objects, and leave the unnecessary data out of the drawing.

- Create new information as you draw. You're not obligated to draw your subject exactly as it appears unless you've been told to do so. Go ahead and alter, modify, add to, and basically treat the object you're observing as drawing data from which you create a new image. This is a creative design process.

- There's no harm in using a ruler or drafting triangle to help you keep lines straight. It's easy to accidentally get your lines crooked, which can diminish the quality of the drawing.

- Tilt your drawing board up so you can work with your face square to the paper. If the board is flat and you're looking at it from a severe angle, the image may stretch out of proportion.

- If you have trouble drawing objects such as furniture or cars, try massing them out in simple rectangular "shoe-box" form first and then gradually blocking in the details.

- Edit out unnecessary items and show only the information that you need to tell your design story. For example, if you're drawing a natural landscape and an ugly road and bridge is in the view, just leave them out!

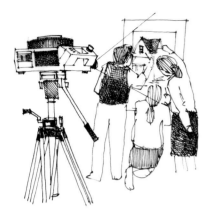

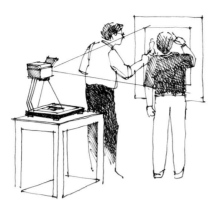

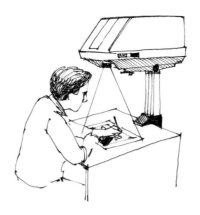

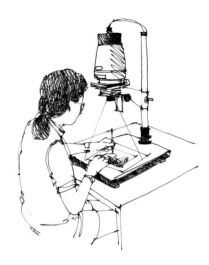

Fig. 3.36 Slide projector. 35mm slides have been the most common medium for recording and storing visual information. A standard Kodak Carousel projector is the most flexible and easy to use machine when projecting photographs. Most schools and offices have one to use.

Fig. 3.37 Overhead transparency projector. This inexpensive projector can be found everywhere. Any image original can be projected with this machine, but must first be copied onto clear film. Always copy onto a clear film product that is specified for the copier or you could seriously damage the machine.

Fig. 3.38 Opaque projector. This projector is quite effective for projecting original photographs without any intermediate reprographic process. It is available in schools, but not found in most offices. Because of its large size, this projector isn't as mobile and flexible to use as the other options. The machine pictured is called an Artograph, which enlarges an image of an object mounted inside the overhead housing.

Fig. 3.39 Photographic enlarger. If you have access to photographic darkroom equipment, you can project 35mm slides or negatives using a standard enlarger. The projected image won't be as large or bright as the other options, but this machine is an effective tool for creating small drawings.

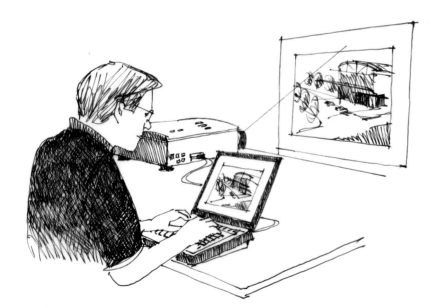

Fig. 3.40 LCD projector. This projector may be expensive, but it is becoming a popular office and school machine for projecting computer-based images. Your photograph can be either scanned into the computer or imported from a digital camera. The LCD projector is bright, adjustable, and full color.

Projection Image Drawings

You can take all the guesswork out of creating a base drawing by projecting photographs or other images and drawing from the projected images. You can project slides, of course, but did you know that you could insert a color negative in a slide mount and get similar results? Another projection technique is overhead projection. Remember the old opaque projectors once used in high schools? Well, they're still around, and so are overhead projectors that use clear transparencies.

For a *slide projection,* pick a smooth wall surface where you can tape up a sheet of paper, vellum, tracing paper, or Mylar at a level that will be comfortable for you to work standing up. Make sure the drawing surface is square to the floor. Set a 35mm slide projector on a table, and project your transparency or negative directly onto the drawing surface. Paper will give you the sharpest projection; the translucent nature of vellum, tracing paper, or Mylar tends to slightly blur the image. Try to elevate the projector as high as possible so you don't have to bend over. Some projectors have an

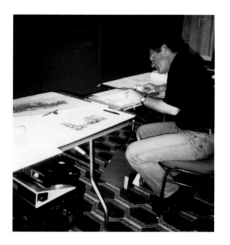

Fig. 3.41 Improvised slide projection.
The series of sketches on this page were all generated from 35mm color slides taken of downtown Sioux City, Iowa. Notice the slide projector propped up beneath the table. A small mirror is placed at an angle to reflect the slide vertically onto a piece of glass placed between two tables. The projected image acts just like a light table and is quite easy to trace over.

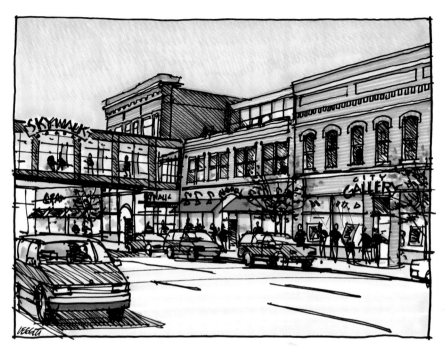

Fig. 3.43

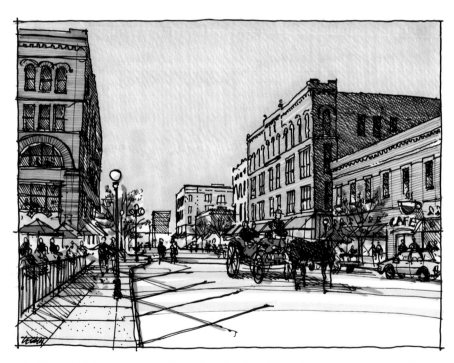

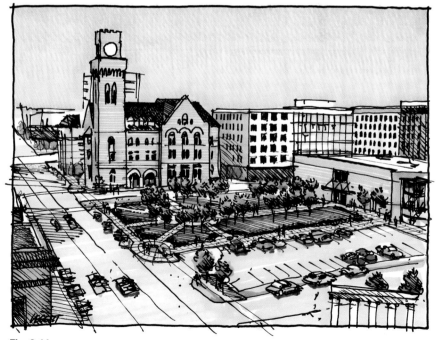

Fig. 3.42 – 3.44 Downtown revitalization sketches. These images are from a series of twelve sketches that helped visualize architectural and landscape improvements to the historic downtown district. Each 9 x 12" sketch originated from a 35mm slide projected from beneath (Fig. 3.41). Felt-tip pen on vellum with Chartpak AD marker applied directly onto the vellum.

Fig. 3.44

integral camera mount for screwing onto a tripod, just like a camera. This makes it easier to elevate the projector to a comfortable eye level and work while standing. A variation of the tripod technique is to reverse the tripod and shine the projector straight down onto a horizontal surface.

A slide projector, a mirror, and some creative engineering can be fashioned into a *mirror slide projection* setup. The advantage of this system is that you can work on a comfortable surface and really have control over the traced image. Take a lightweight framed mirror, mount some eye screws in each corner of the wood frame, and suspend the mirror from your basement rafters at a 45-degree angle. Position the projector so that it bounces the image against the mirror and down onto a horizontal surface, such as a desktop or drawing table. Standard plate glass mirrors have the reflective surface at the rear face of the glass, which will cause a slight "ghosting" of the image. If you can find one, a front-surfaced mirror is ideal. A zoom lens on the slide projector lets you adjust the size of the image on your paper.

A variation on this technique is to position the mirror beneath a large piece of glass, placed horizontally between two tabletops. Tape tracing paper to the top of the glass surface, and the image shines up beneath the tracing paper. It takes a while to get the hang of this approach, but you can then draw as if you are tracing on a light table and the results are terrific (Fig. 3.42)!

More and more, schools and offices are equipped with *overhead transparency projectors*. The machines are very lightweight and portable. The only drawback is that they project only transparent originals, so to project a photograph you must first copy it onto transparency film. Don't panic! Standard 8½ x 11" films are made for the specific purpose of copying text documents. Place your photograph in a copier, set the enlarging mode, and—using the halftone and light contrast setting—copy it onto a sheet of transparency film. The rest is easy. Just put the transparent photograph in the projector and trace the image as you would with a standard slide projector.

New overhead *LCD projectors* are designed specifically to enlarge computer-generated files. If your photograph has been scanned or taken with a digital camera, you have the option of projecting the electronic image. As LCD projectors and digital cameras become more popular, so will their prices. This digital projection technology will eventually replace traditional 35mm film and slide projectors. Digital photo resolution now equals that of film, and faster computers are making it easier to manipulate the data associated with large image files.

Fig. 3.45 Mirror slide projection. The projected image reflects off the suspended mirror and down to the desk surface. This is effective when your drawings are 11 x 17" or smaller.

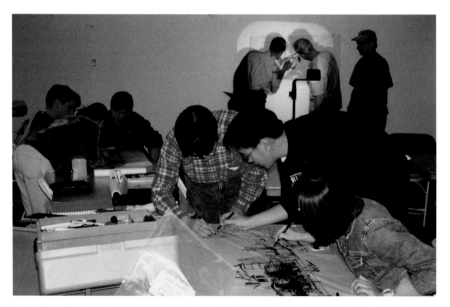

Fig. 3.46 Overhead transparency projection. Teams of students work on large drawings that were generated by enlarging photographs onto a wall with an overhead projector. These projectors are very common in schools and offices.

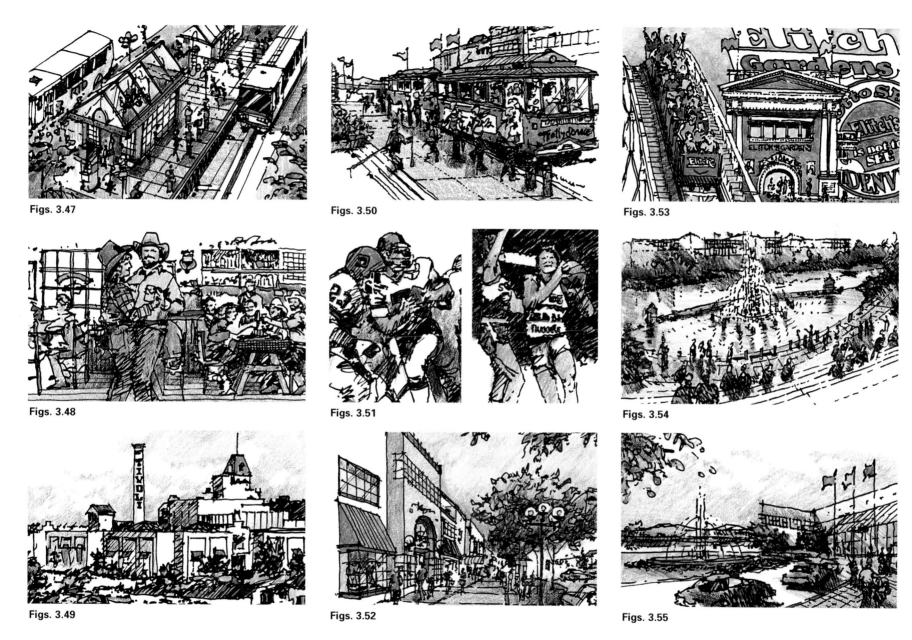

Figs. 3.47

Figs. 3.48

Figs. 3.49

Figs. 3.50

Figs. 3.51

Figs. 3.52

Figs. 3.53

Figs. 3.54

Figs. 3.55

Figs. 3.47–3.55 Opaque projection sketches. These are a few of the nearly 40 sketches that were quickly generated to promote a new convention center. Each 3 1/2 x 5 1/2" sketch was kept small to save time and keep the detail to a minimum. The images included a variety of architectural, interior, and landscape design subjects. An opaque projector was utilized to project research material needed to create the drawings. A permanent ink pen was used on Mylar, which was then copied onto bond paper and colored with Prismacolor pencils.

Fig. 3.56 Sketching from a television. This 6 1/2 x 10" tropical sketch originated from a movie video utilizing the following steps: (1) a 35mm photograph (slow exposure) was taken of the television screen while the movie was paused on the subject to be drawn, (2) film was developed and a photographic print was enlarged to 8 1/2 x 11" on a standard copier, (3) the copied image was traced and modified on vellum with a felt-tip pen.

If you have access to standard darkroom equipment, you can use an enlarger as a *photographic enlarger slide projection* setup. Put your film (transparency or negative) in the negative mount of the enlarger, open the aperture, and shine the image onto a table surface. This method works especially well if your drawing will be 11 x 17" or smaller. Enlargers are designed for relatively short exposures, so keep your drawing time as short as possible and be aware of the heat buildup in the enlarger.

Some projection techniques involve enlarging images from prints instead of transparencies or negatives. 4 x 6" prints work well for this purpose. *Opaque projectors* are common in schools for the purpose of projecting book pages. Place the original photograph in the machine and adjust the distance to the wall. Light sources in these machines are marginal, so you'll need to work in a dark room.

There are several brands of art projectors that are specifically designed for *direct projection* of flat artwork onto a drawing surface. Your photograph is placed on an 8½ x 11" copy board inside the projector housing and is illuminated by 250-watt lights. The image is reflected against a high-quality front-surfaced mirror and directed through a lens onto a horizontal drawing surface. Some art projectors can be adjusted to throw the image onto a wall surface. A 4 x 6" photograph could easily be enlarged to 4 x 6 feet with this technique. Direct projectors are invaluable tools for professional illustrators and graphic designers. It's a good idea to visit an art supply store and get familiar with what's on the market, even if it's not in your budget just yet. Until it is, the other methods described here will work fine.

Drawing from Computers and Monitors

Television projection is a method that Jon Gnagy and others pioneered in the 1950s. But with today's technology, you have control of the image source! Rent a movie, find a frame you want to draw, set the VCR on pause, and draw directly on a piece of Mylar taped to the television screen. Some VCRs kick out of the pause mode after several minutes, so you'll need to work fast. You could also set up a camera on a tripod and take pictures of the television screen, and then draw from the photographs. Make your exposures slower than $1/125$ of a second, or your pictures will have diagonal break lines due to the frequency of the electronic TV image. You can draw from a computer monitor, too. Scanned pictures, digital photographs, CAD drawings, and other images can be traced easily, with the monitor providing the light source.

It's a stretch, but you could even focus a camcorder on a photograph you want to draw, hook the video camera up to your television, and trace the enlarged photo from the screen. You can even patch the camcorder into an LCD projector and draw from the projection. It all depends on what equipment you have available. Experiment!

Fig. 3.57 Projecting onto large surfaces. Conference rooms are ideal for projecting images because of the large wall surfaces and floor area. The overhead projector on the left is propped up on a wastebasket to give it a higher projection angle. The slide projector on the right is mounted to a standard tripod at about 6' above the floor. Everyone is drawing at a comfortable eye level.

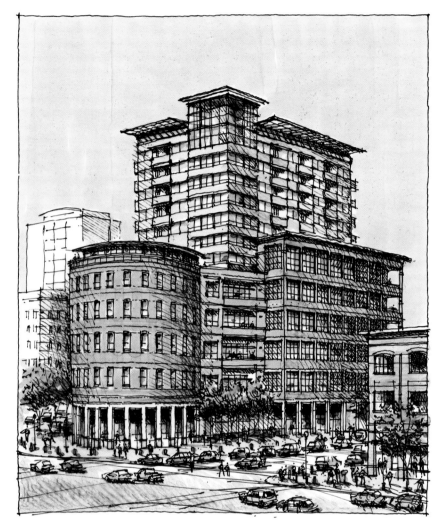

Fig. 3.58 Photo enlarger projection. The 35mm slide (Fig. 3.59) was enlarged in a standard photographic enlarger to 9 x 11" and roughed out with pencil in 15 minutes. The pencil sketch was then traced with a fine-point felt-tip pen on vellum. Chartpak AD markers added color and tone.

Fig. 3.59 35mm model slide. This very rough massing model was photographed from many different angles to best view the building.

Quick Tips *Projected Image Drawing*

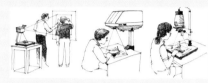

- Be familiar with the projection equipment that's available at home, work, or school for you to use. Do your best with the available equipment.

- Light bulbs for slide projectors are expensive. You can extend their life by letting the projector cool down completely before moving the machine. When a bulb gets hot, the filament becomes brittle and is very susceptible to damage. Moving a warm projector could result in a ruined bulb.

- Adjust the ambient room light so you can see the line work you're tracing. If the room is too bright, it will wash out the detail in the projected image. On the other hand, it will be too difficult to see your drawing surface in a room that's too dark.

- Always take lots of photographs of your subject from different angles. Better to have a larger selection to choose from than just a few images.

- If you have a design that lends itself to a before-and-after theme, create your drawing from the photograph and present both the original picture and the final drawing. The comparison between the two will be very informative for the viewer.

- It's much easier to draw from a projected image on a horizontal surface (tabletop) than a vertical surface (wall). Unless you're projecting a very large image, try to project onto a horizontal surface. Drawing on a wall surface can exhaust your arms.

Overlay and Trace

Tracing is easy, useful, and fun, but creating drawings by tracing has a few limitations. First, you don't have the ability to shrink or enlarge an image on the spot the way you do with a projected image. You're stuck with one-to-one proportion—although you can reduce or enlarge an original on a copier prior to the tracing phase. You may have difficulty tracing details if your Mylar or tracing paper is too thick, but there are ways around these obstacles, such as using a thinner material or working on a light table.

Sources for Tracing People, Cars, and Trees

You have lots of options for finding images to trace into your drawings, so you should never allow yourself to be in a situation in which you have to illustrate a car or person from your imagination—unless you have experience drawing these two difficult subjects. Good drawings can be ruined with ugly people and awful cars. You can avoid this drawing trap by knowing where to find sources for difficult subjects and learning how to customize the images in your drawing.

Line drawings of people are usually found in entourage books, which are great sources of people in various poses and different environments. They're typically standing or sitting, as individuals or in pairs. People are also shown at different scales, so you don't have to keep reducing or enlarging the images. Photographs of people can be found in magazines or staged with a camera and a willing subject. For example, if you have a unique drawing problem that requires a family playing with a pet dog, grab a camera and pose family, friends, or neighbors to get the exact image you need! You might want to spend an afternoon taking candid photographs of people in various situations at a mall or downtown commercial area—then keep them on file for future use. It's a fairly simple matter to enlarge your photographs on a copier to the size required for your drawing and then trace the information.

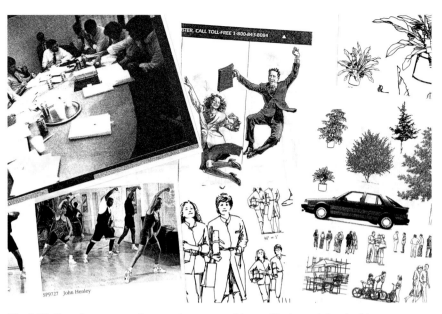

Fig. 3.60 Drawing sources for people, cars, and trees. Start a notebook of images you can trace. In addition to the typical entourage images, begin saving pictures from magazines, reference photographs you take, and images from books. Over time, you'll fill up the notebook and develop a collection of tracing sources you'll use with confidence.

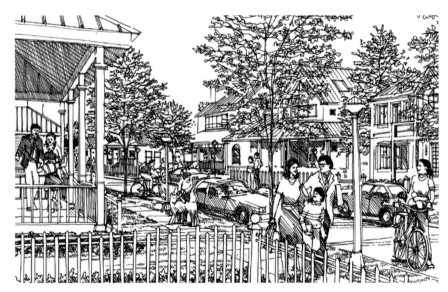

Fig. 3.61 Don't be afraid to draw people. This complicated drawing involved numerous sources of information to create the houses, trees, cars, and people. There are 24 people drawn in the scene. Compare this drawing with the mock-up (Fig. 3.62) and notice the amount of image "editing" that occurred during the process. The drawing is 18 x 24", permanent ink pen on Mylar.

Fig. 3.62 Drawing in stages. Most of the people in this drawing mock-up were traced from an entourage sourcebook. They were enlarged and reduced to best fit in proportion to their location. Several trees were traced as well. The cars in the drawing were not traced, but blocked out as simple shapes. The original house sketches were too small and were redrawn in red pencil. All of the elements in the drawing are spread out to give equal emphasis to both the foreground and background of the composition. This mock-up is on vellum with felt-tip pen and red pencil.

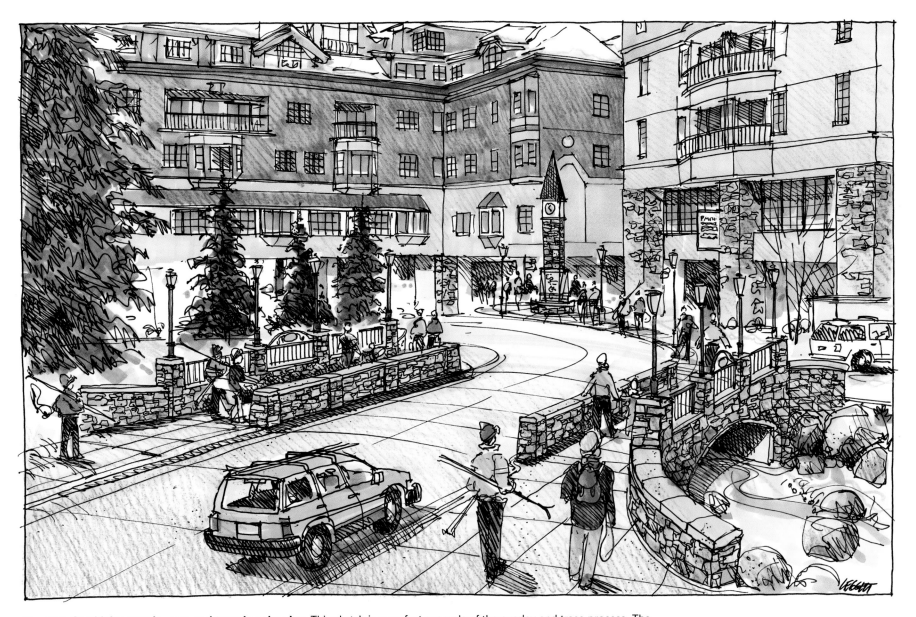

Fig. 3.63 Combining people, cars, and trees in a drawing. This sketch is a perfect example of the overlay and trace process. The drawing originated from a photograph of the existing village street and bridge (Fig. 3.64). This 10 x 15 1/2" drawing shows a new stone bridge, decorative lighting, and a clock tower. Chartpak AD markers and colored pencils were applied to an OCE 30-lb print. The cars were traced, skiers added to reinforce the resort theme, and pine trees added to match the existing ones.

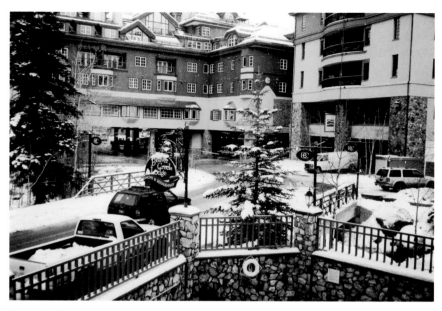

Fig. 3.64 Take a photograph from high ground. This photo was taken from a second-floor vantage point that worked well to show the new bridge. Taking a photo another level higher might have been even better. Always look for the best view when taking reference photographs for sketches.

Fig. 3.65 Final sketch with design changes. Compare this sketch of the village street with Fig. 3.63 and look for the changes. This alternative scheme reflects a simplified bridge design, more cars, and no clock tower. To highlight the entrance to a hotel, the large pine trees were eliminated on the left side of the drawing. This drawing took very little time to create because most of the information was simply traced from the previous drawing.

Sources for Tracing Cars and Landscaping

Cars, trucks, vans, buses, planes, bicycles, and other forms of transportation aren't well covered in entourage books. Sport utility vehicles and vans don't even exist in most entourage books, even though these vehicles are extremely popular. Cars are outdated very quickly, and the ones that show up in source books are practically worthless. The best vehicle information can come from visiting auto dealerships or auto shows and gathering your own literature on current models. You can also take a camera and photograph vehicles in parking lots and on the streets. As with people, if you have a specific vehicle or situation to draw, find it, photograph it, resize it, and then trace it. It's that simple!

Many great books on landscaping are available. Purchase one at a local bookstore or check one out at the library, and you'll find every tree and plant type you could ever imagine needing to draw. Entourage books also have sections devoted to outdoor and indoor plants. The information that already exists in print is so good that you probably won't need to take photographs of real landscaping very often, especially since when you need it it's usually the wrong season—when flower beds don't exist and trees are leafless, for example. Chapter 5 covers drawing people, cars, and landscaping in much greater detail.

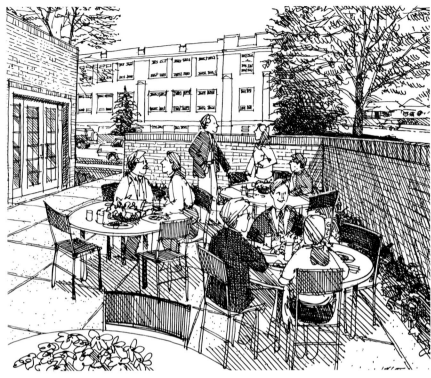

Fig. 3.66 Original dining terrace sketch. This sketch features a private courtyard between several buildings. It took a lot of care and time to make sure the perspective was accurate and the people were drawn well. Delineating all of the bricks also took time. The sketch was made on Mylar with a permanent ink pen and took 4 hours to draw.

Jumpstart Your Drawing by Recycling

Save all of your drawings, because you might need them in creating new sketches. Many conceptual designs for architectural, interior, and landscape projects have elements that may exist in other projects, such as a building shape, an interior furniture setting, or a landscaped wall treatment. When creating new concept sketches for a project, why not recycle elements or "cut and paste" them from one drawing to another. This can occur many different ways, and each method saves you valuable time in the process of communicating your design ideas. Consider the existing drawing information as your "base," which you will trace and modify to create a new drawing. To have an existing perspective as a reference can really simplify your drawing process. Some elements in existing drawings for you to trace might

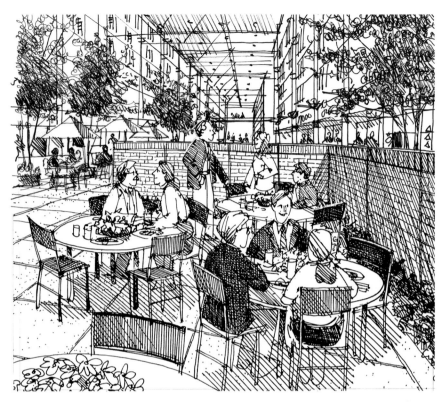

Fig. 3.67 Recycled dining terrace sketch. This drawing shows a large interior atrium with trees, multiple dining areas, and overhead roofed truss. The bottom half of the drawing is an exact copy of the sketch shown in Fig. 3.66. The atrium space was added to match the same perspective. This drawing was completed in 30 minutes when it might otherwise have taken hours to draw. Recycling this amount of information requires that you either did the original drawing or have permission to use it in another sketch.

include people, grouped objects, landscape details, perspective lines, massing of objects, existing conditions that will be modified or added to, distant land features, graphics, and many others.

The clear advantage to recycling existing drawings is that accuracy and proportion are almost guaranteed. Photography captures information in an honest manner. A photograph has the best and most accurate perspective and proportions of a subject. Begin with a photo and then trace over the image, adding your own modifications and design elements. You can even trace over another drawing and layer on changes to the image. You'll find many examples of these methods in this book. Shortcuts are everywhere. You just need to be aware of how you can find them and take advantage of them.

Fig. 3.68 Photograph of two-story building. This picture was found in a marketing brochure and has a simple two-point, eye-level perspective. The scale of the building and rhythm of the windows were very useful in creating a base for a sketch of a new mixed-use building.

Fig. 3.69 Overlay and trace. Although the new building had not even been designed, the client needed a sketch to get others excited about the potential project. The photograph was used as an underlay, to capture the general perspective, mass, and patterns. New openings, street trees, and roof forms were drawn in red pencil. The new building mock-up took about an hour to make and was quite believable.

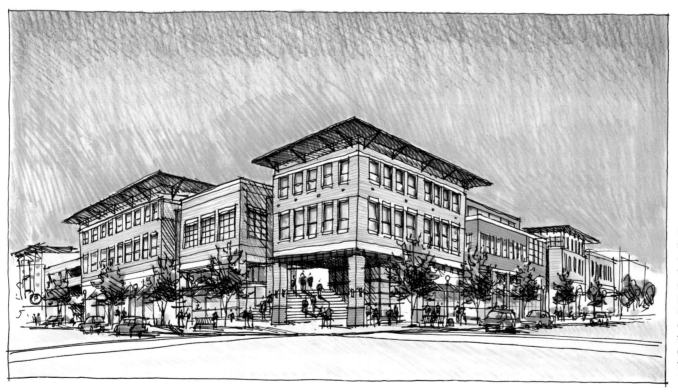

Fig. 3.70 Finished mixed-use building sketch. A sheet of vellum was taped over the mock-up and the final sketch was drawn with a felt-tip pen. The drawing was copied onto OCE 30-lb paper and colored with Chartpak AD markers. Colored pencils were used to delineate brick patterns and add texture to the sky and ground. The 9 x 16" dimension of the drawing was ideal for reproducing on a color copier and 11 x 17" scanner.

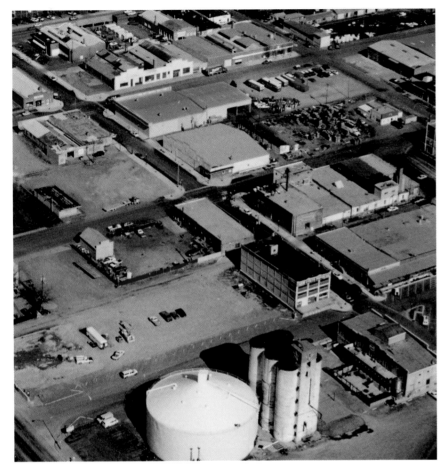

Fig. 3.71 Downtown aerial photograph. This photo was taken 750′ above the ground and was ideal for developing a sketch to illustrate future infill buildings in this historic industrial warehouse district. The 4 x 6" print was enlarged to 11 x 17" on a color copier and traced.

Fig. 3.72 Long-range development. The original structures (Fig. 3.71) are shown as redeveloped buildings in this view of the distant future. Color was eventually added to the line drawing with Chartpak AD markers.

Tracing over Photographs

Tracing from photographs is difficult unless you first enlarge the picture. If an original photo is 4 x 6", you should enlarge it several times on a copier. If you have access to a computer scanner, you can scan photographs and enlarge them with the computer before you print them. Remember that the computer enables you to print enlarged photographs in sections or "tiles," which then can be taped together and traced if need be. A copier will manage 11 x 17" prints rather well. If you need your photograph even larger, there are several alternatives for enlarging the image. You can plot the image on an office large-format inkjet plotter, or enlarge it with an OCE digital copier. Local reprographic centers have these machines and can help you with enlargements.

The amount of time you invest in a drawing is proportional to the size of the image. As a rule of thumb, keep your images smaller than 8½ x 11". Jump up to the 11 x 17" format only if the detail requires the larger size. If you ever need to display the drawing in a large presentation format, scan the drawing and digitally blow it up.

Fig. 3.73 **Polaroid photos are quick.** The angle of this picture was established to draw potential redevelopment on the edge of an historic downtown. A Polaroid camera was used because of the limited number of pictures needed and quick processing time.

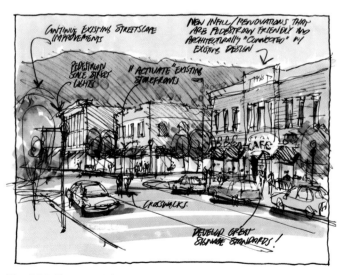

Fig. 3.74 **Commercial redevelopment.** The Polaroid photo was enlarged on a copier and quickly traced to sketch the existing buildings with a new two-story building in the foreground. Trees and awnings add character to the 8 1/2 x 11" drawing. Felt-tip pen with Chartpak AD markers on vellum.

Fig. 3.75 **Photograph a site from above.** This photo was taken from a hillside overlooking the site for a new retail and entertainment center. Always try to photograph your site from a high vantage point to capture more of the ground area in the picture.

Fig. 3.76 **New use for a leftover space.** This 6 x 8" drawing illustrates the character of the development without showing a lot of detail. The terraces, walks, people, banners, vehicle drop-off, roof forms, and color tell the story of an active development. Felt-tip pen with Chartpak AD markers on vellum.

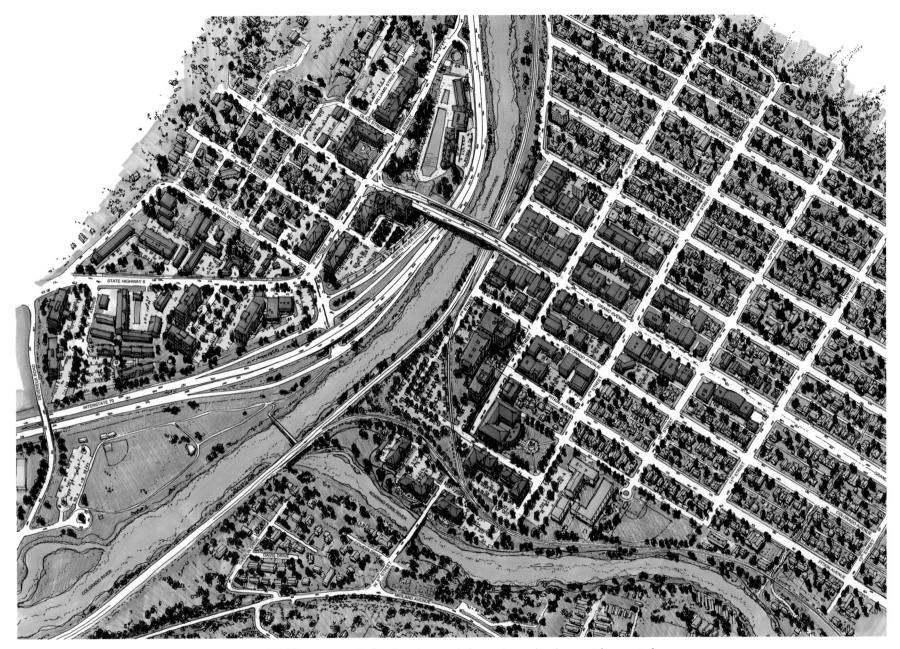

Fig. 3.77 Drawing traced from an aerial photograph. This axonometric drawing shows existing and new development for most of this small town. Different land-use areas are color coded. Trees and cars are added to help give the drawing scale and character. The 30 x 40" illustration was drawn with a permanent ink pen on Mylar, OCE printed on presentation-weight bond paper and colored with Chartpak AD markers. Colored pencil was added for texture. A drawing of this size and complexity can easily take a week to produce, but is highly effective in communicating citywide planning concepts. The drawing was printed as a poster and distributed to the town residents for review.

Tracing from Aerial Photographs

Some large-scale architectural and planning projects that involve multiple acres of property can be effectively illustrated by using aerial photographs. These pictures can either be taken as low-altitude oblique photos overlooking the site (Fig. 3.71), or high-altitude plan photos taken from several thousand feet above the area (Fig. 3.78). Most aerial photographs are black-and-white and can be purchased from companies specializing in land photography. Some companies now offer their information in digital formats for purchase on CD.

Fig. 3.78 High-resolution aerial photograph. The 8 x 10" black-and-white photo of this downtown was rotated at 60 degrees to capture multiple sides of the buildings and streets. The photo was scanned and plotted at 30 x 40" for use as a base in the final overlay drawing.

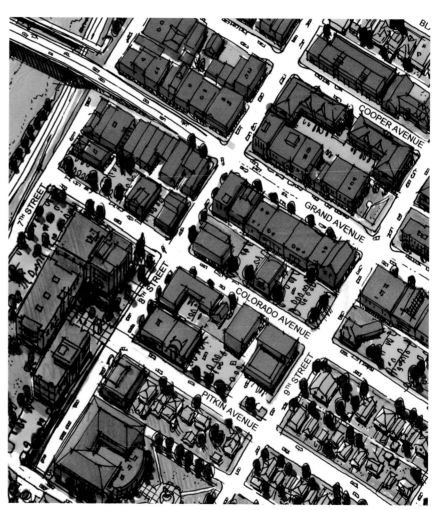

Fig. 3.79 Actual size. This is a sample of the drawing shown at the exact size of the original.

Fig. 3.80 Italian hill town photograph. This photograph is an inspiring image of the ridgeline growth pattern of a European town. The photograph was enlarged and traced.

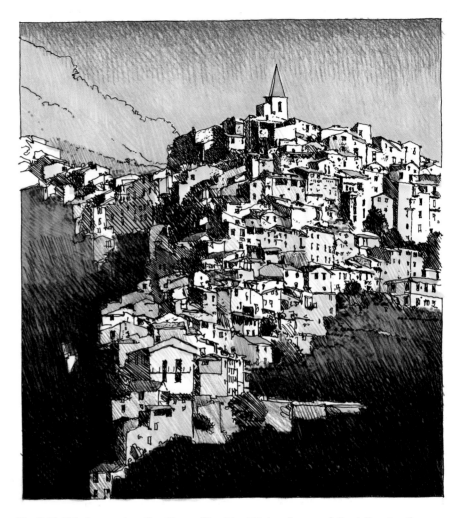

Fig. 3.81 Window and wall patterns. The 14 x 15" drawing carefully delineates the overlapping and stepped building facades of the town. Permanent ink on Mylar, OCE printed on presentation-weight bond and colored with Chartpak AD markers and Prismacolor pencils.

Editing Choices As You Trace

It isn't necessary to trace all of the information you see in a photograph. You can highlight the important elements by tracing them and leave out detail not important to the drawing. For example, the buildings in Fig. 3.81 are delineated with contrasting black-and-white geometric shapes to emphasize the architectural composition of buildings layering down the hillside. Most of the landscape is minimally detailed or not drawn at all.

You can also trace over a photograph simply to capture the scale and perspective and replace the original information with new design ideas. The drawing in Fig. 3.83 replicates the building scale and perspective, but completely changes the facade treatment of the store.

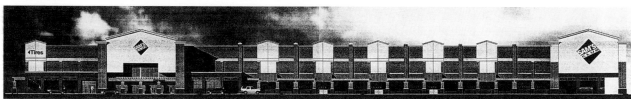

Fig. 3.82 Proposed building facade.
This photo-realistic computer perspective and elevation includes people, cars, repetitive facade patterns, signage, and architectural details. The image was used as an underlay for a series of sketches showing potential modifications to the exterior design. *Computer model by Raymond Harris.*

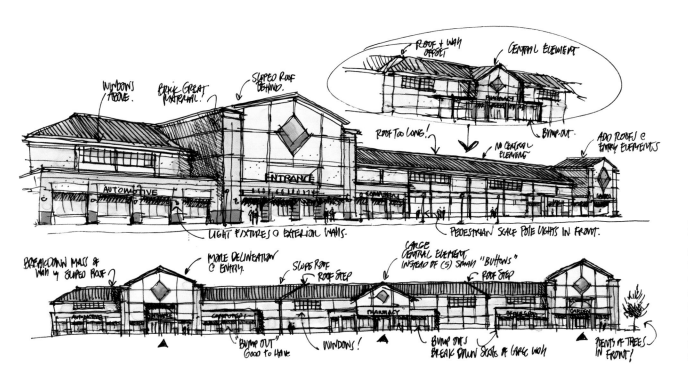

Fig. 3.83 Alternative facade sketch.
This 30-minute sketch illustrates different roof forms and exterior treatment to the building shown in Fig. 3.82. The drawing simply communicates an alternative architectural concept and is purposely drawn rough with little detail. A more detailed and time-consuming sketch wasn't necessary at this point in the design process. Felt-tip pen on trace with Chartpak AD marker color.

Drawing Mock-up and Manipulation

Most often, your final trace drawing will evolve from several sources of information. The building might come from a computer plot, while trees and people originate from tracing files. Using a copier to enlarge and reduce various images, you can tape together a montage of images to construct a drawing composition. Use the montage as a base, and then create your final drawing by tracing and illustrating the montage. Even after the drawing is finished, you can manipulate it in the computer with numerous filters and image modification tools. Figures 3.84–3.86 are examples of this process.

Fig. 3.84 Drawing mock-up. A number of sketches were copied from an old book, trimmed and taped together to form a composition of figures gathered around a campfire. Although it was very rough, it formed the base of the final drawing, which was overlaid and traced from the mock-up.

Fig. 3.85 Storyteller sketch. This final drawing hardly resembles the mock-up. Additional figures were added to teepees, along with a dramatic night landscape. The sketch was sized 8 x 10 1/2" to fit on a scanner. Permanent ink pen on trace.

Fig. 3.86 Poster with manipulated image. The finished drawing was scanned and inserted into the graphic poster. The image was "stretched" to exaggerate the horizontal landscape and give the figures more of a ghostlike quality. Altering images by computer doesn't have to be this extreme. Using an eraser tool, you can make minor corrections electronically that might otherwise have been done by hand.

QuickTips *Overlay and Tracing*

- Label a 9 x 12" envelope CLIP-PING FILE FOR DRAWINGS and start filling it with clippings of people, transportation, and landscaping that you find and cut out of news-papers and magazines. As your file gets larger, divide your col-lection into additional envelopes labeled with subcategories so you can find things easily.

- You may need to enlarge or re-duce traceable images from the entourage books to fit the exact size of your drawing. Start a three-ring notebook, label it TRACING FILE FOR DRAWINGS, and save each one of those resized copies for future use.

- If you're tracing an image or a photograph and it's difficult to see all of the detail through your drawing paper, work on a light table. The detail will be much easier to see. An easy makeshift light table is a piece of glass propped up on books with a desk lamp placed beneath the glass.

- The more work you accomplish in the mock-up stage of a draw-ing, the easier and faster it will be to trace and complete the final drawing (Fig. 3.62).

- When you trace people, make sure to update their clothes and hairstyles to reflect current fash-ion. Redraw vehicles to reflect current models.

- Your local library is an excellent source of traceable material, such as magazines, picture books, trav-el books, and children's books. If you find a reference book that cannot be checked out, use the library's copier to obtain your tracing images.

- The best sources of people to trace may come from drawings that you've already done. Always keep copies of your completed drawings and "recycle" portions of them in new drawings (Figs. 3.87 and 3.88).

- Sometimes the image you want to trace is backward. If the image is simple enough, you can trace it on vellum, then flip the vellum over and trace it again. The image can also be copied onto clear film (the same product that is used for over-head projectors), and then flipped and traced. You can also scan and flip images on a computer.

- If you're having trouble drawing faces on people, don't hesitate to have your people facing away from the viewer. Draw faces only on the people in the foreground; the ones in the background can be drawn with a minimal amount of detail.

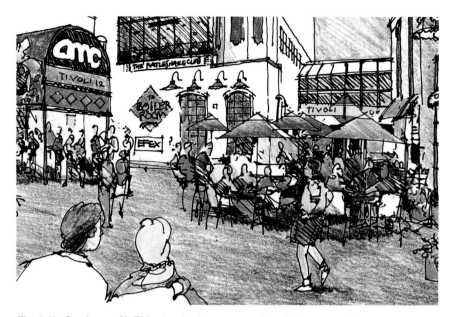

Fig. 3.87 Outdoor café. This sketch shows an outdoor dining area adjacent to a movie theater. The focus of the drawing is on the people dining beneath the umbrel-las. Colored pencil on standard bond copy.

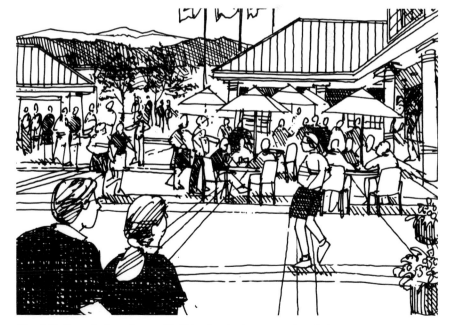

Fig. 3.88 Recycled outdoor café. This sketch shows another dining scene, traced from the previous drawing (Fig. 3.87) with a very different outdoor setting. The time saved by recycling that portion of the image was substantial.

4

LEARNING YOUR CCCs

Understanding the ABCs of drawing isn't enough to meet the graphic demands of today's world. You also need to know what the CCCs— *camera, copier,* and *computer*—can do for your drawing process.

"The camera is an instrument that teaches people how to see without a camera."

~ Dorothea Lange

The Handy Camera
Camera Equipment and What's Best to Use for Drawing

Equipment designed to take still pictures is now available in film, video, and digital formats. Digital photography is an emerging technology and may eventually replace film. The most versatile and common photo technology uses light-sensitive film. The majority of cameras sold are either "point-and-shoot" cameras or single lens reflex (SLR) cameras. Point-and-shoot cameras, especially if equipped with a 35–70 zoom lens, are more than adequate for most of your drawing needs. You will need an SLR camera only for special close-up images or if you want to manipulate the depth of field with special exposures. Disposable cameras are another option, but the technology is limited and doesn't include the option of slide film.

Try experimenting with different cameras. Find one that suits your budget and your needs, including getting the film processed quickly. The following discussion of photography will focus on 35mm cameras, color negative film, and color transparency—or slide—film. Digital photography will be covered in detail on page 88.

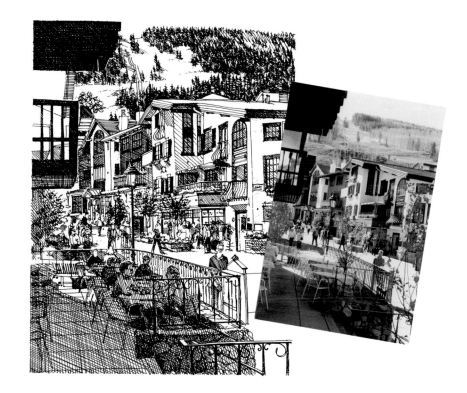

Fig. 4.1 Add more information than the photo provides. This black-and-white drawing was made by enlarging the 4 x 6" color photograph with an opaque projector (Fig. 3.38) and tracing the image. The outdoor terrace in the foreground was empty and extra people were added to the drawing. The original artwork was 10 x 13" permanent ink on Mylar.

Your Lens Makes a Difference

When you begin using photography in your drawings, you need to know that the particular lens that you use might distort your photographs—and the drawings you make from them. Wide-angle lenses tend to inflate objects in the foreground and shrink objects on the edges of the picture. Telephoto lenses tend to condense the foreground and background objects. As a rule of thumb, try to keep your camera lens in the 55mm range for the most realistic representation of your subject.

Film and Developing Options

35mm color print film is very common and available at convenience stores, drugstores, malls, supermarkets, discount stores, camera stores, and photo processing centers. You can also get your print film processed at most of these locations. One-hour processing is available, but you'll pay a premium for that service. Sometimes, the advantage of saving time outweighs the extra dollars you'll spend on processing—but if you plan ahead you can use the one- or three-day service at a local store at a fraction of the cost. Oversized 4 x 6" glossy prints are preferred for use in the drawing process.

Color transparency film—or slide film—is great to use in creating drawings, but is more difficult to buy and process. If you can't find it in a convenience or grocery store, try camera stores and photo processing centers. Make sure the slide film has an "E-6 processing" label on it, or you may be in for a week-long wait while the film is processed out-of-state. Local slide developing services have E-6 processors, and can probably get your film developed in a few hours or days. Doing your homework about local availability of slide film processing before you commit to using transparencies in your work can save you a lot of grief.

If you're in a real hurry, Polaroid cameras are an option. Each print is expensive, but there is a great benefit to having instant pictures to draw from in a severe time crunch.

Fig. 4.2 Try projecting a color negative. You may not always have access to slide film. If you took the picture with color print film, cut the color film negative apart, insert the frame into a 35mm plastic slide mount, and enlarge the image with a standard slide projector. The negative will be a bit green and orange, but will still have enough detail to trace. This 9 x 14" pencil drawing was generated using that technique and completed with additional furniture and interior detail.

Fig. 4.3 Take a Polaroid photograph of your subject. The easiest way to draw an airport shuttle van was to visit a nearby hotel and wait for a van to show up. The Polaroid picture was taken with the individuals posed in order to accurately size the people in the final image. 5 x 8" permanent ink on Mylar.

Fig. 4.4 Step 1: 4 x 6" color photograph. This alley was being studied for possible redevelopment. Several photographs were taken showing different views of the alley. This photo was then enlarged in color to 11 x 17" on a standard office copier.

Fig. 4.5 Step 2: Red pencil mock-up. The color copy was overlaid with trace and a red pencil mock-up was used to block out a small park, storefront, and landscaping.

Fig. 4.6 Step 3: Final colored drawing. Vellum was overlaid on the mock-up and the final drawing was created using a felt-tip pen. Chartpak AD markers were added directly to the original 9 x 15" artwork. This drawing was presented along with the photograph to communicate a before-and-after story about the alley project.

Fig. 4.7 Early digital photography. This image was taken with a "first-generation" digital camera that had very poor resolution and color quality. The images were stored on a standard office floppy disk and easily transferred into the computer through the A-drive. Although the picture quality was marginal, the instant imaging and timesaving speed of digital photography was certainly worth the investment.

Fig. 4.8 Quick drawing from a digital photograph. This 6 x 9" black-and-white drawing was traced directly over a color print made from a digital image (Fig. 4.7). The historic building, sidewalk, and cars were traced and new infill development added to the final ink on vellum drawing.

Digital Photography Is Here to Stay

The image quality of digital cameras is now equal to that of traditional film. When digital cameras first appeared several years ago, the image resolution (640 x 480) was quite rough (Fig. 4.7). Now, high-resolution digital cameras (2048 x 1536, 3.3 megapixels) can rival the image clarity of 35mm film. Digital photography requires a computer for storing the electronic data and a color printer and software to process the images. With this equipment, the time between taking a picture and having a color print to draw from is down to a few minutes. A "digital desktop system" (camera, computer, and printer) is valuable when I'm working on community planning projects in rural areas where even one-hour film processing doesn't exist (Fig. 4.9). Digital photography also enables you to immediately project the photographic image using an LCD projector (Fig. 3.40).

Fig. 4.9 Digital desktop system. This portable system was invaluable for a community-planning workshop in rural Colorado. The images taken with a digital camera were downloaded into the laptop computer and immediately printed on a contact sheet for viewing and selection. Certain images were then printed on an inexpensive color DeskJet printer and traced over. The final drawings were taped on the presentation board alongside the photograph for public review and comment.

Fig. 4.10 Composite photograph of streetscape. This image was assembled from six separate photographs taken from different camera positions along the street. Taped together, they may look chopped, but the facade of the buildings is accurately recorded without distortion. This series of images was taken with a 35mm camera, 55mm lens using color print film.

Fig. 4.11

How to Take Great Photographs for Drawing

When you're taking photographs to use as a basis for drawing, be careful to frame your picture and wait for the best photo opportunity. If it's a street scene with cars and people, wait for any big, ugly trucks to pass and get a picture with plenty of people walking and with cars in the frame. The more objects in the photo, the less you'll have to add to the drawing at a later time.

If your subject doesn't fit in a single picture, you can take a series of panoramic photographs, moving the camera in horizontal increments with slight overlaps (Fig. 4.10). Keep the camera lens at a normal 55mm to avoid distortion when you tape the panoramic photos together. Be sure to use a flash infill if you're facing a light source or the sun. Seeing detail in the dark shadows of a photographic print or slide is difficult and can be minimized if you use a flash.

This book can't teach you everything about photography, but it can show you the value of photography as a shortcut in making drawings and in recording your work. It's worth it to make an effort to learn the basics of photography by experimenting in school or in a class at your local camera store. Even though cameras are becoming more and more automatic and foolproof, cameras don't take great pictures, people do!

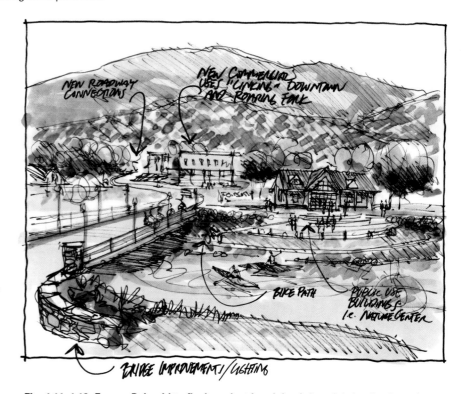

Fig. 4.11–4.12 From a Polaroid to final product in minimal time. It is hard to beat the instant Polaroid picture when timing is critical. This existing riverside scene was photographed (Fig. 4.11) and the picture enlarged to 8 1/2 x 11" on an office copier and quickly traced to create the final drawing of a new river development, all within 60 minutes. Felt-tip pen on vellum with Chartpak AD markers applied directly to the original artwork.

Fig. 4.14

Fig. 4.13–4.14 Direct method from a digital photograph. This quick sketch was drawn to show potential lobby modifications to an existing museum. The 7 x 9½" ink on velum drawing with colored markers took 15 minutes to draw.

Step-by-Step Drawing with Photographs

The following examples show two different techniques for creating drawings from photographs. The *direct drawing method* is the fastest way to create a drawing. Some subjects are basic enough to allow you to generate a final drawing directly from a photograph without need for a preliminary sketch mock-up. There is so little variation between the photo and the drawing that you can focus all of your creativity on the line and drawing technique. Sometimes you might need to lightly sketch a part of the drawing in pencil if you plan to make some minor changes. Take a pencil and lightly draw those modifications right on the Mylar. When you're comfortable with the alterations, draw an ink line right over the pencil. Pencil lines can be erased later with a kneaded eraser (Figs. 4.13 and 4.16).

Fig. 4.15–4.16 Using a photograph for reference. Drawings don't have to be exactly traced from a photograph. The photo of this street intersection was used as a reference for the final drawing (Fig. 4.16). Notice that the perspective of the photograph is slightly different from that of the drawing. 6 x 8" permanent ink pen on vellum with Chartpak AD markers applied directly to the original artwork.

Fig. 4.16

Fig. 4.17 Step 1: Photograph the existing streetscape. The photograph was taken with a 35mm camera and processed in one hour at a local drugstore. The print was enlarged on a black-and-white office copier to 8 1/2 x 11" and used as the base for the red pencil mock-up.

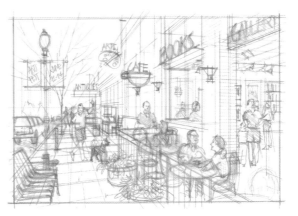

Fig. 4.18 Step 2: Red pencil mock-up. The overall perspective and scale was established from the photograph. The sidewalk was widened and new landscaping, furniture, graphics, and activities were blocked out at this stage of the drawing.

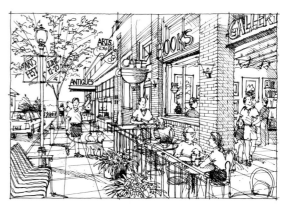

Fig. 4.19 Step 3: Final ink line drawing. A sheet of trace was taped over the red pencil mock-up and the final drawing was created with very little change between the two versions. A digital print on 30-lb presentation bond was made of the line drawing and colored with Chartpak AD markers and Prismacolor pencils.

The *indirect drawing method* involves an interim pencil mock-up of the drawing. Take a photograph and imagine using the image as the base information for a more complicated drawing (Fig. 4.17). You might make a quick thumbnail sketch of your drawing idea before starting the pencil mock-up. Once you're satisfied with the composition, project or trace the photograph onto vellum and copy the important information in pencil. Then begin adding character to the drawing with people, windows, landscaping, and other elements that illustrate your concept. You can refer to a tracing file for people and landscaping. Make all of your design decisions on the tracing paper at this step in the process (Fig. 4.18).

When you've finished the mock-up, overlay the drawing with Mylar or vellum and start final delineation in ink. Remember that you can always make last-minute corrections with light pencil on the drawing (Fig. 4.19). Although the indirect method takes more time than the direct method, it guarantees you great results because you can capture all of your design ideas in the mock-up sketch long before you invest your time in the final ink drawing.

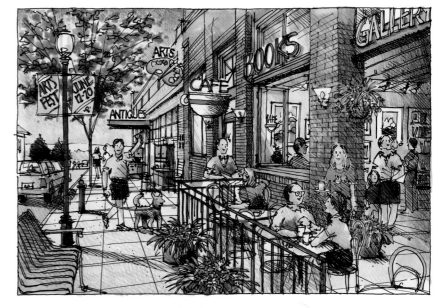

Fig. 4.20 Step 4: Color and computer modifications. After the drawing was colored, the brick column near the right side of the drawing appeared too bare. Working over a light table, another person and more plants were sketched onto a blank sheet of the same paper. To pull together the scattered changes, the column was redrawn as well. Color was added to the new "patch," which was then cut out and spray mounted directly over the colored drawing. The edges of the paper patch didn't quite match the drawing beneath. To correct the problem, the drawing was scanned at 300 dpi and cleaned up using Photoshop software.

Photographing Plans and Models

If you have to draw a complicated building perspective, you can set up a study model and photograph it from many different angles. A point-and-shoot camera will work, but using a 35mm SLR camera mounted on a tripod will let you record the greatest amount of detail. By setting a slow shutter speed and a high f-stop (ƒ16 or ƒ22), you can get more of the front, middle, and rear portions of the model in focus. The benefit of photographing several views of the model is that you can then pick the best perspective for the drawing. If a model doesn't exist, you can fabricate a very rough mock-up of a few walls and corners of the building, glue them to a site plan, and take photos of this "skeleton model" (Fig. 4.26). This should give you enough information to construct the framework of the drawing.

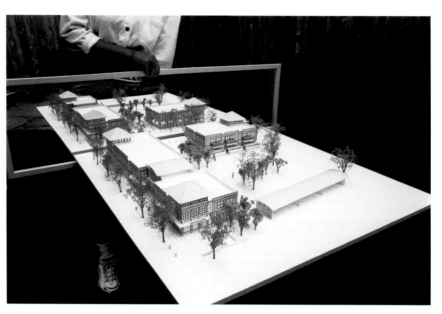

Fig. 4.22 Use a mirror to double your model. The study model of this mixed-use project was built for only half of the proposed development. A mirror was held up to the model's edge and positioned to reflect the model in the right perspective. The photograph helped show the overall massing of the project, with half of the time invested making the model. Drawings were also generated from the photographs.

Fig. 4.21 Photograph a massing model. This rough model was constructed with foam core blocks and colored paper. Different planning scenarios were arranged and each photographed using a 35mm camera and slide film. The slides were used for recording the alternatives and for creating an aerial perspective of the preferred option.

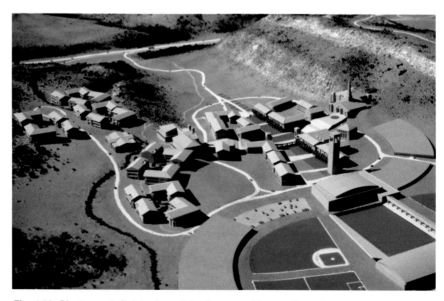

Fig. 4.23 Photograph finished models. Some architectural models are built with accurate forms and information. Photographs of these models are easy to turn into great drawings.

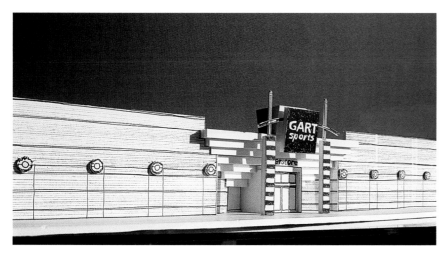

Fig. 4.24–4.25 Photograph the model from eye level. The photograph of this study model was taken at a low enough angle to represent an eye-level view of the building. The slide was then projected onto paper and drawn with pen, pencil, and minimal gray tones to create a quick sketch of the proposed building.

Fig. 4.25

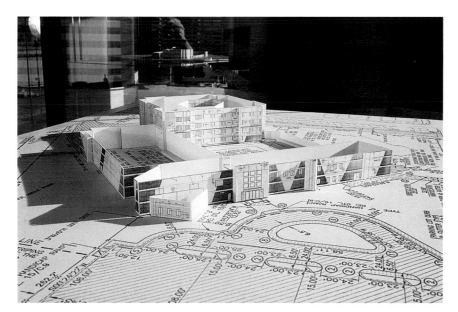

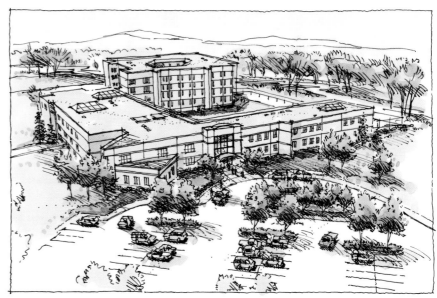

Fig. 4.26 Skeleton model built to photograph. The client needed a sketch of the proposed building in a short time. A massing model was quickly assembled by spray-mounting the building elevations to cardboard and gluing the pieces together on a site plan. The model was photographed from many different angles with 35mm slide film.

Fig. 4.27 Final sketch from the projected slide. The color slide was projected onto bond paper using a photographic enlarger (Fig. 3.39) and blocked out with red pencil. The final drawing was created with a permanent ink pen on vellum and colored directly with Chartpak AD markers.

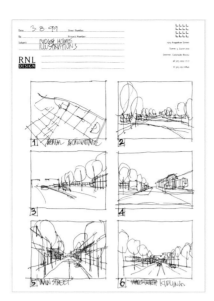

Fig. 4.28 Storyboard ideas for drawings.

Visualizing a Planning Study

The following pages illustrate the process by which a single planning project was visualized. In addition to the plans, maps, diagrams, and text describing the overall design, a number of drawings were needed to help convey the quality and visual character of the plan. The process began with a storyboard of thumbnail sketches that identified specific drawings and views (Fig. 4.28).

Fig. 4.28 Storyboard ideas for drawings. These quick 2 x 3" thumbnail sketches were the roadmap for developing the final drawings. Image 1 represented the aerial perspective (Fig. 4.33). Image 4 identified drawing a light rail station (Fig. 4.37). *Drawings by Pat Dawe.*

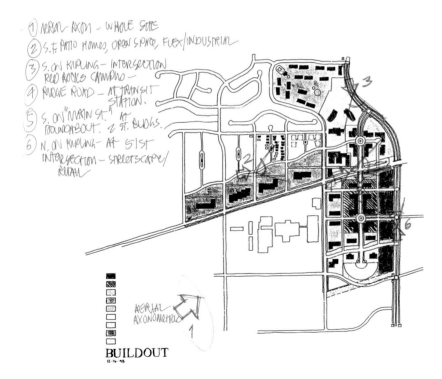

Fig. 4.29 Image matching to the site plan. The numbered thumbnail sketches (Fig. 4.28) were actual views of specific locations on the site plan. Each view was drawn on a reduced copy of the plan and identified with an arrow. The aerial view is shown in the lower left corner of the page.

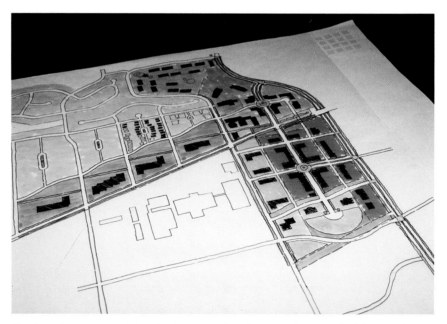

Fig. 4.30 35mm slide of the site diagram. The plan was photographed from various angles and heights, each viewing the site from the general direction identified in Fig. 4.29. The best slide was selected and enlarged to 11 x 17" with a color copier. That copy was then enlarged again in pieces and spliced together to form the 17 x 24" base photograph to be traced.

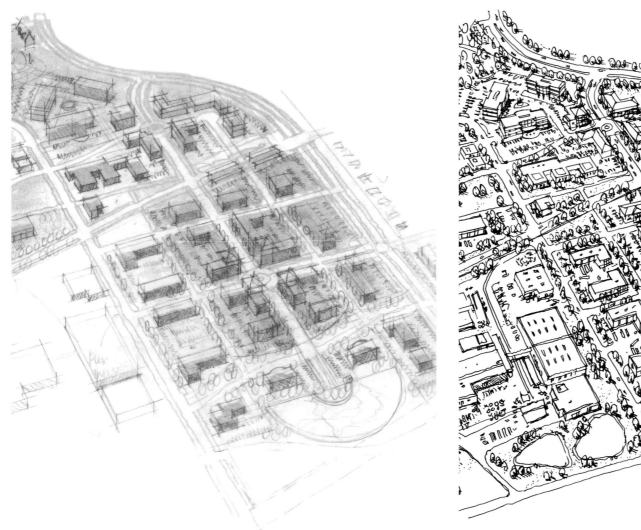

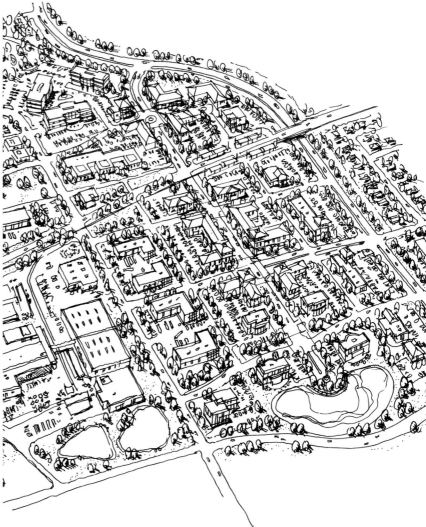

Fig. 4.31 Red pencil mock-up of the buildings. The black footprints of buildings in the photograph were extruded in three dimensions and enhanced with roof forms and shadows. Trees and parking areas were also roughed into the drawing. Perimeter areas were blocked in with houses and adjacent development.

Fig. 4.32 Final black-and-white ink drawing. When the red pencil mock-up was completed, the final drawing was traced with a permanent ink pen on vellum. Any miscellaneous drawing corrections were made with white correction fluid on the vellum. The drawing was then digitally reproduced onto 30-lb presentation paper and colored (Fig. 4.33).

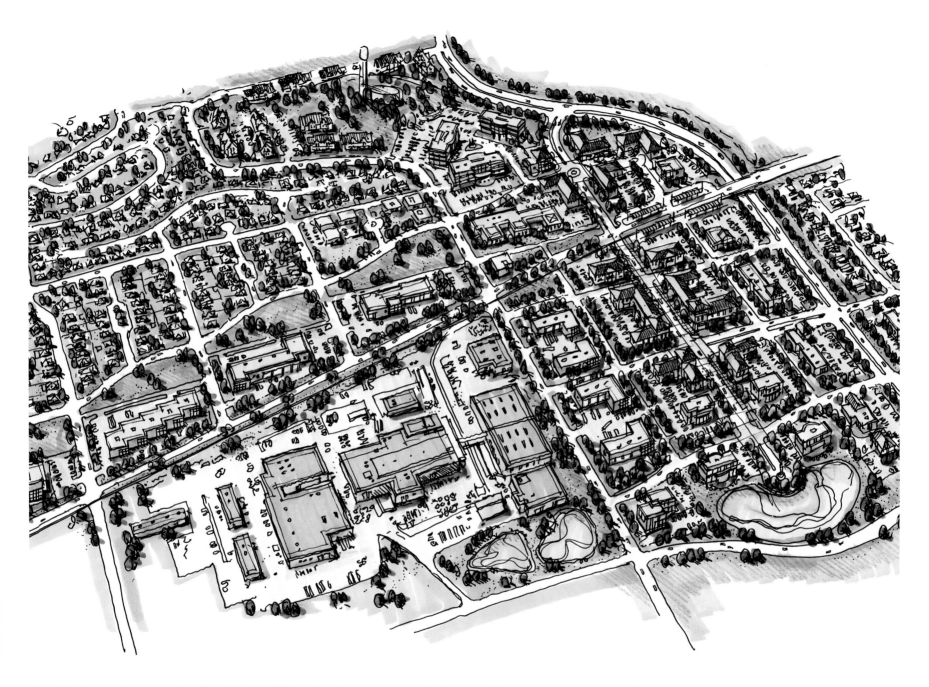

Fig. 4.33 Final aerial perspective. The 12½ x 24" OCE digital print was colored with Chartpak AD markers and enhanced with Prismacolor pencils. Because of the dimension of the drawing, the image was outsourced to a reprographics company, scanned at 250 dpi, same size, with a large-format scanner, and burned onto a CD. Avoid scanning images any less than 250 dpi. Usually, 300 dpi is preferred, although then the file size may exceed 100 megabytes, making it a challenge to process with a standard computer.

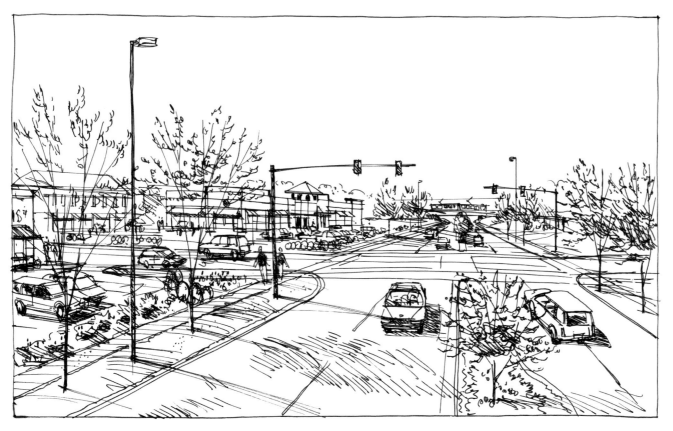

Fig. 4.34–4.36 Ground-level views of the site development. The aerial view of the overall site was an excellent visualization of the entire development but couldn't show the close-up detail of the architecture, landscaping, or street activities. A series of five simple one-point perspectives were drawn that illustrated the design ideas from locations identified in the storyboard (Figs. 4.28 and 4.29). Each drawing was produced at the same 9 x 15" size, using the same drawing approach. Permanent ink pen on vellum with Chartpak AD markers and Prismacolor pencils on OCE digital prints.

Fig. 4.35

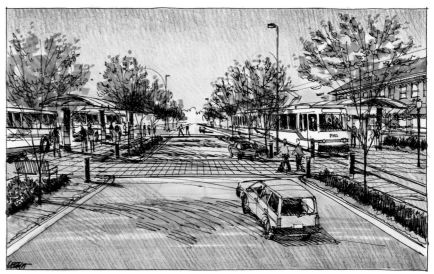

Fig. 4.36

Fig. 4.37 **Digital contact sheet**. A series of 45 digital photographs were taken of the downtown area. The images were downloaded into the computer and viewed with ACDSee software. A printout of the photographs was made with a color printer using the same software. Always make a "digital contact print" of your photographs to keep track of the images for future use.

Redevelopment Drawings from Digital Photographs

The drawings on these pages reflect a quick visualization study for enhancing a small downtown commercial area. Reference photographs were taken with a digital camera and saved on a standard office floppy disk. The drawings were never colored, because the black-and-white versions were acceptable for use in a client presentation.

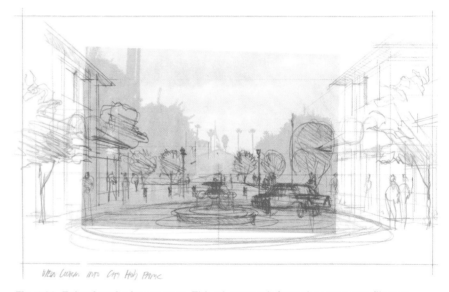

Fig. 4.38 **Enlarging the image area**. This photograph from the computer file was printed black-and-white on 8 1/2 x 11" bond paper and used as base information for the drawing. The red pencil mock-up was developed over the photograph, and the drawing size was expanded to 9 1/2 x 16" to view more of the adjacent development of each side of the central plaza.

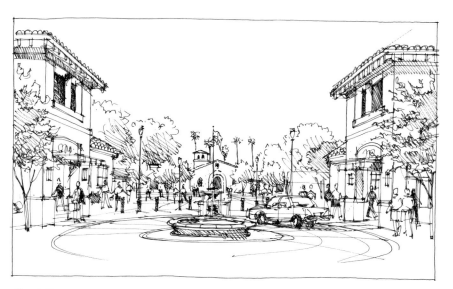

Fig. 4.39–4.40 Before-and-after comparison. Photographs and drawings, shown side by side, are an effective method for communicating the design improvements made to an existing place. This method of comparing the existing with the proposed is very easy for clients to understand. The pairs of images on this page show the existing conditions in colored photographs and the proposed improvements in black-and-white drawings. A more successful presentation would be to show the existing conditions in black and white and show the new changes in color.

Fig. 4.40

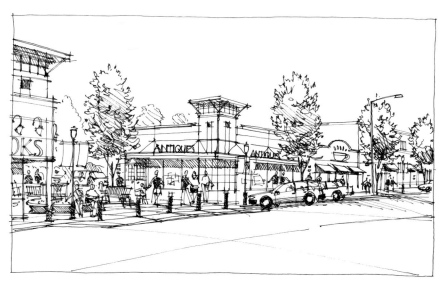

Fig. 4.41–4.42 Midblock public spaces. This before-and-after pair of images shows the existing downtown commercial storefronts in the digital photograph. The drawing was created using the same technique as shown with Fig. 4.38, and illustrates a possible open-space park and pedestrian connection to off-street parking areas behind the buildings. 9 1/2 x 16" permanent ink on vellum, no color.

Fig. 4.42

Fig. 4.43 Step 1: Digital photograph. Many different views of the site plan were taken and downloaded into a computer. This view was selected and printed on 11 x 17" paper with a standard office laser printer that had the ability to print on larger papers. The image quality was adjusted in Photoshop to increase the contrast.

Fig. 4.44 Step 2: Red pencil mock-up. The scale of the drawing was large enough to block out most of the drawing detail at this stage. The window patterns, paving linework, car shapes, and landscaping are shown.

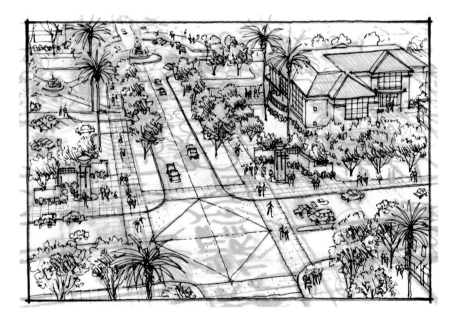

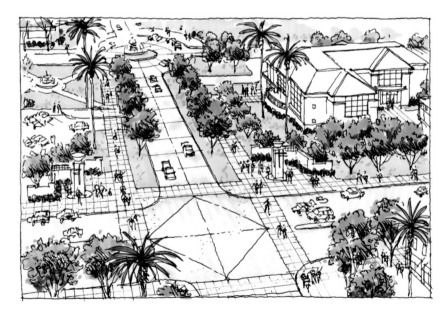

Fig. 4.45 Step 3: Final ink drawing. A sheet of vellum was taped over the red pencil mock-up and the final drawing was completed with a permanent ink pen. Because of the fine detail of the sidewalk pattern, a fine-point pen and straight edge was used to carefully draw the lines.

Fig. 4.46 Step 4: Color applied in phases. Coloring this drawing took four distinct phases: (1) marker added to the ground surfaces and landscaping, (2) marker added to the building, cars, and people, (3) shadows added with marker, and (4) colored pencil texture added to the pavement, grass, and building.

Digital Photograph of a Site Plan

The drawings on these pages show the step-by-step development of an aerial perspective view of a downtown civic space. This and two other drawings were produced from a conceptual site plan that was photographed from different viewpoints with a digital camera.

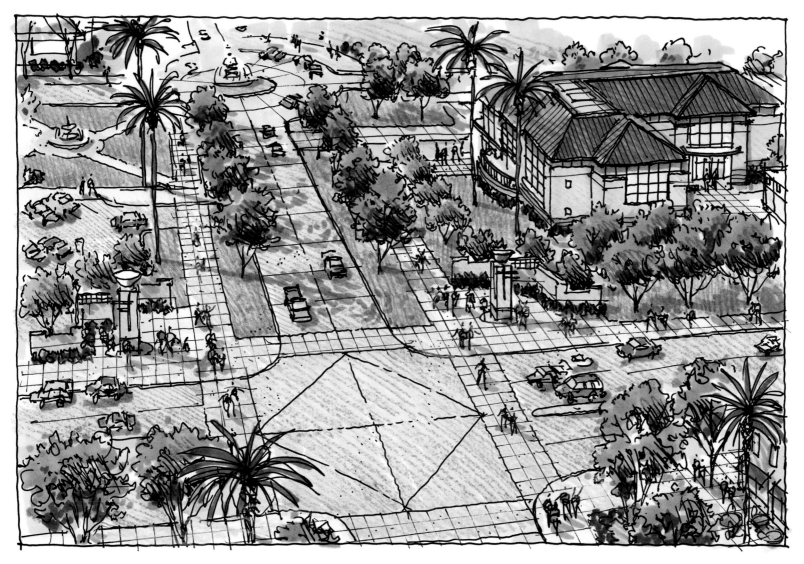

Fig. 4.47 Final aerial perspective. The 8 x 12" color drawing took about one day to produce, from the first digital photograph of the site plan to the final colored-pencil texture. The digital camera saved several hours that would have been consumed with film development and travel time to and from the photo lab. That time saved was well spent on improving the drawing.

Fig. 4.48 Step 1: Photograph the site from a plane. Most regional airports have flight training schools. Flight instructors will often make extra money by taking short flights with photographers to document sites. This flight took less than an hour and cost less that $100 in plane and pilot fees. Time allowed us to circle the site several times at 750 feet above the ground and shoot several rolls of 35mm color slides. Use high-speed film for sharp pictures, since these small planes tend to get bumped around in the wind.

Drawing from Multiple Photographs

For certain projects you may have to rely on combining two or more photographs into a single drawing. This aerial perspective of a proposed office and hotel development was created from two photographic sources: an aerial photograph (Fig. 4.48) and a photograph of the proposed site plan (Fig. 4.49). The challenge of creating an accurately scaled drawing was solved by the site plan photo, which clearly showed each building in location and at the same perspective as the aerial photograph.

Fig. 4.49 Step 2: Photograph the site plan from the same angle. Once the aerial photograph had been selected, I took additional 35mm slides of the site plan for the proposed development at the same angle as the aerial photo. By taking a role of photos at slightly different angles, I was able to select the individual slide that best matched the photo perspective.

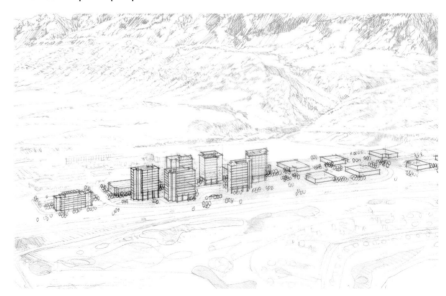

Fig. 4.50 Step 3: Merge the two photographs together. Using a slide projector, both photographs were projected and traced onto the same sheet of paper. Similar proportions were established by adjusting the zoom lens of the projector. The buildings were then blocked out in red pen on a trace overlay. The height of each building was slightly exaggerated to make the architecture more visible.

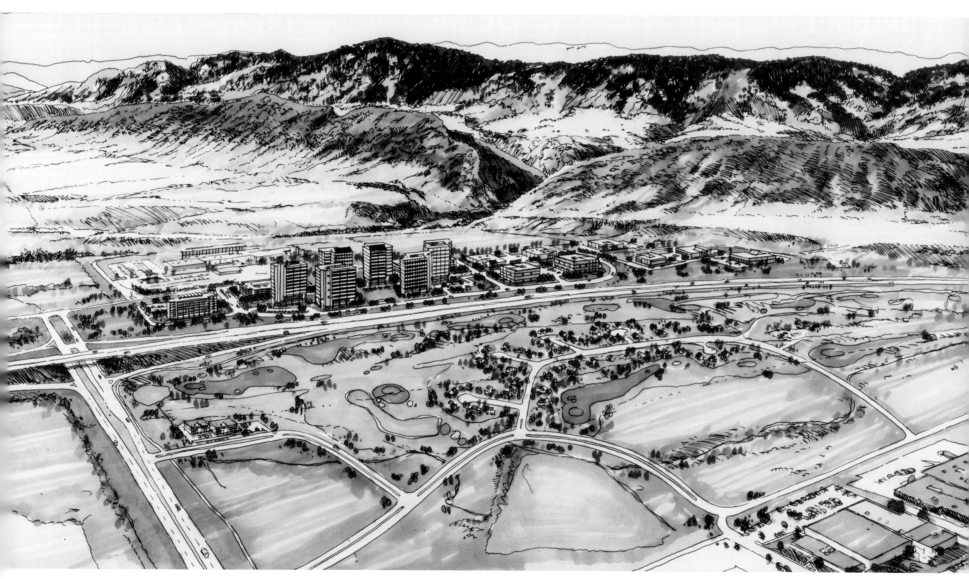

Fig. 4.51 Step 4: Final ink drawing and color. The final 15 x 28" drawing was completed with a permanent ink pen on Mylar. A blackline diazo print was made from the mylar original and colored with Chartpak AD markers. An 8 1/2 x 11" photographic record of the color drawing was made before the original artwork was mounted onto foam core and laminated for a formal presentation.

Fig. 4.52–4.53 Posed photographs made into drawings. It may be necessary sometimes to wait for the right photo opportunity to happen, by hovering at a street corner to photograph a bus, for example. You can also pose individuals for a photograph that might be used to create a drawing. One of the photographs above is of a person with a hard hat on, posed at a computer. The photograph was used as the base for a drawing of an office workstation (Fig. 4.53) . . . without the hard hat!

Fig. 4.54–4.55 Interior photographs capture scale and perspective. This corridor photograph was used as base information for the drawing of an interior retail mall. The photo established the one-point perspective and height of people. The photo was enlarged in an opaque projector (Fig. 3.38) to 7 x 10" and drawn with permanent ink on trace. The original artwork was scanned into a computer file, printed onto vellum with a DeskJet printer, and colored with Chartpak AD markers on the vellum print.

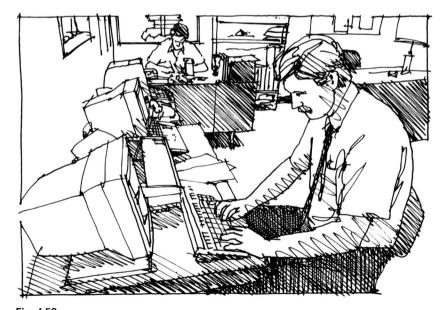

Fig. 4.53

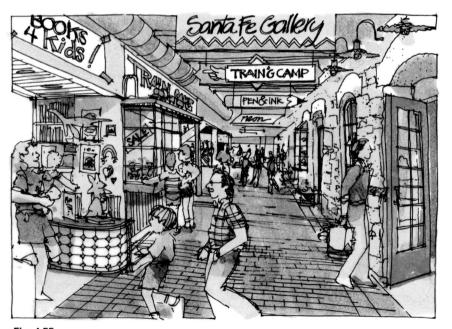

Fig. 4.55

Photograph Your Drawings, Too

You should always try to keep a visual record of your completed drawings. A record of your work is important for your portfolio, and also for evaluating, over time, the evolution of your drawing progress and the success of different drawings at communicating design ideas. Understanding and learning from your less successful drawings will help keep you from repeating mistakes. Scanning is becoming a preferred method for documenting drawings. If you take 35mm slides, use color-corrected copy lights and tungsten film that is matched to the same color as the lights. Take more than one slide of each drawing, "bracketing" the exposure to have several options to select from. Make additional copies of your slide library and file the originals in a safe location.

Quick Tips *Cameras*

- Find out where you can get film developed easily, and plan your drawing time around the available service.

- When you take photographs outside, always have the sun at your back. That way you'll always have a well-lighted subject. Avoid taking pictures into the sun, as the images will be dark and poorly contrasted.

- If you can vary your camera's exposure settings, it's better to use a higher f-stop (*f*22), which increases the depth of field and ensures that a larger area will be in focus.

- When you take photographs of people, transportation, and landscaping for use in drawings, file them in a 9 x 12" envelope labeled PHOTO FILE FOR DRAWINGS and save those pictures for future use in your drawings. If there are negatives, keep them with the prints in the same envelope.

- Film is less expensive than your time. Always take more pictures than you think you need, so you have lots of images to choose from. It's better to overshoot than to trudge back to retake pictures because you didn't get the right ones!

- If you're using print film and the area that you're photographing is too wide to get into a single photograph, take a panoramic photo series (overlapping multiple pictures taken from left to right) and then splice the prints together to create a single image.

- Here are some easy solutions to common photography problems:

Distortion of the subject due to a wide-angle lens	*. . . Shoot with a 55mm lens*
Subject too dark to see	*. . . Shoot with a flash*
Multiple photos in a panorama don't align	*. . . Switch from wide-angle to 55mm lens*
Interior photos too dark	*. . . Shoot with faster film (ISO 200 or 400)*

- When you're taking photographs indoors, use a fast ISO 400 film. Try to avoid taking flash photographs because the backgrounds of flash pictures are often very dark.

- Avoid using a wide-angle lens, such as a 21mm or 28mm. The optical distortion is so great that your drawing will look blatantly like one generated from a photograph.

"One machine can do the work of fifty ordinary men.

No machine can do the work of one extraordinary man."

~ Elbert Hubbard

The Reliable Copier

Improved Quality of Traditional Copiers

The quality of commercial and office photocopiers has consistently improved over recent years. There are now standard paper copiers, large-document copiers, digital color copiers, and large-format color reproduction machines. High-quality black-and-white and color copiers are usually available at your local copy center and large commercial office supply stores.

The typical copier has 8½ x 11" and 8½ x 14" paper trays. Many copiers also reproduce larger images on 11 x 17" paper. Older machines that once had limited enlarging and reduction settings have now been replaced by copiers with continuous 25–400% zoom capabilities.

With any drawing, always make sure to keep the edges of the image area at least ½" smaller than the paper dimension you plan to copy onto. For example, if you want to copy onto 11 x 17" paper, then keep your image area 10 x 16" or less.

Fig. 4.56 Copy an image from a magazine and draw it! This 6 x 6" drawing of baseball players was created as a themed image promoting a new town development. The drawing was traced with a permanent ink pen on vellum taped over a black-and-white copy taken from a sports magazine.

Fig. 4.57 Composite drawing made from multiple copies. The baseball drawing (Fig. 4.56) was reduced in half on a copier and spliced together with two other drawings that were each reduced copies. The composite drawing was retouched with white correction fluid and copied again onto 8 ½ x 11" bond paper. The final version was then colored with Prismacolor pencils.

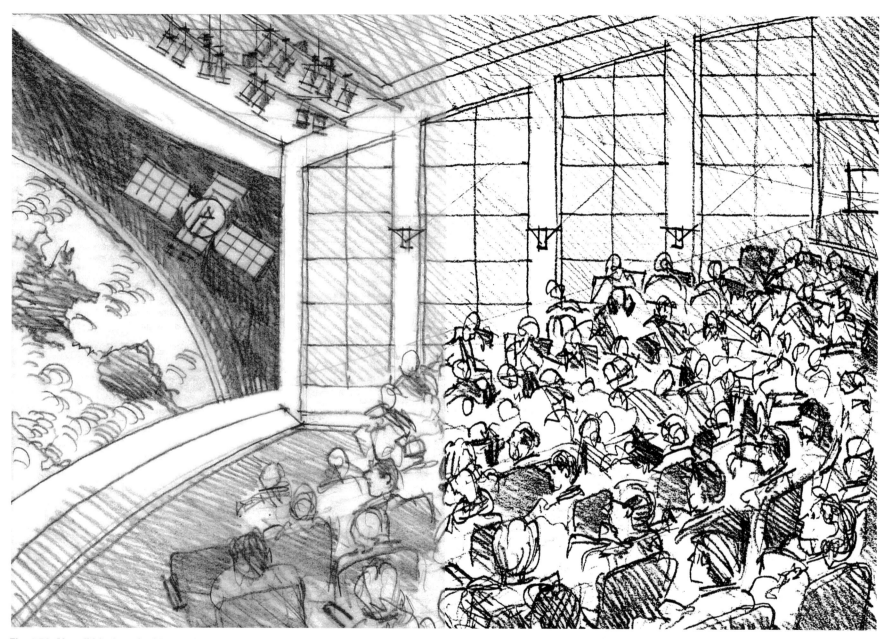

Fig. 4.58 Not all black-and-white copies are alike. This side-by-side comparison is from the same original pencil drawing, copied in black and white using two different machines. The image on the left was copied on a color copier using the black-and-white setting. Color copiers are machines designed for high-quality continuous tone reproduction. This black-and-white copy reproduced the gray tones of the pencil very accurately.

Fig. 4.59 Lack of gray tone. The copy on the right was made from a standard office copier, without any custom setting. These office machines are designed for large-quantity reproduction of text documents. They tend to reproduce images in high contrast and lack the ability to copy continuous tone. Research different copiers available for your use and find those machines that will best reproduce your work. Never make poor-quality copies of your work if you are aware of better machines to use.

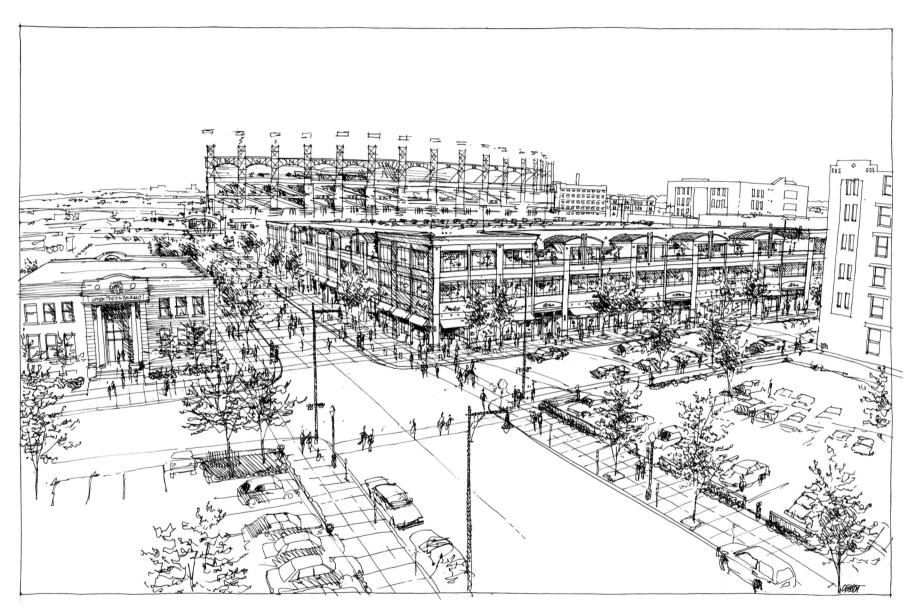

Fig. 4.60 Large drawing reduced and then colored. The image complexity and detail of this perspective dictated that the original artwork be 12 x 24" in size. If the drawing had been colored at the same dimension, it would have been difficult to reproduce and would have lost quality in the photographic process. When the line drawing was completed, it was reduced to 9½ x 15" by a service bureau using the (now outdated) film and chemical process. The reduced version was then copied onto 11 x 17" bond paper in the office copier and colored with Prismacolor pencils. "First-generation" color copies were made from the colored drawing and bound into presentation reports.

New Digital Copying Systems

Traditional copy technology requires high temperatures, hot rolls, and electrostatic charges to transfer toner to the paper. In recent years, a new reprographic technology has emerged that has dramatically improved our ability to make reproductions of original artwork. The machine I'm most familiar with is the *OCE 9800* made by a company named OCE-USA, Inc. The machine is a single scanning/copying/plotting system, with an LED plotter engine and 400 dpi resolution. It can reproduce gray scales better than any large-format copier I've ever used. Best of all, it is capable of printing on many different papers (the 30-lb presentation paper is highly recommended), and solvent-based markers don't smear when applied directly onto the paper. This digital copying technology is available at most service bureaus and repro centers. It most likely will replace all diazo and electrophotographic copying in the next few years.

Fig. 4.62

Fig. 4.61–4.63 Poor-quality copy from a photograph. Not all copiers reproduce gray tones well. This 200% enlargement was made on a standard office copier from a 4 x 6" photograph taken inside an industrial building. The copy quality was very poor, but good enough to trace the basic space, window patterns, and perspective for the final drawing. A red pencil mock-up was created over the photocopy (Fig. 4.62) and the final 7 x 11" drawing was traced on vellum with a permanent ink pen (Fig. 4.63). An alternative to using the office copier would have been to enlarge the photo with a color copier, since those machines reproduce continuous tone much better than standard copy machines.

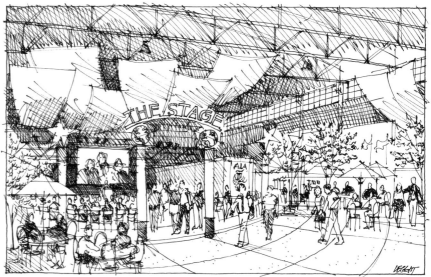

Fig. 4.63

Copying Artwork Greater Than 11 x 17"

If you're using a standard copy machine and the size of your original drawing is greater than 11 x 17", you may have to copy the image in halves and splice the pieces together. Another option is to use a large-format copier, which has the same hot roller, toner, and technology as a standard copier but with a 36"-wide paper capacity. The machine is only capable of reproducing your original at the same size, and the quality is marginal. Some design schools and professional offices have these machines in-house, and you will probably be able to find one to use at your local copy center. Before the introduction of large-format digital copiers, traditional reprographic film was a popular choice for duplicating large-format drawings. This involved stat cameras, film positives, film negatives, chemical processing, and reliance on time-consuming and expensive reprographic service bureaus. The recent introduction of the OCE digital copier has made it the best option for reproducing large drawings. The image quality and variable enlargement/reduction capability of this machine make it your best choice for making copies of large drawings.

Changing Exposure and Reduction Modes

There's no tried-and-true formula for choosing the right exposure or reduction settings for making copies. The best bet is to experiment with the manual settings until you get the optimum reproduction of your original. An ink drawing, for instance, will probably reproduce best at a very different setting from a pencil drawing with gray tones. Check the settings often, because copiers often default to automatic exposure.

Quality of Color Copying

Color copiers are great, but digital color copiers sometimes produce less than desirable results. A typical color copier can produce only about 2000 color images before it must be thoroughly serviced, cleaned, and color balanced. The first copies made right after the machine's cleaning will be beautiful, but if you happen to be last in line before a routine cleaning, the color of your copies may not be very accurate. You can try calling the copy center to ask them when they last had their color copier serviced, and when the next cleaning is scheduled. If color quality is important, and you're not in a hurry, you might even want to wait to have your copies made.

Fig. 4.64 Different image sources assembled for a drawing. Two historic images from a history book were enlarged on a copier, cut out, and taped together to make a composition for the drawing. The pioneer family sitting in front of the sod home wasn't as dynamic as the family from another picture. The second family photo was taped over the first and used in the final drawing. The square format of the drawing also dictated that the windmill be moved closer to the house.

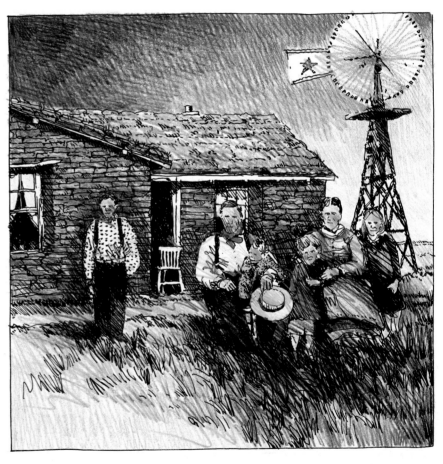

Fig. 4.65 Pioneer family portrait. The 10½ x 10½" drawing was sized to fit on a color copier. The original drawing was permanent ink on Mylar. A black-and-white copy was made from the original and then colored with Prismacolor pencils. The drawing was used in a proposal for a new museum.

Quick Tips *Copiers*

- Some color copiers can enlarge an original drawing well beyond 11 x 17". The equipment digitally "tiles" the enlargement onto multiple sheets of paper that can then be accurately spliced together. For a nominal investment, you can turn your drawing into a poster.

- Research the different types of papers you can use for making copies. Color copiers use a much brighter and higher grade of paper than the duller papers used in standard copiers. You can purchase a ream of high-quality paper and use it for all your copying work.

- Compare different copiers you have access to. They may vary greatly in quality of reproduction. You're not looking for speed so much as how well the copier reproduces fine lines, black areas, and gray tones. Pick the best copier and use it again.

- A reduced drawing often looks better than a full-size copy. All minor imperfections are less noticeable at even a slightly reduced size.

- Never assume that color copies will come back perfect. Ask when the reproduction company last had its machines cleaned, what the best exposure might be for your drawing, and what the normal turnaround time is (so you don't have to pay rush charges). Ask a lot of questions!

- Color copies can be made on different weights of paper. You can even have double-sided color copies made! Take a class trip or make a personal visit to a reproduction company and have a sales representative give you a thorough explanation of their copy services. The company wants your business, and should be very willing to answer all your questions.

- Many schools and offices have their own color copiers, but the quality of the copies may be poor because the machines often aren't serviced frequently. You'll probably get the best copies from professional reproduction companies with higher-quality machines that are maintained on a regular basis.

- If you are doing a large order of color copies, ask the reproduction service to show you the first copy "for approval." You can ask them to make color and contrast adjustments at that time, before the rest of the job has been processed. This can prevent disappointing surprises after the copies have been made.

- If your original color drawing is bigger than 11 x 17", you'll need an interim color photographic print made before you can have color copies made.

- Order photographic prints on matte instead of glossy paper. You'll get a better color match with matte photographs.

- Drawings created in a small format and enlarged to 11 x 17" are great for quick design presentations. Plan ahead, and size the original in the same proportions as the enlargement. An original image area of 4 x 6½" will enlarge to 11 x 17" perfectly.

- Experimenting with different settings on the copier can enhance tones and contrasts in a pencil drawing. Be careful not to "burn off" the lighter pencil lines by setting the density too light.

- Always try to have an extra black-and-white or color copy made of your drawing to file away. You can recycle it into other drawings and use it for your portfolio.

What You Need to Know About Copyright Laws

There are laws against photocopying photographs and drawings from most magazines and books. Many copy centers turn down jobs that involve possible copyright violations. Please be aware that if you photocopy any artwork or photography produced by another party, you must get approval unless permission is specifically given to copy the image. Exceptions to this rule are clip-art and entourage books, which are published for the express purpose of being reproduced.

- Here are easy solutions to common copier problems:

Background too dark	*. . . Place a sheet of paper over the original before closing the lid*
Edge of image cut off	*. . . Leave at least a ½" border on all sides of your original*
Linework seems gray and uneven	*. . . Toner in copier needs to be replaced*
Dark splotches on the copy	*. . . Clean the glass, which probably has correction fluid on it*
Inaccurate color reproduction	*. . . Copier in need of routine service*

Drawing from Computers

The Emerging Computer

Computers and the visual arts have finally merged! Computer software can do photo manipulation, graphic design, desktop publishing, multimedia presentations, animation, engineering, architectural design, and drafting. People are even creating serious fine art with computers.

Computer use in drawing is developing fast. In 1990, you could barely create and plot simple perspectives for architectural designs. By 1995, the first 3-D perspectives with hidden lines, materials, shadows, and light sources were generated. The past few years have seen real-time 3-D animation "walk-throughs" and fool-the-eye composites of computer-generated images and photographs. These amazing developments created a subtle backlash in the business of design. What happened to the hand-drawn line? In response to these changes, several companies began producing software that converts stiff CAD drawings into an irregular series of "squiggly lines," overlapping ends and segments (Fig 4.68). New software can even modify computer-generated images and make them look like hand-drawn sketches (Fig. 4.122). There is no end in sight to the variety of software options and advances in computer technology. The following pages represent a brief glimpse into the wonderful possibilities of computer visualization. Some examples were quick and easy to create, while others were very time-consuming and complicated.

All of the computer images in this book were produced from one of these primary software programs: AutoCAD, 3D Studio VIZ, and Form Z. Secondary programs used were Adobe Photoshop, Adobe Illustrator, Squiggle, and others. Become familiar with the different software options and learn how to use them for different drawing projects. Always look for new visualization tools and don't be afraid to experiment with new technologies as they are developed.

Fig. 4.67 Complex interior/exterior computer model as a design tool. This AutoCAD model was created to show both interior and exterior materials. The same model appears in different versions in Figs. 4.79 and Fig. 4.85. Extremely detailed, this model was a valuable tool in the development of the building design. *Computer model by Doug Spuler.*

Fig. 4.66 AutoCAD wireframe with hidden lines. This wireframe perspective took several days to create due to the complexity of the forms and window patterns. Different views were plotted and traced to create several pencil drawings promoting a new hotel (Fig. 5.10). A computer model with "hidden lines" is one that has the appearance of solid building masses without transparent walls (Fig. 4.97). *Computer model by Jesse Adkins.*

Fig. 4.68 AutoCAD model with squiggle added to the linework. This computer image was brought into a PLT file and modified with software to make the lines appear hand-drawn. The image was then plotted. This technique is valuable in the early design phases of projects as it helps "soften" CAD drawings, making them less formal. Clients can sometimes feel rushed through the design process when they see early computer drawings that are often stiff and intimidating. Combining computer drawings with hand drawings can solve that problem. *Computer model by John Decker.*

Fig. 4.70 Realistic computer modeling helps neighbors understand design. The residents in adjacent neighborhoods were concerned about views into a proposed campus. To resolve their issues, an accurate computer model was created using an AutoCAD model of the new buildings and a scanned aerial photograph of the area "draped" over a Digital Terrain Model (DTM). All of the components were brought into 3D Studio VIZ and assembled. The buildings can be seen in Fig. 4.109. *Computer model by Trent Cito.*

Fig. 4.69 Photo-realistic computer rendering. This interior view of an office building lobby was accurately rendered with AutoCAD, 3D Studio VIZ, and Lightscape to represent the true perspective, proportions, and lighting design for the space. *Computer model by Trent Cito.*

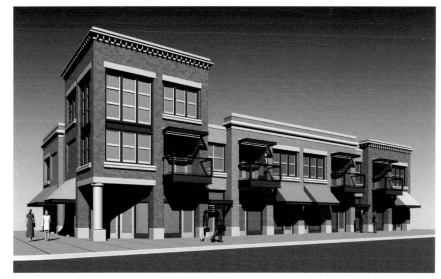

Fig. 4.71 Libraries of materials and textures are available. The different brick and stone patterns shown in this Form Z rendered model were selected from a large library of materials within the software program. The people are standard computer-generated figures. *Computer model by Dan Kessler.*

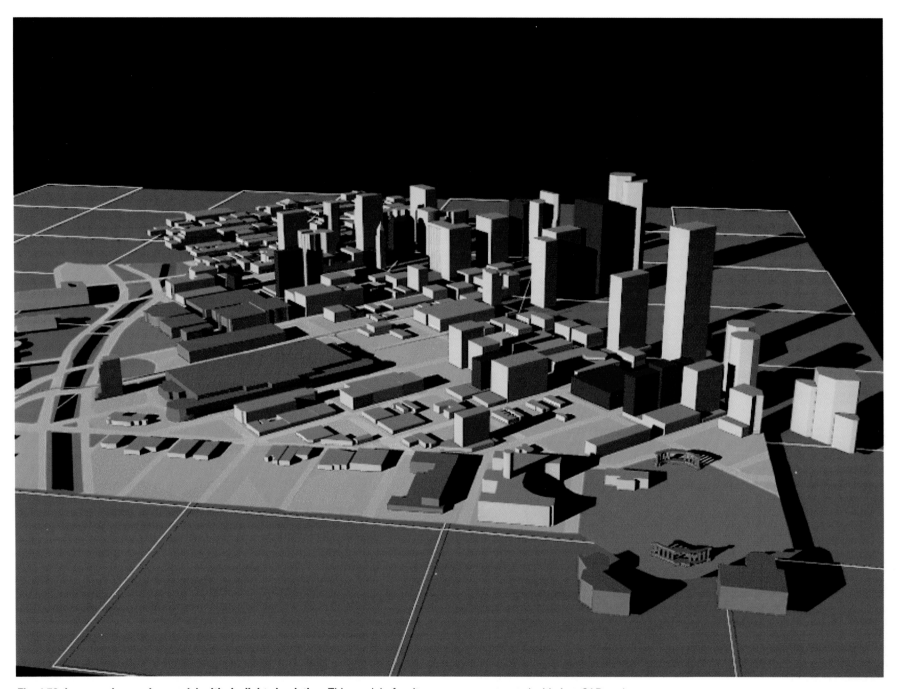

Fig. 4.72 Large-scale massing model with daylight simulation. This model of a city core was constructed with AutoCAD and rendered in 3D Studio VIZ. Buildings were colored to identify different uses and shadows were established with-sun angle modeling representing the exact time of day and year. *Computer model by John Decker.*

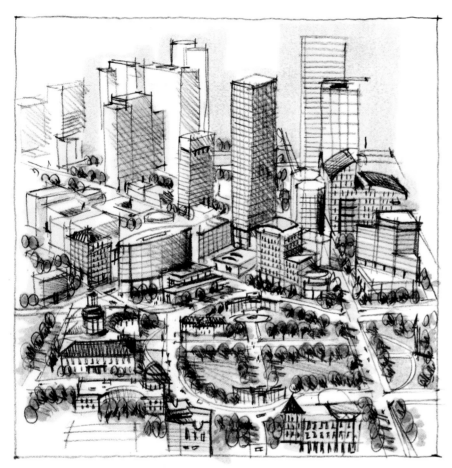

Fig. 4.73 Drawing from computer massing models. Although the computer model seen in Fig. 4.72 has simple building massing, the proportions and perspective make it an accurate base for creating an illustrative perspective view. A portion of the computer model was enlarged and traced to show more building facade detail, landscaping, and color. New buildings were added to the composition. 7 x 7" ink on trace, scanned and printed on vellum. Chartpak AD markers were applied to the reverse side of the print.

Computer Modeling for Drawing

Computers can be productive drawing tools, given the right software and experience. The visual product generated will depend on the level of visualization the project requires: simple vs. highly sophisticated, more conceptual vs. more realistic. Often, a computer model is created to assist in the design of a particular building, interior space, or landscape concept. Hand drawings are generated from the computer model to assist in visualizing the design (Fig. 4.86). Other times, a specific hand drawing is requested, and

Fig. 4.74 Computer model generated for an interior perspective. This interior model was created with 3D Studio VIZ with enough detail and scale to be used as base information for a perspective drawing (Fig. 4.75). One of the challenges of computer modeling is learning how to set the perspective view, angle, and camera lens. A severe wide-angle camera lens can skew the perspective so much that it appears unrealistic. This image may have looked better with a less wide-angle view. *Computer model by Heather Mourer.*

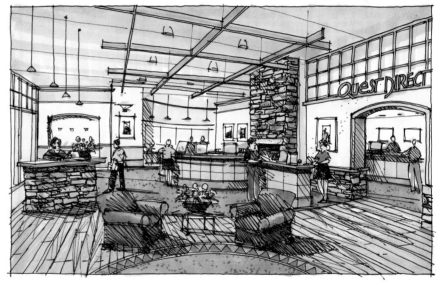

Fig. 4.75 Interior perspective from a computer model. A version of the computer model seen in Fig. 4.74 was used as a base for constructing this drawing. People in the computer model were traced and others added. Linework in the 3D StudioVIZ computer model helped determine the perspective vanishing points. Drawing interior spaces with complicated floor plans is very easy when a computer model this basic is created. 8 x 13" permanent ink pen on vellum, OCE printed on 30-lb presentation bond and colored with Chartpak AD markers and Prismacolor pencils.

to help create an accurate perspective, a computer model is made (Fig. 4.75). The illustrations on the next few pages show how computer models and hand drawings can be closely connected with each other in the design process. The ideal designer is an individual who can not only draw well by hand but easily visualize an idea using computer tools.

Adding Character to Computer Models

The accuracy of computer rendering is difficult to match with a hand drawing. The character of a hand drawing is equally difficult to match with a computer rendering. Both have their advantages and place in the design visualization process. Computers are quick tools for massing space and buildings. They are great for studying relationships between buildings and understanding complicated geometric shapes, but they can also lack charac-

ter and personality by poorly delineating people, landscaping, graphics, furniture, cars, lighting, and many other elements that add to the character of a visual presentation. You can add all of these elements if you have the time and technical expertise. Hand drawing can pick up where basic computer modeling stops by easily filling in the elements that add valuable personality and scale.

Fig. 4.76 Computer massing model without any scale or character. This quickly generated Form Z massing model was built to understand the relationship between several office buildings and a potential transit station. Architectural form and massing was established, but the image lacked any human scale or natural elements. *Computer model by Larry Doane.*

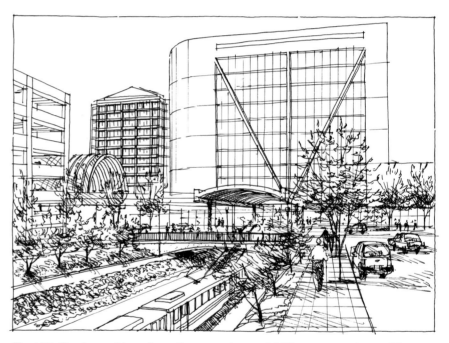

Fig. 4.77 Overlay and trace from the computer model. The computer image (Fig. 4.76) was printed on 11 x 17" paper and used as a base for this drawing. The block on the left side of the page was drawn as a parking structure. Floors and windows were added to the building facades. Trees, ground cover, railings, and sidewalks were drawn, and people, cars, and a light rail train added the street level activity. 10 x 14" permanent ink on vellum.

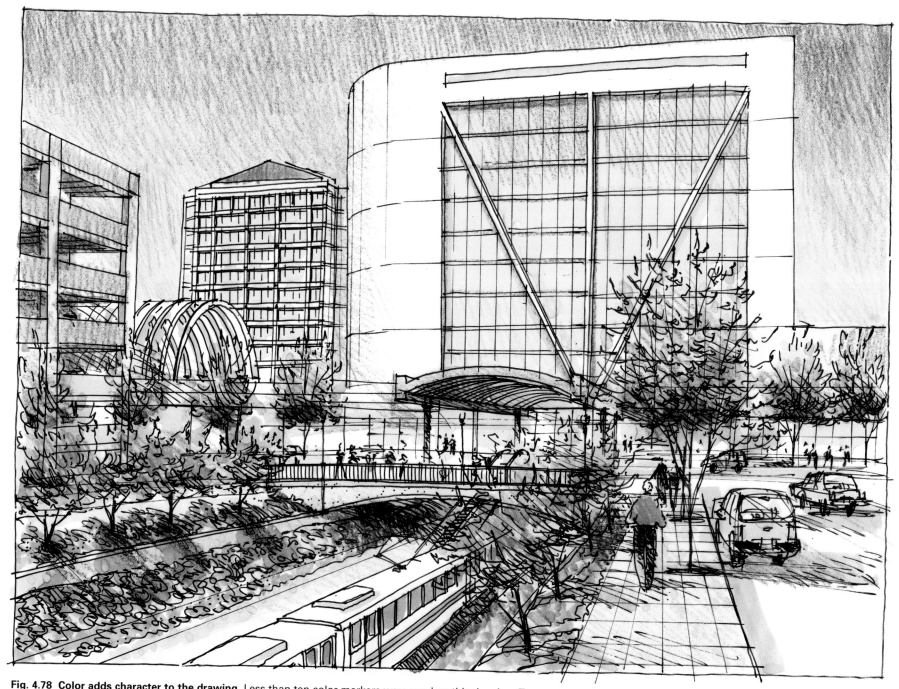

Fig. 4.78 Color adds character to the drawing. Less than ten color markers were used on this drawing. Two green markers were used on the shade trees, two for the ornamental trees, one for the walls and sidewalk, one for the sky, one for shadows, and a couple for the highlights. Texture was added with colored pencils. All of the color was applied directly to the original artwork.

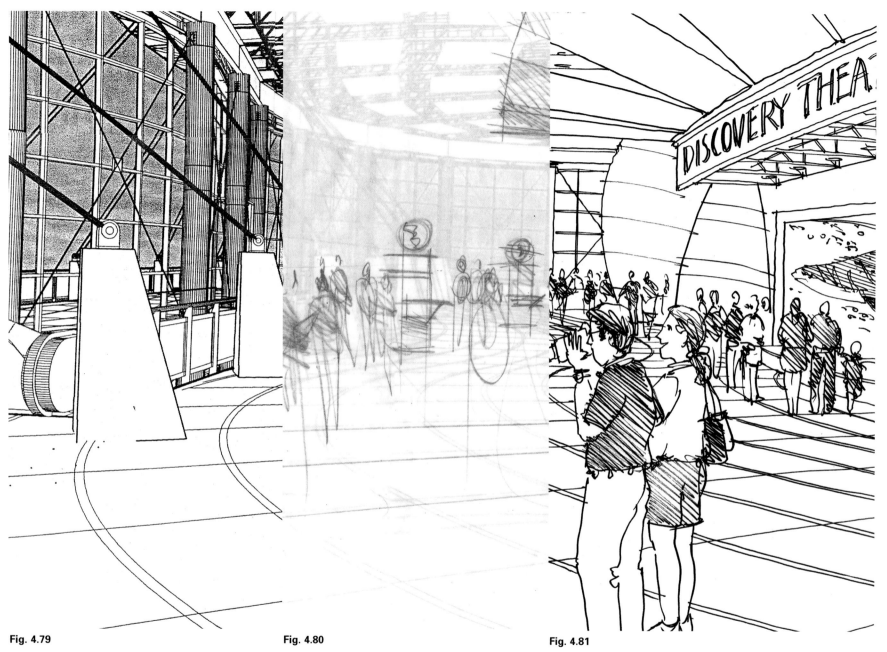

Fig. 4.79 **Fig. 4.80** **Fig. 4.81**

Fig. 4.79 – 4.81 Drawing a complex interior space. The computer model that was shown in Fig. 4.67 was used as the base of this drawing. Working closely with the architect who created the computer model, an eye-level view was selected with a view of the building that best represented the overall space. A red pencil mock-up established the placement of people and additional interior elements. The final 17 x 24" drawing was made with a permanent ink pen on vellum. The drawing was colored with markers on an OCE digital print. *Computer model by Doug Spuler.*

Drawing from Wireframes

Computer-aided drafting (CAD) programs, such as AutoCAD, allow you to create floor plans, site information, and detailed building elevations on the computer. That information can then be translated into a perspective drawing by expanding the same lines into a 3-D view. Detailed information about the building can be manipulated in different views and plotted to form the baseline information of your perspective drawing. Commands are built into the computer program that can clean up overlapping and confusing line information; the "hidden line" command causes the background lines to disappear, which creates a more solid appearance to the building mass.

Computer Plotting Options

A computer-generated drawing has to somehow be printed. Large-format black-and-white plotters are now as common in design firms as copiers. Color plotters are becoming more affordable and may eventually replace blackline plotters. If you don't have access to a plotter, find a local service bureau that will instruct you about storing the information on disks so that they can output the information on their equipment. An alternative to large-format plotting is to print a smaller image on your computer printer, either at 8½ x 11" or 11 x 17". You can also print a larger version of the image in pieces and tape them together.

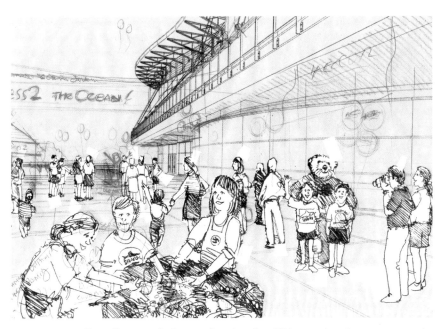

Fig. 4.85–4.86 Recycling people for another drawing. This exterior view was created using the same steps as with Fig. 4.79. People were copied from other drawings, reduced to an appropriate size to fit the perspective and taped to the red pencil mock-up. Notice the "recycled" figures on the right side of the drawing appear in Fig. 4.81. 12 ½ x 22" permanent ink on vellum.

Fig. 4.82–4.84 15-minute hidden line wireframe. The extremely quick and simple wireframe generated for this building identified the floor levels and basic wall setbacks. Minimal time was invested creating the wireframe, but it offered enough information to use as a base to overlay and make a red pencil mock-up and final 13 x 23" line drawing.

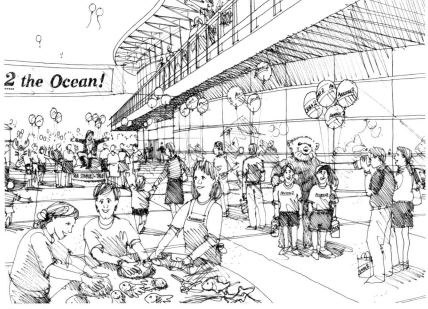

Fig. 4.86

Fig. 4.87 Step 1: Building an interior model for drawing. This interior space included columns, roof trusses, and a sloped ramp between floors. To create an accurate drawing of the space, 1 hour was spent making a simple AutoCAD wireframe with just those elements needed for the drawing. The model was plotted 11 x 17" on an office laser printer. *Computer model by Trent Cito.*

Fig. 4.88 Step 2: Red pencil mock-up. Trace was taped over the computer wireframe, and the basic elements of the interior retail space were blocked out in red pencil. Signage was also identified in this step.

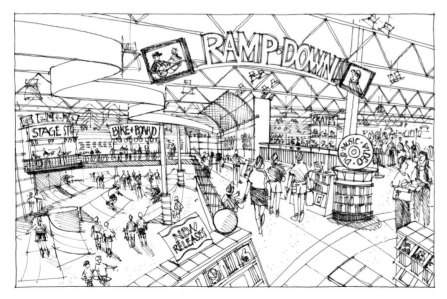

Fig. 4.89 Step 3: Black-and-white line drawing. The final 10 x 16" drawing was traced on vellum with a permanent ink pen. Overlapping lines and miscellaneous drawing errors were eliminated on the drawing with a white correction fluid pen.

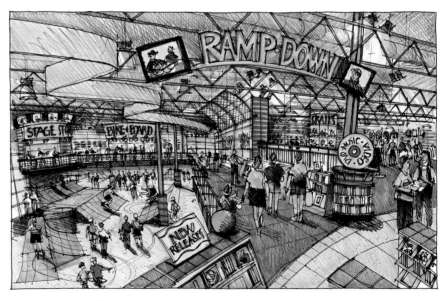

Fig. 4.90 Step 4: Final color drawing. The line drawing was OCE printed on 30-lb presentation bond and colored with Chartpak AD markers and Prismacolor pencils. The 10 x 16" format was ideal for scanning on an 11 x 17" flat-bed scanner. Image files of this drawing and three other views of the retail space were plotted in color at 24 x 36" and used for a client presentation.

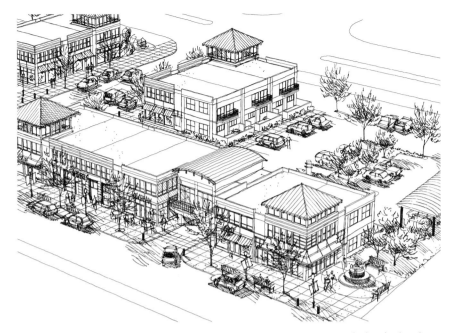

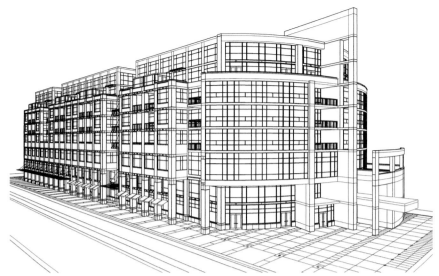

Fig. 4.91 Drawing directly on a wireframe plot. If the computer rendering is developed with enough detail and information, you can make a large plot of the wireframe and draw directly on it. This AutoCAD wireframe had no trees, lighting, signage, cars, people, or street elements. The image was plotted 24 x 36" with Squiggle software to give the linework a hand-drawn appearance. Street elements and shadows were then drawn directly onto the plot. White correction fluid was used to clean up the linework near the additional elements. *Computer model by John Decker.*

Fig. 4.93–4.94 Weekend wireframe. A rush deadline to promote a proposed mixed-use building forced the design team into finding new shortcuts to visualize the building design. One of the architects spent his weekend constructing an AutoCAD wireframe of the front two faces of the building. All other data for the building were eliminated. On Monday, the wireframe was presented in a number of different perspective views, which were then plotted 24 x 36" on vellum. As in Fig. 4.91, people, cars, and trees were drawn directly on the plot. Linework behind the trees was carefully erased from the vellum with an electric eraser. The time needed to embellish the wireframe was about 4 hours. Color was applied on an OCE digital print with Chartpak AD markers and Prismacolor pencils. *Computer model by Doug Spuler.*

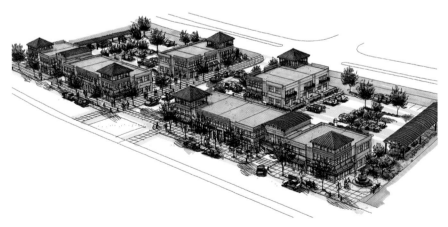

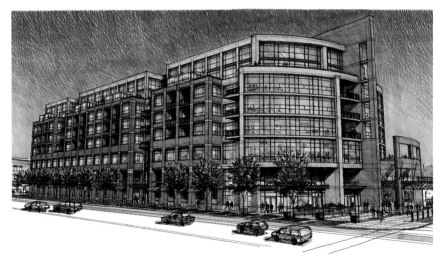

Fig. 4.92 Colored perspective in half the time. The hand-modified computer wireframe was OCE printed on 30-lb presentation bond and colored with markers and pencils. The final drawing looks completely hand drawn and only took a fraction of the time it might have taken if the computer had not played a primary role in the visualization process.

Fig. 4.94

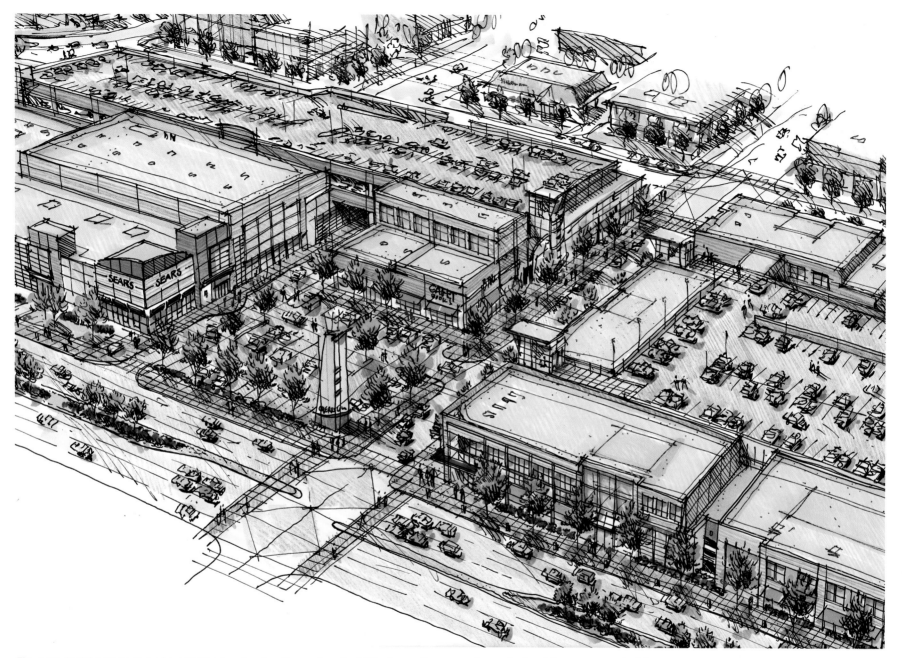

Fig. 4.95 Aerial perspective of a neighborhood redevelopment project. The large site area and complexity of the numerous buildings demanded that a computer model be constructed as a base for the drawing. The AutoCAD wireframe was constructed from pieces of elevation studies (Fig. 4.96) aligned above the site plan. There was enough information in the computer model to generate the correct building heights, window locations, and general dimensions. The 15 x 32" drawing was made with a permanent ink pen on Mylar, OCE printed on presentation bond, and colored with Chartpak AD markers and Prismacolor pencils.

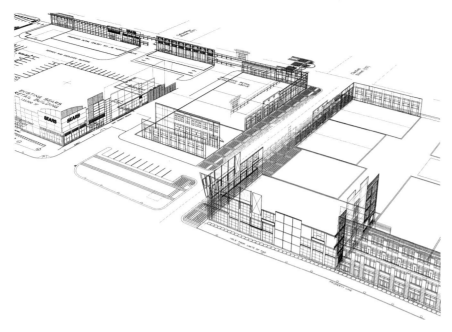

Fig. 4.96

Assembling Elevations in Vertical Planes

Another method of visualizing a design is to assemble the three dimensions for the building by taking separate facade elevations and placing them in vertical planes over the floor plan. The method is quick and allows you to manipulate the AutoCAD model like any other model. One drawback, as seen on these pages, is the obvious transparent character of the computer model (Fig. 4.97).

Fig. 4.97–4.99 Ground-level computer wireframe. The AutoCAD model for the development (Fig. 4.96) was viewed from above and at eye level. Different views were created and saved. This view was plotted at 12 x 24" for tracing. The red pencil mock-up was developed on trace over the wireframe and traced again on Mylar with a permanent ink pen. The final 9 x 22" colored version was an OCE print, colored with Chartpak AD markers and Prismacolor pencils. *Computer model by Jesse Adkins.*

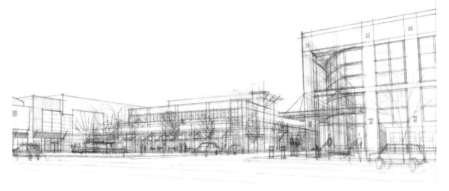

Fig. 4.98

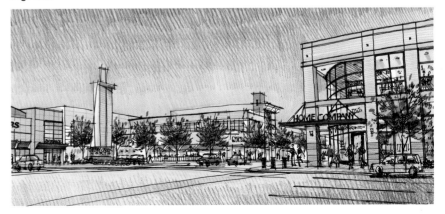

Fig. 4.99

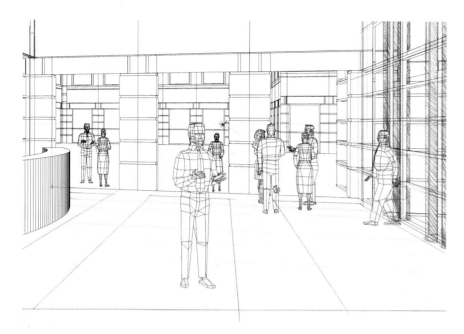

Fig. 4.100 AutoCAD people placed for scale. The figures shown in this computer wireframe were located on the plan to establish proper height for the people. In the final drawing (Fig. 4.101), only a few of the figures in the rear were traced over.

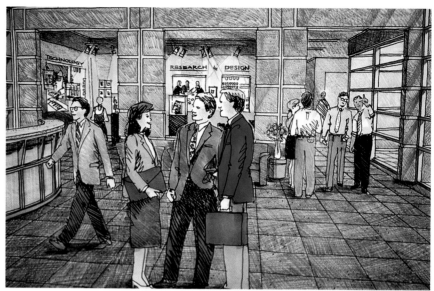

Fig. 4.101 People generated from computer and entourage files. All of the figures in this drawing were traced. The group in the foreground was traced from an entourage file. The same individuals can be seen in Fig. 5.13. The man on the left is drawn again in Fig. 3.24. Most others in the background are either redrawn from other files or created in AutoCAD (Fig. 4.100).

Computer-Generated People, Cars, and Trees

The fine art of creating people, cars, and trees by computer is far from perfect. The human figures can be simple AutoCAD blocks (Fig. 4.100) or photographic copies found in 3D Studio VIZ (Fig. 4.102). You can also find images from the Internet to download. Cars are much better looking in AutoCAD block form and can be fairly close to actual automobile designs. The quality of AutoCAD trees is marginal, and they can often look like paper lanterns and wire brushes (Fig. 4.103). Some architects build their own trees from scratch and use them in different projects. The trees found in Fig. 1.11 were constructed. Look closely and you'll notice that they are all identical.

Fig. 4.102 Photo-realistic people. These individuals were taken from a library of images and inserted with Photoshop into this AutoCAD/3D Studio VIZ model. *Computer model by Trent Cito.*

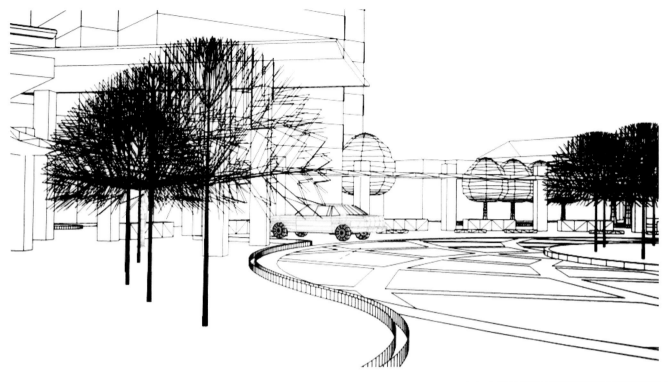

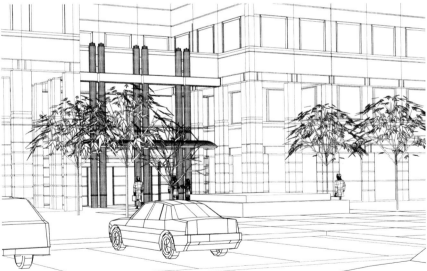

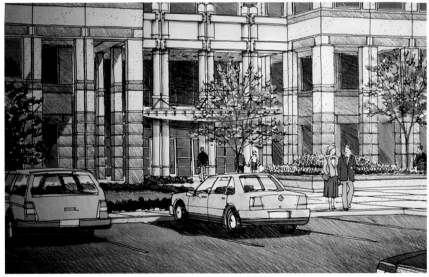

Fig. 4.103 Wire brush trees need to be modified. I caught an architect creating a drawing from this computer wireframe, and his trees were exact tracings of the ones in the wireframe. Not having the confidence to illustrate his own trees, he simply traced what was on the plot! Use computer trees for placement and scale, but don't trace them unless they more accurately represent specific tree species.

Fig. 4.104–4.105 Before-and-after cars and trees. This AutoCAD model accurately represented the exterior site elements in proper scale and location. The final drawing developed a more realistic tree type, but kept the cars and people as they were placed in the computer model.

Fig. 4.105

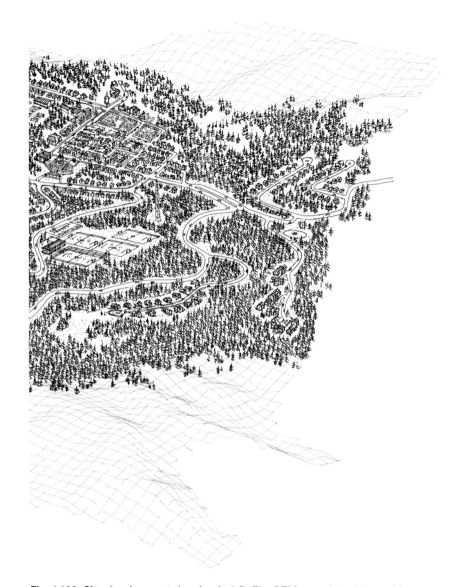

Fig. 4.107–4.108 Perspective view in AutoCAD. The map file of Gunnison, Colorado was given to the planning team by city staff. The file was brought into AutoCAD and adjusted in perspective view. The image was saved and printed 11 x 17" on an office color printer. Several different growth scenario drawings were created on trace overlays with a permanent ink pen and Chartpak AD markers. Each overlay was then spray-mounted directly onto a base map and color-copied for the client presentation.

Fig. 4.106 Site development drawing in 3-D. The DTM was plotted in a grid pattern onto a sheet of Mylar. Portions of the drawing that were drawn over were erased with an electric eraser to avoid conflicting with the fine detail of the drawing. Because of the high-altitude view of the drawing, it is difficult to understand the terrain beneath the trees.

Fig. 4.108

Fig. 4.109–4.111 AutoCAD composite model. This conceptual site model was developed in an early site-planning workshop for a new campus. The topographic information was created as a Digital Terrain Model, and the crude buildings were simple forms with assigned "z" elevations. The same model was viewed from a low angle (Fig. 4.111) and used to generate quick study drawings for the campus buildings (Fig. 4.110). The drawings were created with pencil on vellum and colored on the reverse side with Chartpak AD markers. *Computer model by Trent Cito.*

Site Modeling with Computers

The drawings on these pages illustrate the great value of a computer when drawing physical terrain. An AutoCAD Digital Terrain Model (DTM) will represent actual topographic site elevations in three dimensions. Terrain modeling may not be as evident when the drawing is an aerial perspective (Fig. 4.106) but shows well as low-angle site drawings (Fig. 4.110).

Fig. 4.110 **Fig. 4.111**

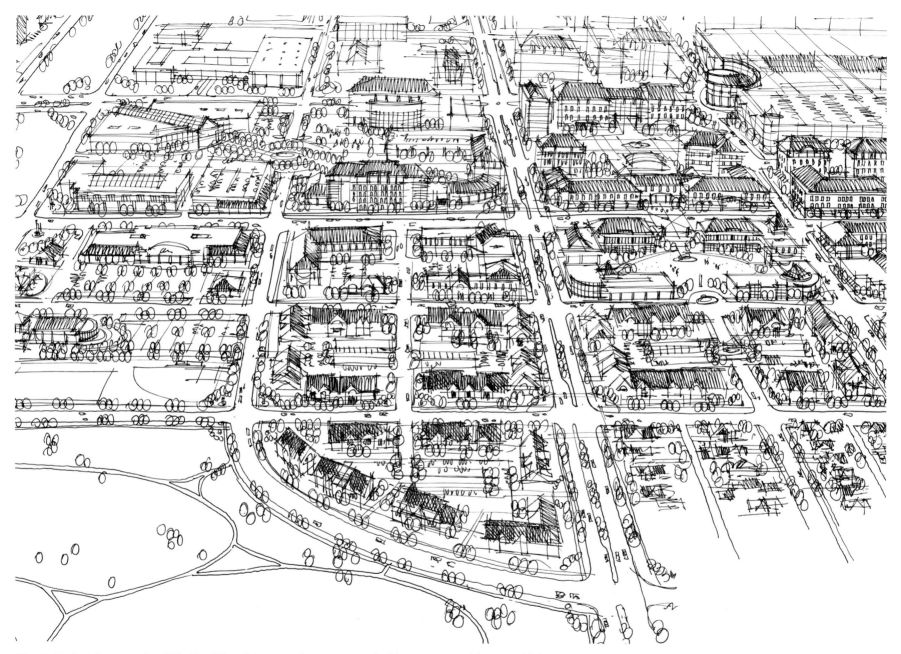

Fig. 4.113 Aerial perspective. This 23 x 38" aerial perspective was created with a permanent ink pen on Mylar. An aerial photograph was taken of the site, scanned and enlarged with Photoshop, and plotted at 24 x 40" (Fig.2.46). The image was constructed in red pencil and finally traced onto Mylar. Another option for generating an aerial perspective is to modify a site plan using a computer (Fig.4.112).

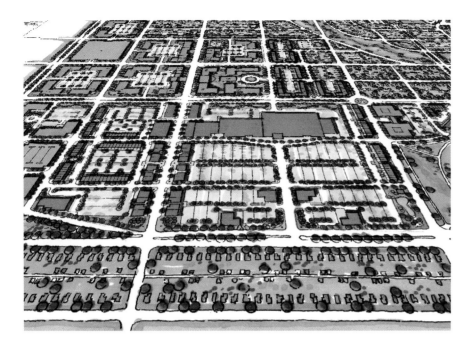

Fig. 4.112 Manipulating an image with a computer. The site plan was scanned and saved as 250 dpi file. Imported into Photoshop, the image area was selected and modified using the transform and perspective tools. This is a rapid method of changing a site plan into a perspective using a computer. Another option is to photograph the site plan from an angle, as was done with Fig. 4.43.

Computer Drawing Versus Hand Drawing

Sophisticated computer equipment makes it possible for a skilled technician to present fully animated "walk-throughs" within 24 hours. Computer renderings and animations can be extremely useful in communicating dynamic site characteristics and building design ideas. On the other hand, drawings made with nothing more than pens, markers, and tracing paper can have equal success in communicating design ideas. Whether you create drawings by hand or by computer is a matter of available time, your computer skill or drawing ability, access to equipment and materials, and common sense in selecting what will best communicate your ideas. If you can operate in both worlds, you'll be far ahead of the crowd.

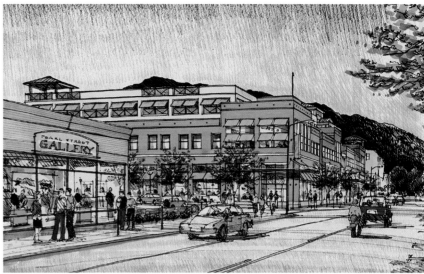

Fig. 4.114 Composite photograph and computer image. The street-level view was photographed with 35mm slide film. The photograph was scanned and enlarged to 24 x 30". The proposed building was modeled in AutoCAD and manipulated to the exact perspective view as the photograph. Both images were then sized to match and used as a base for the final drawing. Because of the accuracy of photographic and computer images, the building seen in this drawing closely matched the building once it was constructed.

Fig. 4.115 Realistic computer model merged with a site photo. The city approval process for this maintenance facility required a photo-realistic computer model of the proposed building. Site photographs were taken and the AutoCAD model was rendered and assembled with the photograph in 3D Studio VIZ. Additional trees were inserted into the site with Photoshop. An 11 x 17" color plot was presented to the client. *Computer model by Trent Cito.*

Computer Manipulation and Hand Drawing Combined

There are few limits to the ways one can speed up the visualization process when challenged with a lack of time. This competition drawing was one of four images generated practically overnight. What appears to be a watercol- or perspective in Fig. 4.119 actually has very little hand drawing on the image. It is mostly a photograph that has been heavily manipulated with a computer. The following steps describe the visualization process.

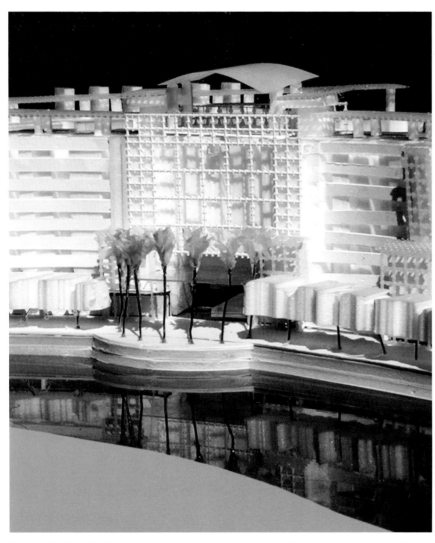

Fig. 4.116 Step 1: Digital photograph of a study model. The foam core and plastic model was photographed in black and white from many different angles with a high-resolution digital camera. The images were burned onto a CD. Trees were carved from foam blocks and the building exterior was fabricated with plastic grids and layers of cardboard.

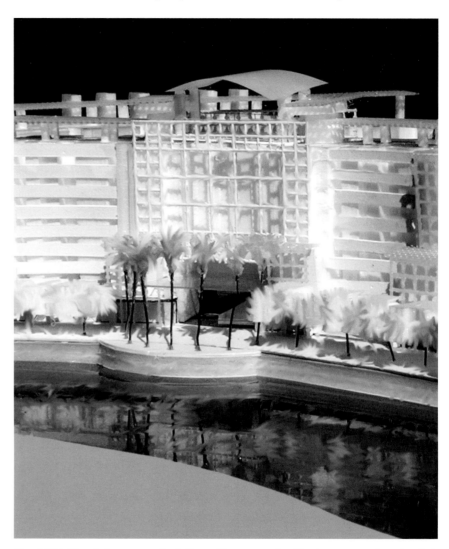

Fig. 4.117 Step 2: Image manipulation with a computer. The image was downloaded into the computer and brought into Photoshop. With the smudge tool, all of the trees were smudged to give a more leaflike appearance to the canopies. The water surface was also smudged to create a ripple effect. The eraser tool was used throughout the photograph to clean up the imperfections of the plastic grid used on the building exterior. Even some of the crooked balconies were straightened.

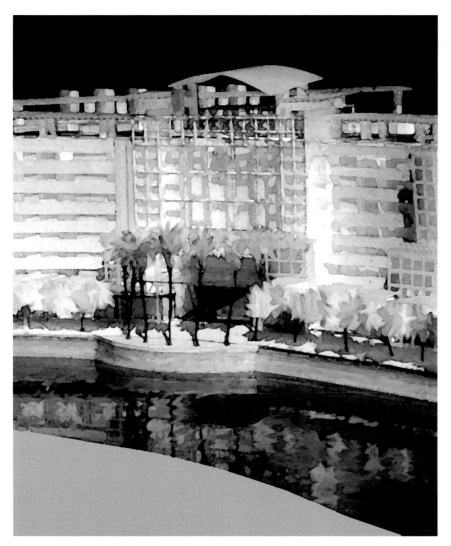

Fig. 4.118 Step 3: Image filtering and sepia tone. A Photoshop watercolor filter was applied several times to the image and gave the photograph an appearance of having been painted. A sepia tone was added to the image, giving it a warm color.

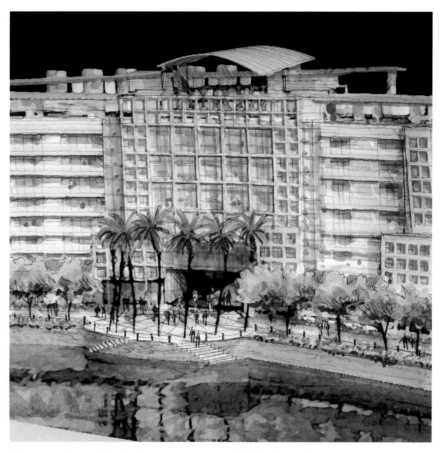

Fig. 4.119 Step 4: Final color and elements added by hand. The manipulated image was finally saved and printed 20 x 30" in color on a large-format plotter. The paper was coated with a surface that accepted pencil and markers. Chartpak AD markers were applied directly to the plotted image for overall color. People, paving patterns, steps, and flowerbeds were then illustrated with a black graphite pencil.

Next Generation of Hand Drawing/Computer Visualization

The computer industry has always tried to imitate hand drawing. Filters can simulate charcoal strokes, pen-and-ink stippling, and even watercolor brush strokes. Your challenge is to stay tuned with computer technology and the rapid advances of visually oriented software. There is every reason to imagine the gap narrowing between drawing by hand and drawing with a computer. New touch screens are already enabling designers to electronically sketch directly on-screen (Fig. 4.120). Some computer drawings are so cloaked that it is nearly impossible to tell the difference between a real hand drawing and a computer-generated image (Fig. 4.122).

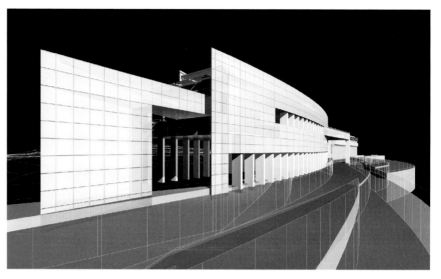

Fig. 4.120

Fig. 4.121–4.122 Computer model transformed into a drawing. This building model was created as a basic rendering in Form Z. The image file was brought into Photoshop, modified, and then brought into Fractal Painter software program and rendered on a dual screen with the brush tool. All of the "pencil lines" were created by actual hand strokes from the pen stylus of the computer. Pressure applied to the stylus pen controlled light and dark tones. The final image appears to be an actual pencil drawing! *Computer model and rendering by Larry Doane.*

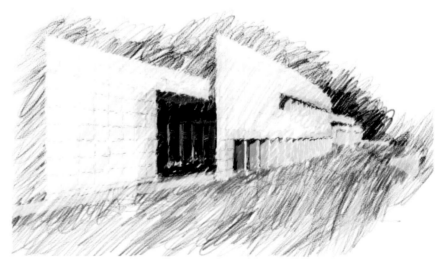

Fig. 4.122

QuickTips *Computers*

- When enlarging a photograph to trace over for a drawing, you can reproduce more detail by scanning the image and enlarging it with a computer than by enlarging the photograph with a standard copier.

- Add people, cars, and trees to computer wireframes to ensure proper sizing of those elements when you create drawings from computer-generated information. It is easy to misjudge the scale of these objects without some visual reference.

- If you rely on other designers to generate computer wireframes, work closely with them to select the exact view for a perspective drawing. Save and print several options for review.

- Save all computer wireframes and renderings in a file to use for future reference and presentation.

- It is easy to commit large amounts of time creating computer models. If you are building a model for the specific purpose of tracing it for a drawing, simplify the computer model and show just enough information to have accuracy and proper scale. Try not to consume too much time generating information not necessary for the drawing process.

- In 3D Studio VIZ, when setting up cameras to show tall buildings, avoid the parallax phenomenon by placing the camera and its target at the same height. Use a wide field of view. Render with the Blow-Up option to clip out all the extra foreground space.

- In 3D Studio VIZ, use a matte/shadow material type applied to a plane for the base of a model to avoid showing the "edge of the world" effect when the edge of the plane appears in the rendering. Essentially, your model casts shadows onto clean space. Your brain then converts the appearance of shadow into what it perceives is an infinitely large surface. You can also use this technique with an alpha channel to paste your rendering into a photograph and have it cast shadows in the photographed surroundings.

- Plot computer wireframes at 11 x 17" or smaller to avoid making oversized drawings. Only plot at a larger size if the amount of detail in the design dictates that the drawing be created at a larger format.

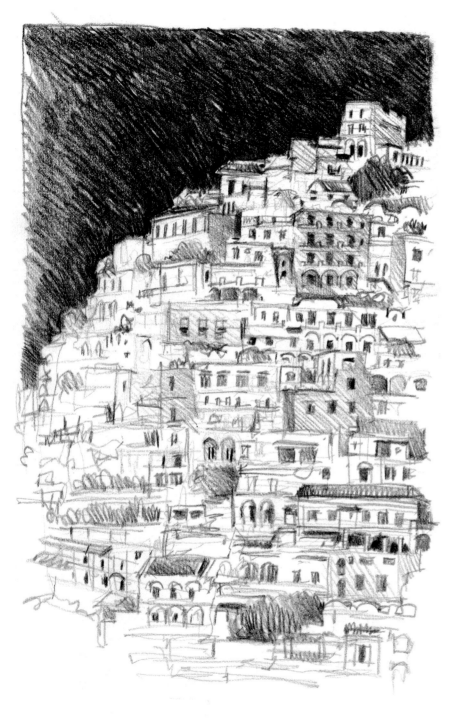

5

TOOLS OF THE TRADE

It's fine to have favorites, but don't think that one pencil or pen will work in every drawing situation. One drawing might be made on Mylar so that mistakes can easily be erased, while another is drawn on vellum and colored directly with marker. This chapter covers some of the basic options. To find your own comfort zone with drawing tools and materials, you'll need to experiment with different brands in different situations.

Fig. 5.1 Field test of a new pencil.
This drawing of an Italian resort was an experiment using a nontraditional wood pencil. The Staedtler Mars Dynagraph plastic lead was developed for use on drafting films. The soft N1 lead worked well on the bond sketchbook paper and didn't smudge like a traditional graphite pencil. The gray tones and blacks are deep and rich.
7 x 10" pencil on bond paper.

> *"The will to succeed
> is important,
> but what's even
> more important
> is the will to prepare."*
> ~ *Bobby Knight*

Finding the Right Pencil

Most of the pencils we draw with are found in three typical categories: fixed lead in a wooden housing, reusable mechanical housing with interchangeable leads, and throwaway mechanical housing with leads. Lead is a generic term for the actual material that lays down the line. Leads can be graphite-based, plastic-based, or even a mix of graphite and plastic. They come in different colors and ranges of hardness, from soft HB leads to superhard 6H leads.

The drawing surface is a factor in how a pencil will perform. Certain pencil types won't be at all effective on paper, yet perform miracles on Mylar. Other pencils have great action on vellum but are much too difficult to use with bond paper. Know the differences! Get hold of several different pencil types and lead densities and try them out on bond paper, tracing paper, vellum, and Mylar.

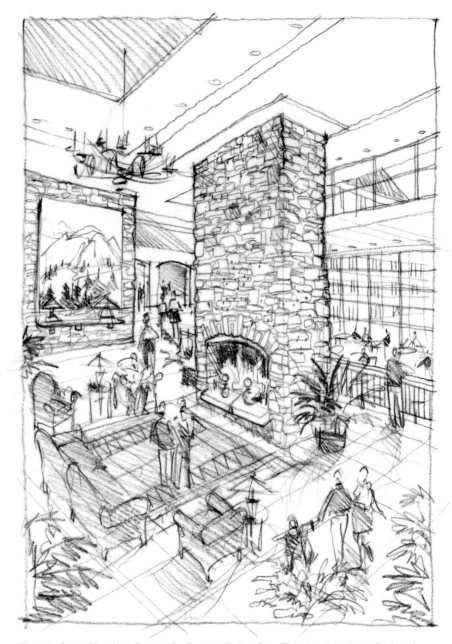

Fig. 5.2 Casual looking linework of a pencil drawing. This interior view of a hotel lobby has a very soft appearance as the pencil linework varies from fine lines of the floor, heavy outlines at the edges of objects, and gray tones of the furniture. Imagine how different this drawing might appear if it were drawn with an ink pen. 7 x 10" plastic lead pencil on vellum.

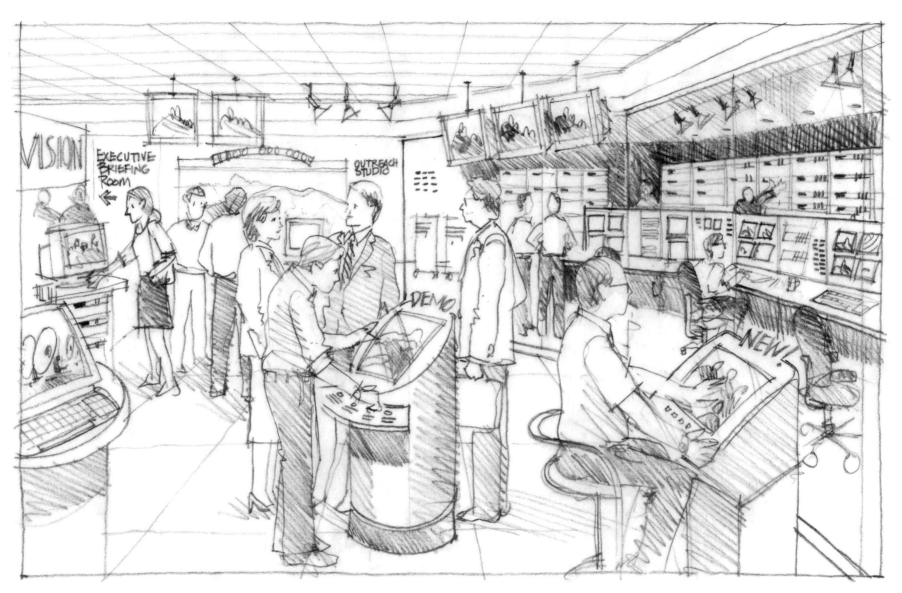

Fig. 5.3 Lines and tones with a single pencil. This 7 x 11" pencil drawing has a completed look without the addition of color. Pencil allows for varied gray tones in shaded areas, while still having crisp lines on the floor and ceiling. Traditional wooden pencil with an HB graphite lead on vellum.

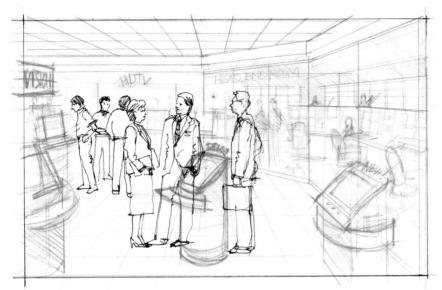

Fig. 5.4 Red pencil mock-up with traced people. The one-point perspective of this interior room was drawn with a Sanford Col-erase wooden pencil. Red lines are easy to see beneath a second sheet of vellum as the final black pencil drawing is completed. People were carefully traced in ink from an entourage file. 7 x 11" on trace.

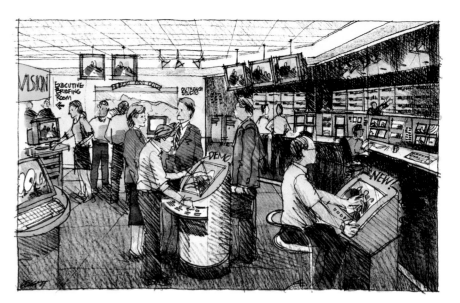

Fig. 5.5 Colored pencil and markers add texture. The pencil drawing (Fig. 5.3) was digitally printed on presentation-weight bond paper and colored with Chartpak AD markers. Additional texture to the carpet and skin tones was added with Prismacolor pencils. Black colored-pencil shading to the right side of the drawing emphasizes different lighting in the adjacent video production room.

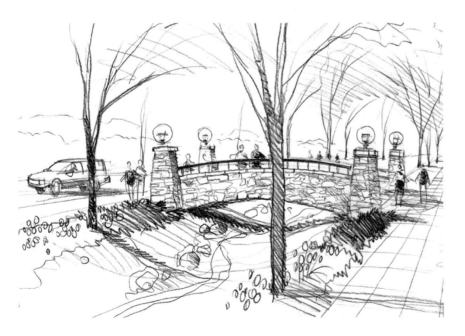

Fig. 5.6 Pencil adds a spontaneous character. Although this 14 x 19" drawing was traced over a redline mock-up, the casual pencil linework of the trees and stone bridge give the drawing a look as if it were drawn on site with a sketchbook. Soft N1 plastic lead pencil on vellum.

Variations of Pencil Drawings

All of the pencil drawings in this book were done on trace, vellum, or bond paper. Graphite tends to smudge if it is drawn with deep tones, the leads are soft, and you are heavy-handed. Avoid smearing the graphite by simply having a slip-sheet of trace between your hand and the completed portions of the drawing. Pencil drawings can be protected with light spray fixative coating applied in a properly ventilated room.

Fig. 5.7 Pushing the limit of black pencil tones. This drawing was lightly blocked out from a projected slide and then drawn with a heavy hand and a very soft pencil. The results show great variations in contrast and bold outlines. 8 x 11" Berol Draughting 314 wood pencil on illustration board, coated with spray fixative.

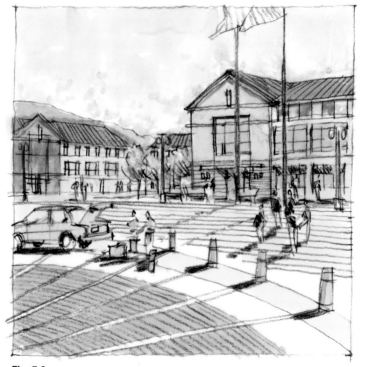

Fig. 5.8–5.9 Quick character studies in pencil. These drawings have a soft and sketchlike quality that shows very little detail about the architecture. Intended only to reflect the general massing and character of the exterior spaces, using a soft pencil on vellum with a light wash of AD Chartpak marker color on the reverse side captured the ambiance of the campus. 6 x 6" soft N1 plastic lead pencil on vellum with Chartpak AD marker color on the reverse side.

Fig. 5.9

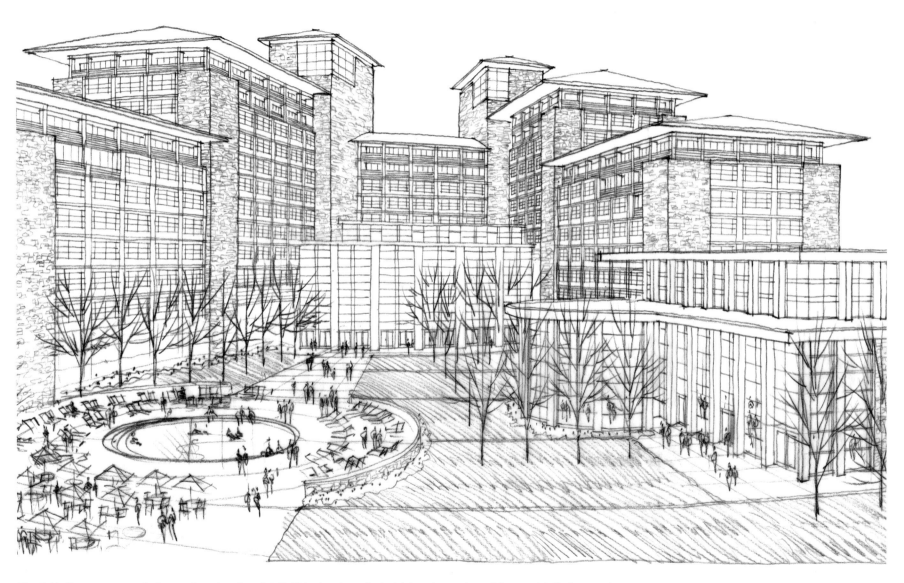

Fig. 5.10 Keep your pencil sharp when drawing detail. This drawing of a hotel facade was traced from a detailed computer wireframe. Because of the amount of detail and stone texture, a hard pencil lead was selected. An electric pencil sharpener is an invaluable tool for working in this level of detail. A drawing of this size and complexity can easily consume half the length of a wood pencil. Color was later added to create shadows and tone. 11 x 22" hard N3 plastic lead pencil on vellum.

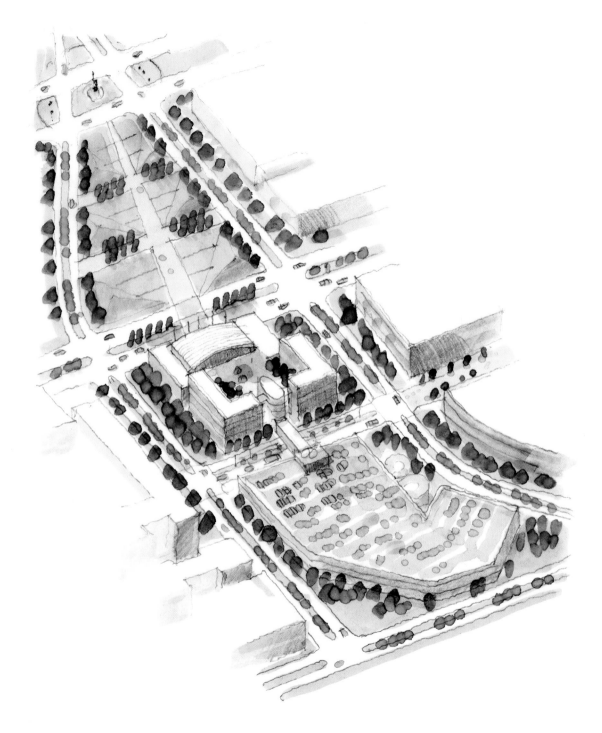

Fig. 5.11 Watercolor effect with pencil and markers. This 8 x 10" aerial perspective was drawn with a soft plastic lead pencil on vellum with very minimal detail and tone. All of the trees and top deck of the parking structure were added with color markers. Chartpak AD markers were applied to the pencil side of the vellum and modeled to give the appearance of a watercolor painting. This technique is very effective when the drawing is no larger than 8 x 10".

Fig. 5.12 Black-and-white pencil study of an interior space. A soft graphite pencil drawing can have a relaxed, sketchlike character. Lines are not perfectly straight and the range of tones is kept minimal. It is important to keep the pencil sharpened to prevent inconsistent thickness of the lines. This drawing was intended as a quick design study and was traced over a redline mock-up of the space. 10½ x 16" pencil on trace.

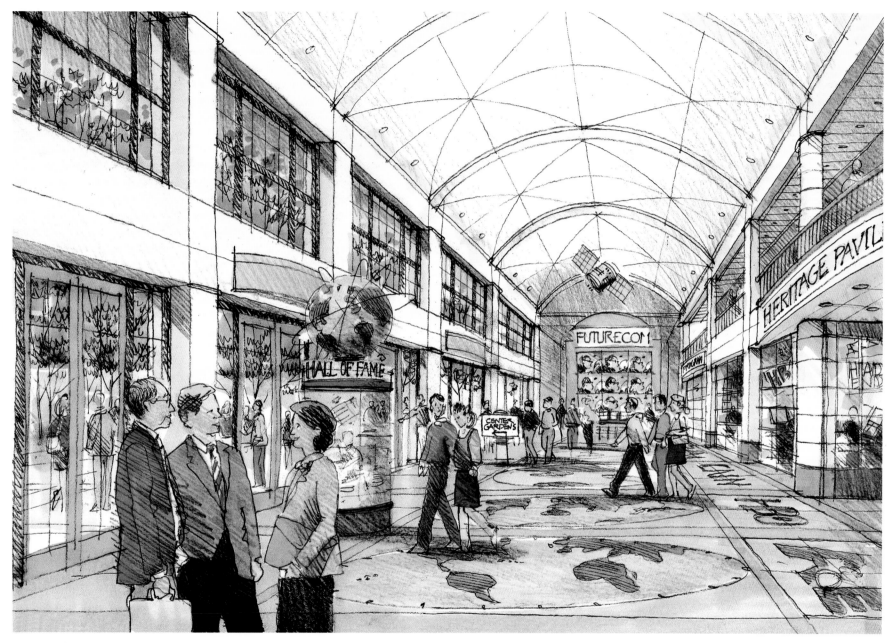

Fig. 5.13 Simple combination of pencil and marker. Many of the colored drawings in this book combine ink line drawings with markers and colored pencil. This interior one-point perspective blends pencil linework and colored pencils for texture and informality. Color markers give color to large surface areas of the drawing. 16 x 16" soft graphite pencil on vellum. Chartpak AD markers and Prismacolor pencils on an OCE digital print.

Work Safely

The drawing materials mentioned in this book offer no danger to your health, with the exception of the ones listed below. Much research has been undertaken to identify harmful chemicals and substances in art materials. In 1988, Congress passed the Labelling of Hazardous Art Materials Act, requiring that labels on all manufactured art materials identify the effects of chemicals used in their products. Art materials are now carefully inspected and monitored for their effects on children, adults, and the elderly.

Be aware of what's in the products you use. Read the labels, understand the possible risks in using the products, and be sensitive to other people who are sharing your studio space. Pay attention to powerful words on product labels, such as *Caution, Danger, Poison,* and *Warning.* The following list includes some of the common drawing tools and art products that have health effects associated with them.

Graphite and chalk dust are bad for your lungs. When working with soft graphite pencils and pastels, use a fan in a well-ventilated room that will blow the dust away from you, toward an exhaust system.

Spray fixatives contain about 2 percent resins or plastics and 98 percent solvents, usually flammable and toxic. Aerosol sprays are the most common. A spray booth that filters and exhausts the fumes directly outside is recommended. Alternatives include spraying outdoors or spraying indoors with windows open, then leaving the building and returning only when your work has dried and the odors are gone.

Solvent-based or permanent markers are more hazardous than water-soluble markers. Permanent markers can contain toluene or xylene, which can cause drowsiness when inhaled over long periods. Use these markers in a well-ventilated room with an exhaust system. Avoid using permanent markers directly on skin. Alcohol-based permanent markers claim to be less harmful, but should also be used in well-ventilated spaces.

Adhesives, such as spray mount and rubber cement, contain chemicals that are dangerous to use. Always use these adhesives in a spray booth or well-ventilated room, or outside if possible. Safe alternatives to these products are hot waxers, which roll melted wax adhesive onto the back of your drawing, or adhesive sheets that act like thin, oversized double-stick tape.

Solvents are used as thinners and cleaners, the most common being turpentine or mineral spirits. They are flammable and highly volatile. They can cause severe respiratory problems and irritate eyes and skin. Use them and store them with caution, always in a well-ventilated space, or outside.

Evolution of a Single Library Drawing

Fig. 5.14 Step 1: Conceptual thumbnail drawing of library. This "first look" at an idea about a library and archive center roughly identifies workstations surrounded by glass-enclosed rooms. The 5-minute drawing was from a series of thumbnail sketches visualizing different program areas within a large museum. 7 x 9" felt-tip pen on bond paper.

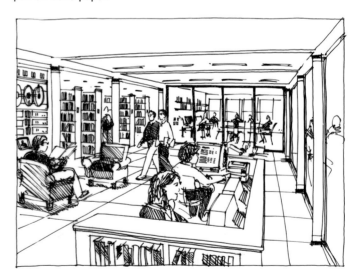

Fig. 5.15 Step 2: Rejected ink line drawing. Traced over a redline mock-up, this ink line drawing clearly identifies those elements sketched in Fig. 5.14. Soft furniture and people were added to the drawing, but for the most part, it is identical to the original conceptual thumbnail drawing. 7 x 9" permanent ink pen on Mylar. This drawing was eventually rejected when the library floor plan and program uses changed.

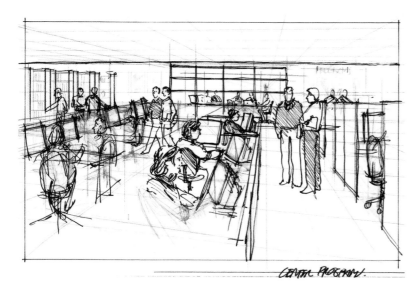

Fig. 5.16 Step 3: Ink and red pencil mock-up of revised library. The enlarged library plan added open workstations and partitions, which required the drawing to stretch horizontally to fit the new elements. This redline mock-up traces a few of the people from Fig. 5.15 and blocks out additional people and the new furniture elements. 7 x 11½" ink and red pencil on vellum.

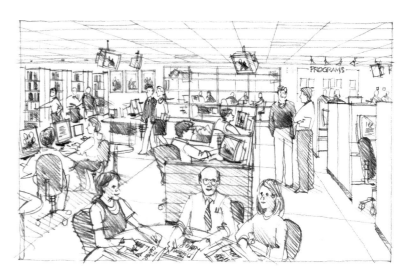

Fig. 5.18 Step 5: Final pencil drawing. This final version of the library drawing was quickly traced from the earlier version (Fig. 5.17) with more people and an informal worktable in the foreground. Television monitors were added to the ceiling. This drawing incorporated all of the floor plan revisions and was finally approved by the design team. 7 x 11½" soft graphite pencil on vellum.

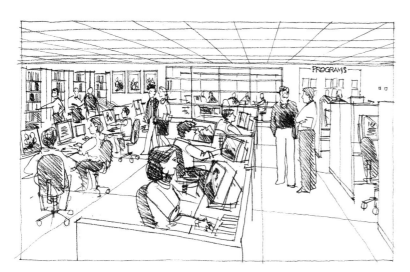

Fig. 5.17 Step 4: Rejected pencil drawing. Again traced over the redline mock-up (Fig. 5.16), this final library drawing was created in pencil to give a more casual appearance than the previous ink version. As with the earlier version of the library plan, this drawing was rejected in favor of a plan with fewer formal workstations and more informal workspaces. 7 x 11½" soft graphite pencil on vellum.

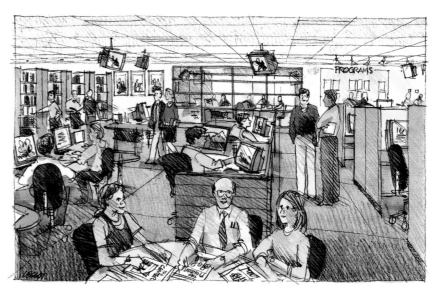

Fig. 5.19 Step 6: Final color drawing of library. The final approved pencil drawing was digitally printed on presentation-weight bond paper and colored with Chartpak AD markers and Prismacolor pencils. Other drawings in the same series are shown in Figs. 2.10, 5.3, 5.13, and 5.33.

The Versatile Ink Pen

Pens are drawing and writing tools that use ink, either waterproof or water soluble. The ink flows from the pen to your paper through a fibrous material (felt-tip pen), plastic nib (hard-point pen), metal blades (fountain pen), metal tube with a wire plunger (mechanical drafting pen), or a roller ball (ballpoint pen). There are even erasable ballpoint pens, with time-delayed drying time that lets you rework your mistakes.

Most designers use ink pens for most of their drawings. Depending on the drawing surface, you can use waterproof or water-based ink pens. On Mylar, lines tend to smudge with water-soluble inks. You can use water-based ink on tracing paper if you'll be using solvent-based markers to color the drawing, because the combination of water-based linework and solvent-based color keeps the ink lines from bleeding.

Drawings created with ink lines are very easy to reproduce using standard copiers, diazo machines, scanners, and digital copiers. They can withstand great reductions without losing quality. People often hesitate to draw with ink, because they think they can't erase it if they make a mistake. That's true on paper, but ink lines on Mylar can be easily erased and redrawn, making waterproof ink on Mylar a great combination.

Fig. 5.20 Water-based felt-tip pen on vellum. This 8 x 8" drawing was created with a Pentel Sign Pen on trace. The medium size of the pen point is ideal for quick sketches with minimal detail. When pens get older and drier, they are effective for adding light gray tones to a drawing. Always have new and old pens at hand to use on drawings for variations to the lines and tones.

Choose a Marker and Stay with It

Markers are pens with fibrous tips that come in many different colors and point sizes. Again, there are water-based markers and solvent-based markers. Some solvent-based markers are under attack because of toxic fumes, but the industry is responding by adjusting ink formulas. Marking pens come in a variety of point shapes and sizes. They can be round or square, and range from a superfine to a ½" line.

Colored markers are available at office supply and art supply stores. You'll be amazed at the variety of types and colors. Some have interchangeable nibs, others come with a fine tip at one end and a broad tip on the other. Try out different marker brands and find out what other designers are using. Once you're comfortable with a specific marker, keep using and replacing that same brand. Chapter 6 will explore color markers and their various applications in drawings.

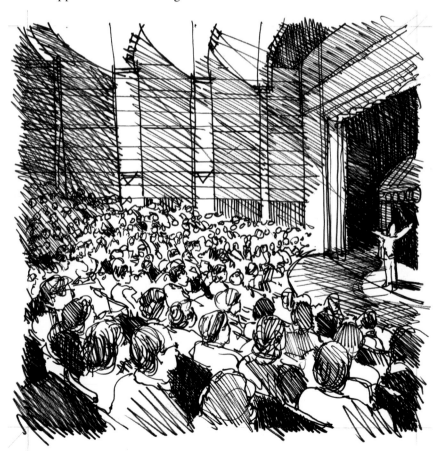

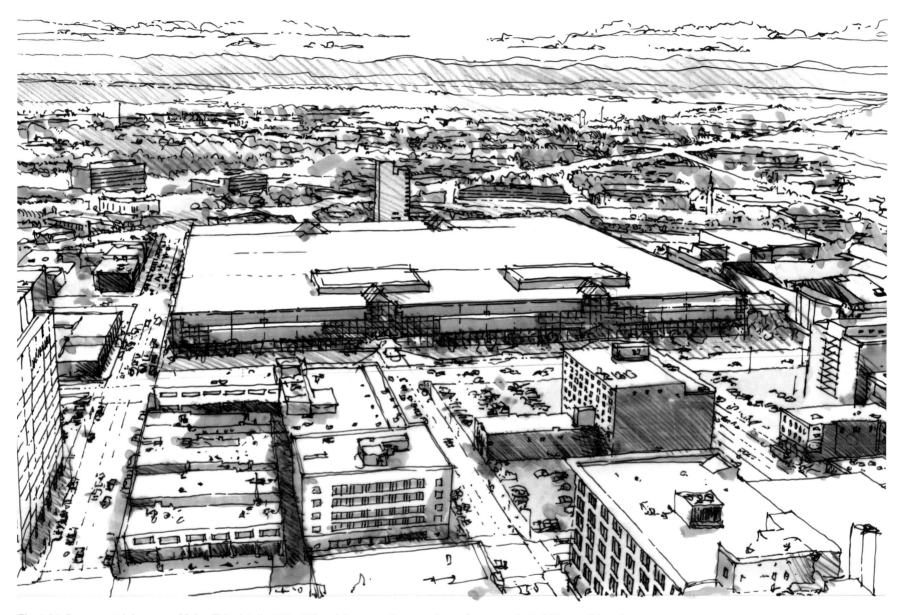

Fig. 5.21 Permanent ink pen on Mylar. This detailed 12 x 18" aerial perspective was drawn from a projected 35mm slide using a Staedtler Lumocolor 318 permanent ink pen on Mylar. The fine point and fast drying characteristics of this pen are effective when quickly drawing fine detail. A wash of gray colored marker on the back side of the Mylar added tone. Graphite pencil hatching in the shadowed areas gave texture to the drawing.

Paper, Vellum, and Mylar

Purchasing Paper

Drawing papers can be purchased in precut sheets, pads, and rolls. There are three general categories of drawing paper: opaque papers, vellum and tracing papers, and Mylar and other synthetic drawing surfaces.

Opaque Drawing Papers

Opaque papers have a wide range of quality, colors, and finishes. Visit an art supply store and study the varieties of papers. On the low end, you'll discover newsprint and brown wrapping paper. High-end papers include the handmade watercolor papers. In the middle range you'll find general-purpose Bristol and bond papers. Try some of them with different pencils and pens and discover which papers work with your drawing style.

Diazo bond papers have light-sensitive coatings, which reproduce linework when exposed to ultraviolet light and developed in a commercial diazo machine. Diazo papers are made to produce blue, brown, or black lines, and come in different weights. With the introduction of sophisticated scanners and computer-based reprographic technology, the new digital machines are quickly replacing the diazo process. Within a few years, diazo reprographics will no longer exist.

Papers available for digital reprographics are currently limited to standard-weight bond, velum, and a heavier 30-lb presentation paper.

Fig. 5.22 Store your drawings away from direct sunlight. Certain ink pens are not formulated to withstand the bleaching effects of ultraviolet exposure from the sun. Newer pens have been improved to remain lightfast or fade-resistant in sunlight. This 19 x 32" ink on Mylar drawing was rolled up and unfortunately stored near direct sunlight. Whether you use UV-rated pens or not, it is always wise to keep your original drawings filed in lightproof locations away from direct sun.

Fig. 5.23–5.24 Severe ultraviolet damage. The original 8¹/₂" x 11" ink on Mylar artwork was hanging for a few years in a well-lit room. UV damage has practically erased some of the lines. A record copy of the original shows the extent of the damage.

Fig. 5.25 Damage from ink bleeding. Designers often use the Sanford Sharpie pen for sketches. The heavy outlines around this house were drawn with a Sharpie. Oils in the ink from the pen have bled far beyond the linework and have stained the vellum. Finer linework was drawn with a different ink pen and was not affected.

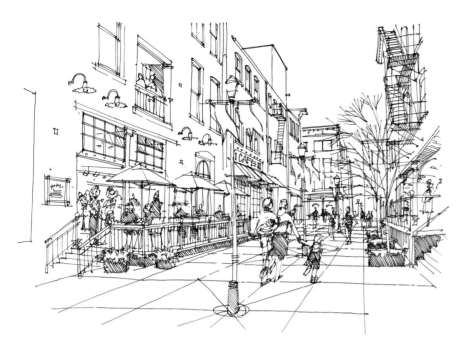

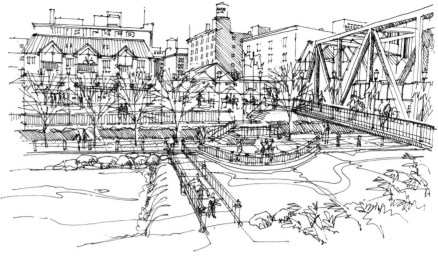

Fig. 5.28

Fig. 5.26–5.29 **Ink drawings on bond paper.** This series of 11 x 17" drawings were all drawn with the same permanent ink pen on precut sheets of standard sketchbook paper. Each drawing was based on a projected 35mm slide with existing and new elements drawn lightly with a graphite pencil. Ink was drawn directly over the pencil lines, which were eventually erased. White correction fluid was applied to correct any minor mistakes in the linework.

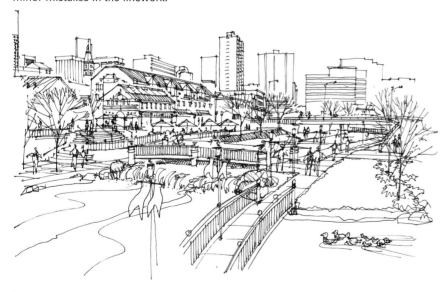

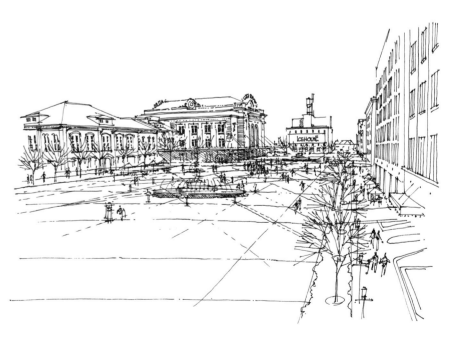

Fig. 5.27

Fig. 5.29

Fig. 5.30 Experiment with different drawing techniques on Mylar. This 7 x 9½" drawing is a series of images depicting a North African theme. The drawings were outlined with a permanent ink pen on 3-mil single-matte Mylar. Tone and texture were added with a soft graphite pencil. The characteristics of drawing with pencil on a Mylar surface are very different from drawing on paper.

Vellum and Tracing Papers

There are two basic weights of translucent drawing paper. The lighter-weight paper is often referred to as "tracing paper," "trace," "skinny," or "bumwad." It usually comes in white or yellow, and is most often sold in rolls. The heavier-weight tracing paper is called "vellum," and is much more durable to draw on and reproduce. Vellum is commonly sold in sheets and pads, but can also be found in rolls. The great benefit of drawing on semi-transparent papers is that you can trace through them, and still get a high-quality print of your drawing if you use the diazo reproduction process. Most of the 11 x 17" or smaller drawings in this book were produced on either trace or vellum. Larger, more time-consuming drawings are usually made on Mylar.

Mylar

Mylar is a very durable and waterproof synthetic drawing material. Developed as a stable media for technical drawing, it comes in different thicknesses, and has either a glossy or matte finish. The most common transparent Mylar is single-matte with a thickness of 3 mils. The great benefit of drawing on Mylar is that ink lines can be easily erased and redrawn, which is not true of opaque paper or tracing paper. Since no drawing is goof-proof or immune to design changes, you'll save time and agony by using Mylar. Tracing onto Mylar over a photograph or drawing mock-up is much easier than tracing on vellum, because Mylar tends to be far more transparent than paper. Purchase Mylar in rolls or precut sheets at your art supply store or where engineering supplies are sold.

Fig. 5.31 Series of Mylar drawings. This collection of 8 x 10" architectural studies were all drawn on 3-mil double-matte Mylar. Major drawing mistakes can be erased using an electric eraser, and scraping the ink from the Mylar surface using an X-acto knife can repair minor mistakes.

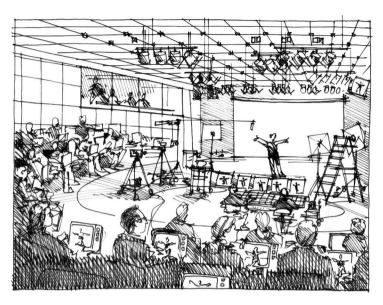

Fig. 5.32–5.33 Comparing an ink drawing with a pencil drawing. This pair of drawings represents different looks for the same production studio. Figure 5.32 was drawn with permanent ink pen on 3-mil double-matte Mylar. All of the tone was created with overlapping diagonal hatching. This drawing could easily be reduced without any loss of detail. Figure 5.33 was drawn with a soft graphite pencil on vellum. Both drawings are approximately the same size. Compare the differences in line-work, tone, and character in the two drawings and try your own experiment with different drawing materials.

Fig. 5.33

Files and Charts

Drawing source files—compiled by you—and *commercial tracing books*—or entourage books—are going to be among your best friends. Have you ever struggled to draw a person or a car from your imagination? Tracing books are filled with people, cars, and trees, placed in different positions and proportions, which you can use to modify and trace into your drawings. Be aware that some of these books may have outdated images, and be creative, because these source books are intended to be used for reference and not as clip-art. Your own files may be your best references, since you will have compiled them yourself to meet your drawing needs.

Have you ever laid out a complicated perspective, and then wondered if it was accurate? Lawson Perspective Charts are among the commercially available *drawing aids* that may be helpful to you. The instructions are simple to follow, and you can easily generate a quick perspective for simple drawing projects. These charts are an easy place to start, but be aware that they are limited in their viewing angles. You will probably find yourself using the other methods described in this book more often than commercial drawing aids.

Drawing People

Drawing people can be one of the most intimidating aspects of the drawing process. In addition to worrying about correctly sizing them for the drawing, decisions are made on what they wear, what they are doing, mixing genders, adding children and pets, and the greatest challenge—what their faces look like! A straightforward approach to successfully drawing people is to think in terms of three primary approaches: drawing them from imagination, tracing them from photographs, and tracing them from entourage files. You can generate people from computer programs and trace them as well.

Fig. 5.34 Drawing people from imagination. The quickest approach to drawing people is from memory. When the drawing is small, people can be "massed" with simple circular shapes for heads and bodies. As people are placed more in the foreground, you can begin tracing them from entourage files. A rule of thumb is to trace people taller than 1½" on your drawing. Any persons smaller in size should be drawn freehand. 6 x 9" permanent ink on vellum.

Fig. 5.35 Drawing people from photographs. In some cases, people can be traced from photography. This is especially worthwhile for drawing faces. Be sure to modify the image in a way that customizes the image according to the theme of your drawing. This example shows how a base photograph is traced and modified using an overlay sheet of Mylar and a permanent ink pen.

Fig. 5.36 **Drawing people from entourage files.** The challenge is not to copy the people exactly as they have been drawn, but to modify them to fit the theme of your drawing. This example shows a stepped approach to tracing an existing image from the entourage book and altering the clothes and arm positions.

Fig. 5.38–5.39 **Collect people images from magazines, brochures, and newspapers.** Start a "people image file" and collect images of people from all possible sources that can be used to trace. The photograph in the upper right corner was used in Fig. 5.20. The photograph in the bottom center was traced and modified for the drawing in Fig. 5.39.

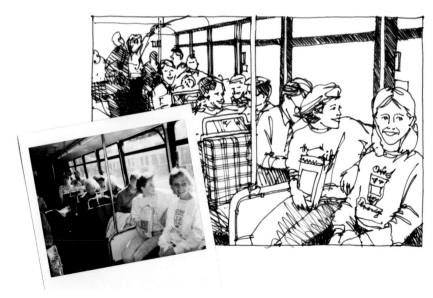

Fig. 5.37 **Photograph your subjects and draw from the pictures.** The drawing of this transit scene was done from a Polaroid photograph taken during a bus ride. Not only did the picture capture an accurate perspective of the bus interior, it also showed face detail that could easily be traced. 5 x 7 1/2" permanent ink on Mylar.

Fig. 5.39

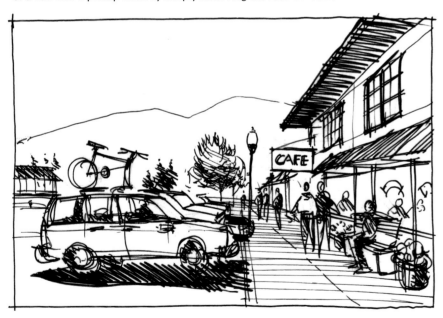

Fig. 5.40 Drawing cars from brochures and advertisements. Try tracing a car from a photograph you find in a magazine. This drawing is a direct trace on Mylar with a permanent ink pen. People and the ski rack were added to the drawing. Tracing can give you practice with drawing different elements of the car. Try changing the body of a van into a pickup truck by simply removing the rear windows.

Fig. 5.41 Drawing cars from imagination. Using shapes similar to a van and a sports utility vehicle (SUV), this drawing captured the general massing of a 4-door "all purpose" vehicle. The bike and rack help give the car added interest. 6 x 9" felt-tip pen on trace.

Drawing Cars

Sources for cars are the same as for people: imagination, photographs, entourage books, and computer-generated images. Cars are difficult to draw in perspective and can often be drawn with inaccurate proportions and angles. If in doubt, take a photograph of cars that can be used as a reference or traced from. Remember to update your cars if you are tracing them from an older entourage file. Great examples of cars can be gathered for free at local auto dealerships and car shows.

Fig. 5.42 Photograph cars in the same perspective as your drawing. If you have the option of determining the perspective of your drawing, take a photograph of a street scene with cars and create the drawing from the original photo. The cars will look believable and will be accurately proportioned. 5 x 7½" permanent ink on Mylar traced from an enlarged Polaroid photograph.

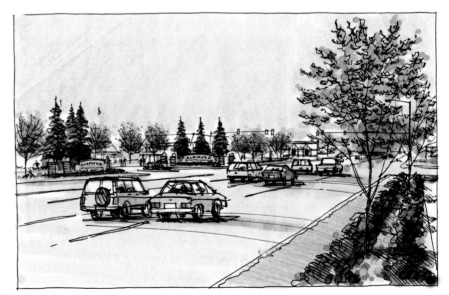

Fig. 5.43 Drawing simple car types. If you can draw three basic car types, you'll be able to repeat them throughout your drawings. This image shows sedans, SUVs, and pickup trucks. Learn these basic shapes and you won't need to worry about drawing any other types. Unless you are illustrating a specific use that requires inserting large trucks, transit vehicles, or special car types, this list will adequately cover most of your drawing needs.

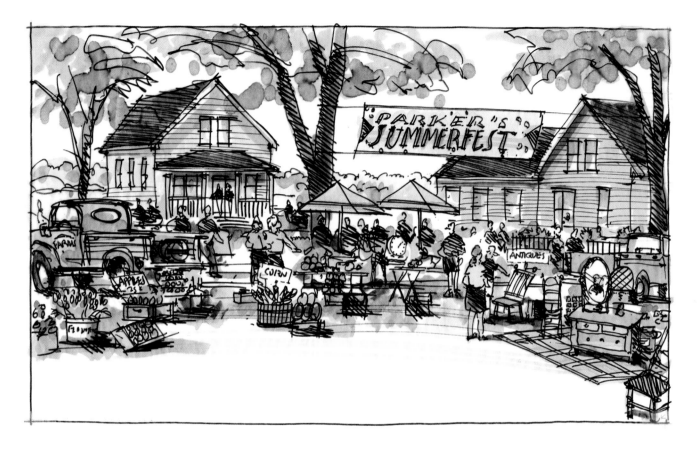

"The [person] who makes no mistakes does not usually make anything."

- Edward John Phelps

Fig. 5.44 Putting people, cars, and trees into a single drawing. This street scene, done from imagination, captures the theme of a farmers market. Most of the people are less than 2″ high and were drawn from imagination. The old truck, scale and antiques were all drawn to reinforce the nostalgic character of the scene. Even the houses and street trees have an old appearance. 10 x 16″ felt-tip pen on trace with Chartpak AD markers applied directly to the trace.

The Right Combination

Putting It All Together for Great Drawings

Finding drawing pens, pencils, and papers that fit your drawing style is an important first step. Next you need to know how to use them in the best combinations, and—especially—which combinations are disastrous. For example, permanent ink pen on Mylar is a great mix, because it avoids ink smearing, BUT water-based ink will smudge badly on Mylar. Vellum and soft pencil is a great combination for drawing lines that produce rich diazo or digital prints, BUT hard pencil will barely show up on vellum. Colored pencils work great to color in drawings that have been reproduced on a copier, BUT applying solvent-based markers to a copier print will melt the toner and smear the line drawing.

There's no perfect formula for combining materials and drawing tools, but there are lots of good basic principles:

• Learn to avoid the mistake of combining the wrong materials
• Get comfortable with some of the choices and practice them
• Keep source files
• Make and use your own sample boards
• Nine out of ten drawings are done on trace, vellum, or Mylar. Most drawings are done in ink. Color is applied with both colored pencils and markers, in a 50–50 split. Keep it simple, know your materials, and you'll make great drawings!

Drawing Trees

Landscaping is a critical element of any drawing. Figures 5.45 and 5.46 show a vacation home with and without landscaping. The drawings were done to illustrate where one should and shouldn't locate a house on the edge of a meadow. Grass, trees, shrubs, and general landscape elements are important for all drawings and can be drawn from imagination or traced from photographs or entourage files. Purchase a book on landscaping and it will have reference photographs of many trees and shrubs. Most of the drawings in this book have just three basic tree types: an evergreen, an ornamental tree, and a shade tree. Figure 5.47 clearly identifies the three types. The amount of detail you put into landscaping will depend on the distance of the tree and the time you have to produce the drawing. For example, leaves can take a long time to draw in ink. If you are short on time, draw only the branches and render the leaves with markers (Figs. 5.44 and 5.48).

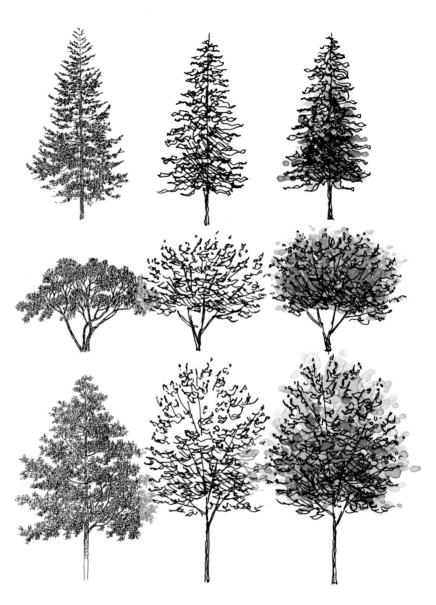

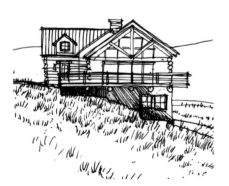

Fig. 5.45

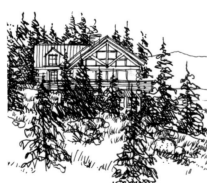

Fig. 5.46

Fig. 5.47 Evergreen, ornamental, and shade trees. These three basic tree types were derived from overly detailed entourage images on the left. The middle images were traced from the original trees with greatly simplified leaves and branches. Color was added with markers to increase the leaves and add more shadows. Yellow marker on the treetops highlights the sunlit leaves.

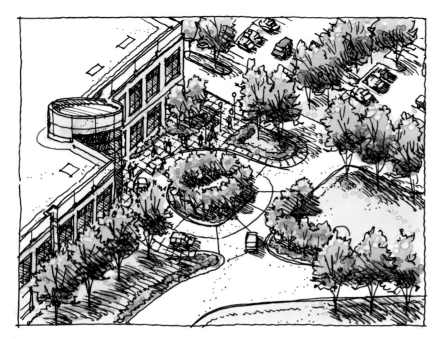

Fig. 5.48 Aerial view of trees and ground cover. This drawing was traced from a digital photograph taken of a site plan. Trees are drawn with a few lines representing the trunk and a single outline representing the leaf canopy. Multiple colors of markers create the leaves and shadows. Ground cover was drawn with two lines, filled with dark green color. Be sure to put shadows beneath all landscape elements. 6 x 8" permanent ink pen on trace with Chartpak AD markers on both sides of the trace.

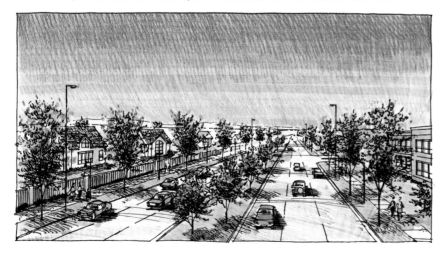

Fig. 5.50 Size and spacing of street trees. The trees in this drawing are spaced down the street so that the homes between them can be seen. Carefully locate street trees so that the objects beyond them can be seen. The tree height should be accurate enough to give a realistic idea of the age of the street. Drawing tall, mature trees in a view of a new development is unrealistic. 7½ x 14" permanent ink on trace with Chartpak AD markers.

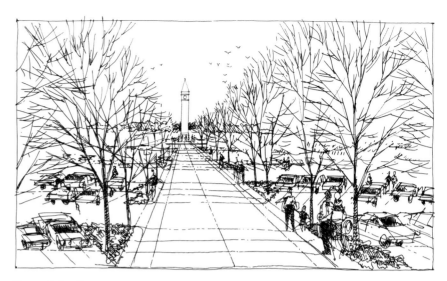

Fig. 5.49 Leafless branches add to the drawing transparency. Not every drawing has to have leaves. This drawing represents a season in which the leaves are no longer on the trees. Additional branches were drawn to compensate for the different character of the tree canopy. 8½ x 15" permanent ink on Mylar.

Fig. 5.51–5.52 Drawing a river's edge bike trail. This 9 x 15" view of a river with overhanging cottonwood trees and ground cover was blocked out in graphite pencil and traced with a felt-tip pen on vellum. Chartpak AD markers were added to the front and back of the vellum. The light sign is contrasted against the dark background of the ground cover in the shade.

Fig. 5.52

Fig. 5.53 Correct mistakes with white correction fluid. If your drawing will be copied or scanned, you can treat it like camera-ready artwork and make any changes to the drawing with standard office correction fluid or a correction fluid pen. This process cleaned up overlapping linework in this exhibit drawing.

Erasing Errors

No drawing—and no designer—is immune to minor mistakes and glitches. Lines may sometimes overlap in odd places, you may suddenly discover a spelling error, or maybe you're unhappy with a particular drawing detail. There are several ways you can clean up your original before it's reproduced and colored. Here are some options.

- *Pencil lines on Mylar* can be easily erased with a kneaded eraser or a hard plastic eraser—the white and pink erasers both work well on pencil. It helps to use a metal erasing shield, to avoid taking away more image than you need to.

- *Ink lines on Mylar* are a bit trickier. Special "imbibed erasers" have erasing fluid incorporated into the plastic. Although these bright yellow and green erasers work well, they tend to leave an oily residue on the Mylar that is difficult to draw over. As an alternative, you can easily use the white or pink plastic erasers on ink by slightly wetting the eraser. Again, use an erasing shield to control exactly what gets erased.

- Electric erasers are wonderful machines that use a wide variety of pencil-shaped erasers. The machine gives you pinpoint accuracy, and it takes little effort to erase large areas of a drawing. Be careful, because if you press

down too hard with an electric eraser, you might scrape away the top surface of the Mylar and ruin your ability to draw over that location. Another simple way to clean up minor overlapping lines is to scrape the ink away using an X-acto knife, but again be careful not to damage the surface of the Mylar in case you have to add more lines to that area.

- *Erasing pencil on vellum or trace* is no different than erasing pencil on Mylar. Ink lines on these materials are much more difficult to erase, because the ink is absorbed into the surface of the paper. Try slightly moistening the eraser, but be careful, because you may start destroying the paper when it gets wet—and you might end up with a hole in your drawing.

- Regardless of how hard you try to erase *ink on vellum,* there will be a ghost image left behind. If the mistake is too large to erase, you can carefully cut out that part and splice in a new piece of vellum. Tape the patch from behind, and feather the new lines in with the existing lines as best you can. A good drawing splice is very difficult to detect once the drawing has been reproduced and colored. If you plan to make a diazo print from the original, use clear acetate tape for the splice. The tape will barely show in the print.

- If you know that your original drawing will be reproduced on a copier or scanned, you can always make minor changes with standard white correction fluid (Fig. 5.53). If you cover large areas, it will be difficult to ink over it due to the hard, irregular surface of the correction fluid. Another option for correcting large mistakes is to glue a white paper patch over the area. Feather the new and existing linework together, just as you would with a splice. Again, the patch works only if you will be using a copier and not a diazo machine to reproduce the drawing.

- When *erasing a drawing on bond paper,* you may have the same problems erasing ink as you have with vellum and trace. If an eraser doesn't sufficiently eliminate the line, you might try correction fluid or even a paper patch. Experiment to find the technique that works best for your drawing.

- *Computer modifications* to drawings are popular and easy to do. Remember that the original artwork remains unchanged, while the electronic version is modified. Software such as Adobe Photoshop is designed for image modification with electronic erasers and rubber stamps. Figures 5.54 and 5.55 show a before-and-after portion of a drawing that was cleaned up in the computer.

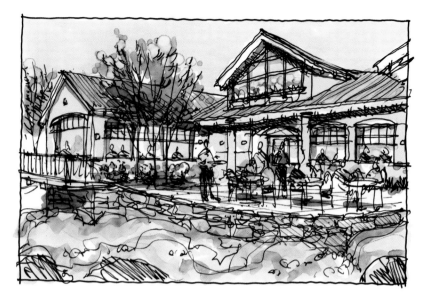

Fig. 5.54--5.55 Before-and-after computer modifications. The original drawing (above) showing an outdoor patio was quickly drawn and has a number of overlapping lines, bleeding markers in the tree leaves, and confusing linework near the tables and chairs. The image was scanned and modified using several tools in the Photoshop program. Using the rubber stamp tool to duplicate some of the green marker spots, the tree leaves were improved. Linework on the building and windows was simplified and people's faces and the tabletops were brightened. This image modification process took over an hour to accomplish and is recommended only for minor changes to drawings.

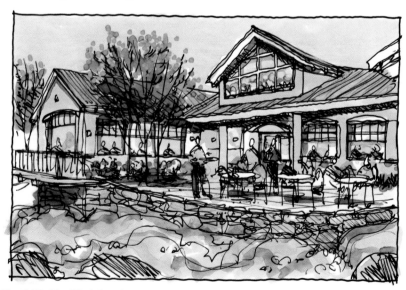

Fig. 5.55 Modified drawing.

Quick Tips *Drawing Tools*

- You can purchase 12 x 18" resealable plastic storage bags, which are ideal for protecting your original artwork and copies from moisture and dust. Never leave your work uncovered. It's a good habit to trim your drawing paper or Mylar to 11 x 17" so it will be easy to file.

- Felt-tip pen points don't stay sharp for long. The surface of Mylar is hard on pens, and wears the points down much faster than paper does. Always have extra pens on hand.

- When coloring with markers, always apply your lightest colors first and gradually build the colors to the darkest markers. Reversing the order will cause the dark colors to smear.

- You can add a texture to a pencil drawing by putting textured poster board underneath the drawing paper and rubbing your pencil over the paper surface. The textured finish of the board will be transferred to the drawing.

- Soft pencil tends to smear when you're drawing on vellum or trace. Lightly spray the drawing with matte fixative as you work. To avoid breathing the fumes of the fixative, spray your drawing outside or in a well-ventilated space.

- Store your drawing pens upright in a tin can or coffee mug, with the nibs pointed down. This keeps the ink close to the nib and the pen tip from drying out.

- If you want different line widths in an ink drawing, you can use special technical pens that come with variable pen points. These pens can be refillable or disposable, with either permanent or water-soluble inks. Technical pens are often difficult to use, though, when you're trying to achieve a loose and variable line style.

- Keep all your original drawings and copies away from direct sunlight. Some drawing inks and colors are subject to UV damage and will fade.

- Don't throw away felt-tip pens and markers that are beginning to dry out. Sometimes a drier pen can be useful for creating a lighter-weight line, a softer gray tone, or a special effect.

- Different shades of gray markers can add varied tones to an original drawing on trace or vellum that is intended to be diazo printed. Experiment with markers and a scrap piece of vellum. Make sure you know how to achieve different gray tones on a diazo print before ever using markers on your original drawing.

6

THE SUCCESS OF COLOR

Fig. 6.1 Desktop color. This represents a typical desktop environment in which a drawing is produced. Over 50 color markers are scattered for use in coloring the 11 x 17" drawing. A record copy of the black-and-white line drawing was made before the original vellum drawing was colored. A sheet of white paper is taped to the table surface and used to test marker colors.

Fig. 6.2 Test your markers on different materials. Color markers look very different depending on what paper they are applied to. Bond paper absorbs marker ink and reproduces the color in deep tones. Marker ink doesn't penetrate the hard surface finish of vellum paper and appears much lighter than if applied to bond paper. Make a test page on different papers with 1 x 1" square color patches. Refer to these color charts whenever you start coloring a drawing.

A black-and-white drawing is often all you need to communicate a design idea, but it has limitations. Imagine trying to portray autumn foliage on a tree with a black-and-white drawing, or sketch a field of wildflowers in shades of gray! Adding color to your drawings can help you define different materials and objects, and also gives life to the image. Sometimes you can create a drawing in black and white, present the idea, and add color to it at a later time. I once participated in a one-day planning workshop that required a series of quick presentation drawings for a public meeting that evening. With only about eight hours—knowing that color drawings take twice as long—I chose to make six black-and-white drawings. Each incorporated enough design elements to tell the story, but lacked the personality of a color drawing. I later went back to my office and applied color with markers to each original. The color drawings were successful in the final presentation.

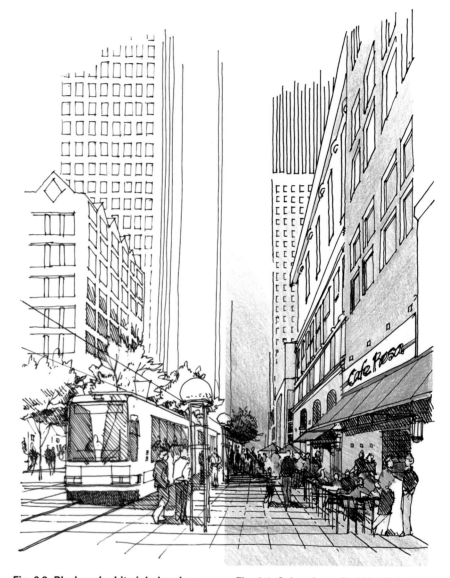

Fig. 6.3 Black-and-white ink drawing. This 10 x 15" drawing of a downtown transit scene was drawn with enough linework and tone to understand the elements without any color. Permanent ink on Mylar.

Fig. 6.4 Colored penciled highlights. The drawing was copied onto bond paper and colored with Prismacolor pencils. Color was used to emphasize the ground-level activity, while the upper portions of the drawing were left with little or no color.

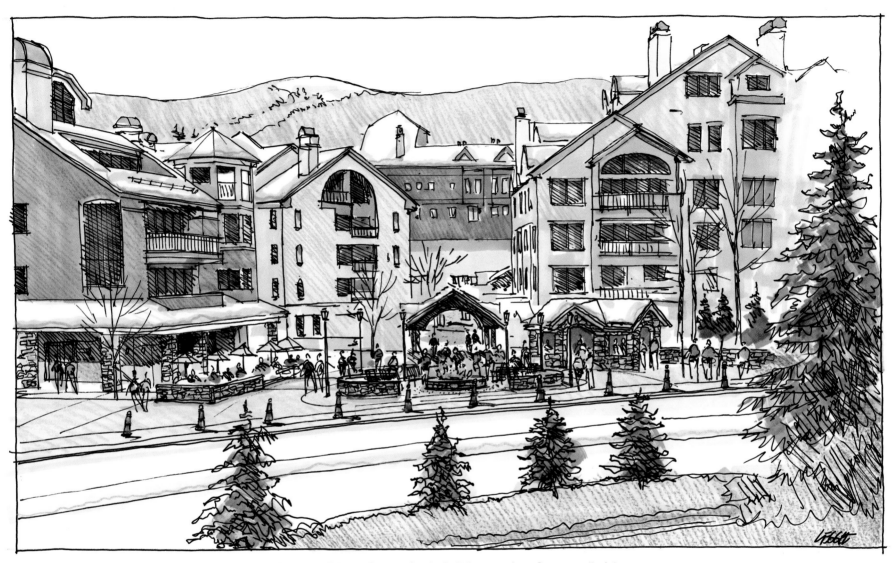

Fig. 6.5 Coloring snow. This drawing of a ski resort plaza uses light earth tones for the building exteriors. Snow on all of the rooftops is left white (uncolored) with a slight amount of light blue marker to represent the shaded snow areas. A blue color pencil line helps define the edge of the snow where a darker shadow might occur. 9¹/₂ x 16" ink on vellum original with Chartpak AD marker and Prismacolor pencils on an OCE digital print.

Planning Ahead for Color

When to Use Color

Don't use color unless you need to. Many subjects and situations lend themselves to being drawn in black and white, or your drawing may need to be black and white for reproduction or printing purposes. But a different situation might demand that color be used, because of the nature of the subject or the requirements of a client. Before you ever start a drawing, you need to be aware of three variables: (1) how much time is available to create the drawing, (2) whether your design will be better communicated in color or black and white, and (3) how the drawing will be presented and/or reproduced. As a general rule, you need to budget the same amount of time to color a drawing as it took to draw the original black-and-white version.

Fig. 6.7 Coloring skies and water. Always color skies and water with varying shades of blue, lightest being near the horizon line. The blue on the left portion of the drawing is consistently shaded and has no sense of depth. The color on the right side has a much more realistic appearance. 10 x 16" ink on trace with Prismacolor pencil applied directly on the original artwork.

Fig. 6.6 Coloring shadows. The dark areas of the audience in this 8 x 10½" drawing are shaded with blue and purple colors. Heads of people are left lighter as they get closer to the stage. Dark color is omitted to represent beams from spotlights, which are colored yellow. The brightest colors in the drawing are concentrated around the stage and single performer. Prismacolor pencils and Chartpak AD markers on an OCE digital print.

Fig. 6.8 Coloring seasonal foliage. This 10½ x 10½" drawing shows a high meadow in late autumn. Mountaintops are left white (uncolored) to represent snow, and the foreground grasses are colored orange and red to reflect the change of season. Prismacolor pencils on a black-and-white copy on standard bond paper.

Fig. 6.9

Fig. 6.10

Fig. 6.11

Fig. 6.12

Fig. 6.13

Fig. 6.14

The Right Size for Adding Color

Not all original drawings will be 11 x 17" or smaller. A drawing might require so much detail that it must be drawn on larger paper. Once the linework is completed, you have a number of options for adding color to the work. You can either color it at the same size as the original artwork, or have the line drawing first reduced and then colored at the smaller size. If you can reduce the drawing to less than 11 x 17", you can easily save it and scan it or copy it on a standard color copier.

If you want to color a *large-format drawing* (larger than 11 x 17"), you can either add color directly to original artwork or color a print made from the original. Be sure to first make a digital, diazo, or large-format copy of the original to serve as a backup in case you're unhappy with the color. The most common approach among designers is to color a print and save the original. Because the final drawing will be too large to scan or copy on conventional machines, your options for reproducing large-format drawings is limited to photo documentation or large-format color scanning. Because each of these options is expensive, it might benefit you to make an 11 x 17" reduction of the line drawing and then color the smaller print.

The benefits of a *reduced-size color drawing* are threefold: you'll spend less time coloring in an 11 x 17" drawing than you would if it were much larger; you can easily have the final artwork color-copied or scanned at a fraction of the price it would cost to reproduce a larger drawing; and the linework in a reduced drawing becomes tighter and sometimes looks even better than the original version. Examples of this method are found in Figs. 2.60 and 2.73.

Fig. 6.9–6.14 Quick color studies for an exhibit. These 5 x 5" drawings were from a series of two dozen quick conceptual sketches for a new aquarium exhibit. Each image was drawn with a felt-tip pen on vellum. A record scan was made before each drawing was colored. Chartpak AD markers were applied directly to the original artwork and each was scanned a second time for use in a presentation document. The side-by-side comparison helps illustrate how color can greatly benefit a drawing that might have been difficult to understand in just black and white.

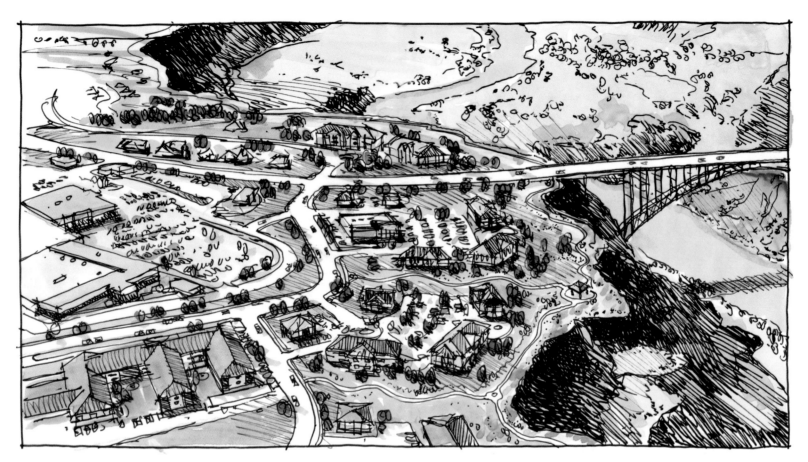

Fig. 6.15 Sized to scan. This 8 x 15" aerial perspective was specifically sized to copy onto an 11 x 17" sheet with 1–1½" borders. The image was color-copied and used in several presentations and scanned with an 11 x 17" flat-bed scanner for additional archiving and reproduction. Always scan your original drawings at 300 dpi for optimum resolution. Store images on CDs for permanent record. Felt-tip pen on vellum with Chartpak AD markers applied directly to the original artwork.

There are several options for reducing large drawings. Reprographic companies are now using digital scanner and high-resolution printers for making reductions of line drawings. I've used machines made by OCE and have been impressed with the 25-400% range of size reproduction and the 400 dpi resolution. These machines can scan up to 36″ wide originals with limitless lengths. Output papers can vary from 16- to 30-lb bond paper, 16- to 20-lb vellum and 3.5- to 4.5-mil polyester film (Mylar). Other reduction options involve copy cameras, orthographic films, and chemical developing processes that are quickly disappearing from the landscape in favor of new technologies.

Fig. 6.16 Color clues from photographs. The colors in the site photograph are muted by haze and distance. The drawing (Fig. 6.15) made from the photo maintains the basic color characteristics but enhances the greens in the foreground and drops out the color in the background to emphasize the dramatic location.

Fig. 6.17 Coloring a digital print. This is one of the most common methods of reproducing and coloring a drawing. The original 8 x 13" permanent ink on trace drawing was digitally copied at the same size onto 30-lb presentation bond paper and colored with Chartpak AD markers and Prismacolor pencils. The original artwork was scanned at 300 dpi and saved as a TIFF image before it was given away to the client.

Fig. 6.19 Coloring on the reverse side of a standard copy. Some copiers will accept certain nontraditional papers. The 8 x 13½" original of this drawing was reproduced onto trace that was hand fed through the copy machine. Coloring was done with Chartpak AD markers on the reverse side of the trace to avoid melting and smearing the toner-based linework.

Fig. 6.18 Coloring directly on the original artwork. This 9 x 11" permanent ink on vellum drawing was colored directly with Chartpak AD markers. To avoid smearing the ink lines with the Chartpak AD markers, all coloring was done on the re-verse side of the vellum. The material is transparent enough to clearly show the color.

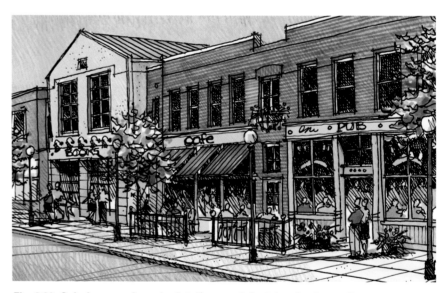

Fig. 6.20 Coloring an enlarged print. If your original drawing is small, you can enlarge it and introduce more detail to the image when you add color. This original 6 x 9" drawing was enlarged 150% with a digital copier onto 30-lb bond paper. Chartpak AD markers and Prismacolor pencils were used for color and the brick pattern on the facade. This "recycled" drawing originated from tracing and modifying portions of the building shown in Fig. 6.21.

Coloring with Technology

There are numerous ways of reproducing drawings and coloring them. In addition to directly coloring an original drawing, you can copy your drawing onto trace and then color the print on the reverse side, digitally reproduce your drawing onto bond paper, or even scan and plot the image onto vellum. The choices are endless, and as technology improves, you should keep current with new reprographic alternatives and explore even faster and more effective methods of drawing.

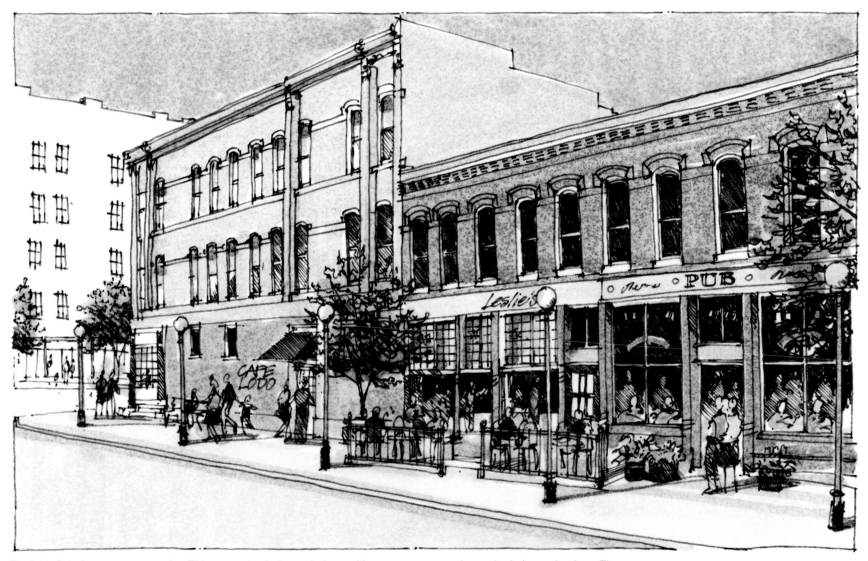

Fig. 6.21 Coloring a computer print. This unusual coloring technique utilizes computer scanning and printing technology. The original 10 x 16" ink line drawing was scanned on an 11 x 17" scanner, then resized in the Photoshop software program, and finally printed onto 8½ x 11" precut vellum using a standard inkjet color printer. Chartpak AD markers were applied to the reverse side of the vellum, and the resulting image reflects a balance of sharp linework and soft color fill.

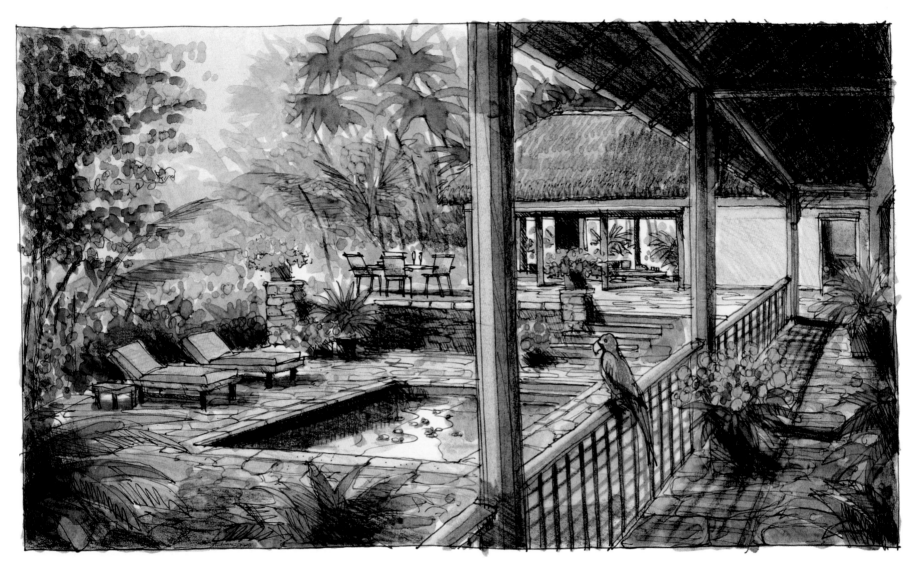

Fig. 6.22 Step 4: Final colored drawing. The final drawing for the outdoor terrace was created on trace with a fine-point, water-base, felt-tip pen. The image was carefully traced over the concept drawing (Fig. 6.25) and directly colored with Chartpak AD markers on the front and reverse side of the paper. A minor amount of colored pencil was added for texture on the building. With this drawing, the decision to color directly on the original artwork was quite risky. Any mistake would have ruined the image and wasted the eight hours that were invested in the final drawing.

The Final Step in a Process

Coloring a drawing is the last creative step in an overall design effort. Creating the outdoor terrace scene (Fig. 6.22) was a lengthy process of combining many steps in visualizing the design concept. Early thumbnail sketches, black-and-white concept drawings, and final color drawings were continuously refined, revised, and developed. A series of five color drawings were finally created for the proposed Caribbean resort.

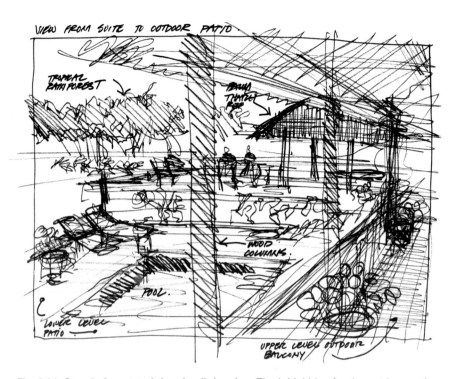

Fig. 6.24 Step 2: Annotated thumbnail drawing. The initial idea for the outdoor patio was sketched in 10 minutes on 8½ x 11" paper with a felt-tip pen. The drawing is so rough that labels were added to help identify different elements of the drawing. The design team selected this image to develop in greater detail.

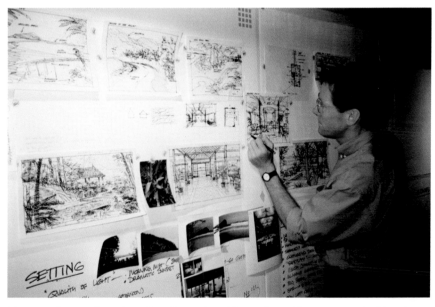

Fig. 6.23 Step 1: Storyboarding the project. The entire wall was covered with reference photographs, thumbnail sketches, and notes describing the design concepts for different program elements of the tropical resort. This storyboarding process quickly identified many different drawings that eventually were edited down to the final five drawings used in the presentation.

Fig. 6.25 Step 3: Formatted concept drawing. At the same time drawings were being developed, a graphic designer was formatting the presentation. Because the final graphic layout was planned early in the design process, it dictated the optimum size of the drawings. This 7½ x 13" concept development drawing was proportioned to fit into the 11 x 17" presentation booklet. Pencil block out with felt-tip pen on bond paper.

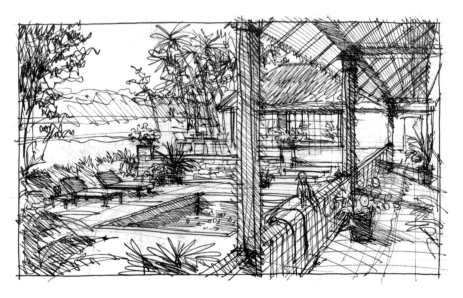

Fig. 6.26 Physical model of a storefront. A 1/4 inch = 1 foot model was quickly built using prints of the storefront elevation spray-glued to museum board and assembled. The 3 x 8" model was photographed from different angles. This image was enlarged 250% on a copier and traced.

The Reliable Colored Pencil

Choosing and Using Colored Pencils

Berol Prismacolor colored pencils are a good choice for most pencil drawings. Derwent Studio pencils can provide some of the more unusual colors. A good art supply store will stock these and many other brands of pencils. As with most other art materials, you can always order them over the Internet and have them shipped directly to you. Generally speaking, the best colored pencil brand is the one that offers the greatest range of color choices and is restocked on a regular basis. There's nothing worse than not being able to replace a colored pencil you use often.

Always have an electric pencil sharpener nearby. In the ongoing quest for drawing shortcuts, you can save a surprising amount of time by not hand-sharpening pencils. Watch out when sharpening, because some colored

Fig. 6.27–6.28 Colored pencil on a standard copy. The 8 x 15" original line drawing was taped to an 11 x 17" carrier sheet and copied same size onto bond paper with a standard office copier. The copier was adjusted to a lighter exposure to keep the linework thin and sharp. Prismacolor pencils were used to color the drawing, using earth tones for the background and accent colors for small display areas and clothing. Dark gray and black pencils were used in the shadows and background.

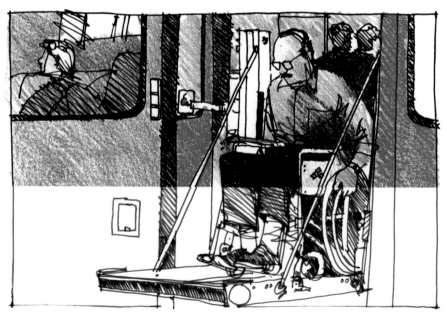

Fig. 6.29–6.30 Colored pencil on textured paper. This 5 x 8" ink drawing on Mylar was copied onto a high-quality paper with a textured finish. The red portions of the drawing show the rich surface grain of the paper. Colored pencils used in small drawings can have quite brilliant results and are easy to control, unlike markers, which tend to bleed and spread across linework. Remember that color markers are ineffective on standard copies because alcohol-based markers melt the toner on the copy and smear the image.

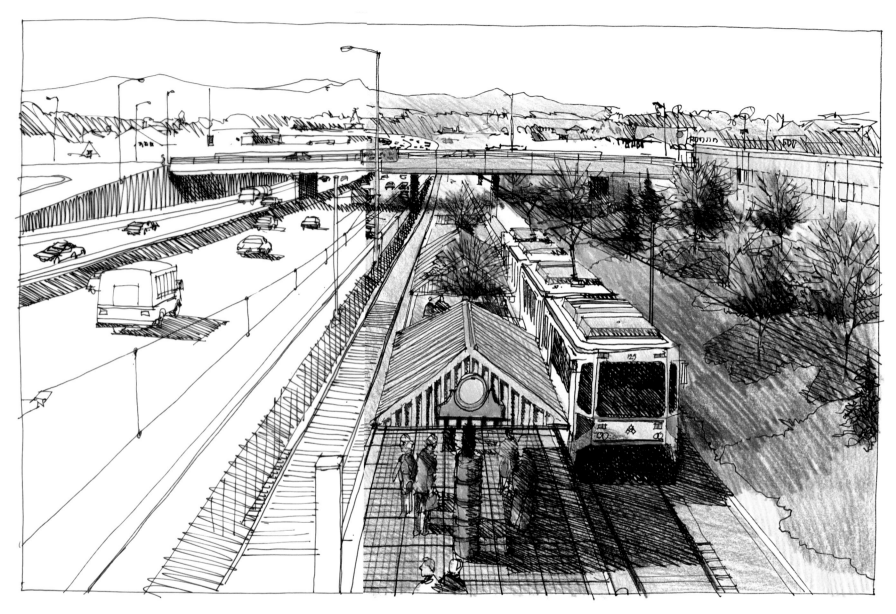

pencils have the color name and identification number at one end. Make sure to sharpen the other end of the pencil so you don't grind away information you'll need when you reorder more of that color. When a pencil gets short and difficult to hold, you can use a pencil extender that adds length to the pencil stub.

Fig. 6.31–6.32 Maximum size for colored pencil drawings. This 10 x 16" drawing is the maximum size for coloring a drawing with pencils. At this size, markers can be much quicker to use. The original drawing was done with a permanent ink pen on Mylar. An 11 x 17" copy was made on a standard office copier and colored with Prismacolor pencils. The paving pattern was added with colored pencils. Note that bright accent colors were used sparingly in clothing and trim on the light-rail train.

Colored pencils are sold in sets of 24 and 36, or individually. Although some colored pencils come with elaborate folding display boxes, it's much better to keep them in a plastic toolbox. You might want to purchase an inexpensive lockable plastic case for all your pencils, markers, and other drawing supplies. Some people use fishing tackle boxes for the same purpose. The more you can keep your supplies organized in a single, secure place, the less likely it will be for those items to get misplaced. If you work with other people using similar supplies, identify yours with a name, tape, or special marking to keep them from getting mixed in with other supplies.

Quick and Easy Colored Pencil Techniques

Two different techniques work well for adding color with pencils: cross-hatching and color blending. The cross-hatching technique takes advantage of the back-and-forth application of the pencil and maintains a loose and spontaneous character (Fig. 6.36). Be sure to keep all your hatching going in the same direction, to avoid the appearance of chaos that occurs when pencil lines go in many different directions. This method also takes far less time to create. The color-blending technique eliminates any pencil lines by carefully "texturing" fields of color. This method requires a lot of practice and is time-consuming, but the results can be very beautiful (Fig. 6.29).

Experiment with the amount of pressure you use to apply the pencil color. Light pressure will create a delicate mix of tones and textures. Heavy pressure generates a bold and color-saturated drawing. The amount of pressure you apply depends on your own drawing preference and the desired effect.

Fig. 6.34 Selected areas of color. It isn't necessary to always color every square inch of your drawing. This airport image used ten colors sparingly in small areas to accent certain elements and contrast others. This "splash of color" took only 5 minutes to add to the 4 x 7" drawing. Prismacolor pencils on a digital print made from an ink drawing.

Fig. 6.33 Solid colors from heavy pressure. Colored pencils are quite beautiful when used in small areas and applied with a lot of pressure. This 5 x 8" drawing really highlights the color variations and brightness of colored pencils. Prismacolor pencils on a standard bond paper copy.

Fig. 6.35 Drawing mock-up in pencil. This outdoor dining terrace scene originated from a photograph taken of the space. The pencil mock-up extended the sides and top of the image that were not captured in the photograph. The 7 x 10" pencil sketch was then overlaid and traced.

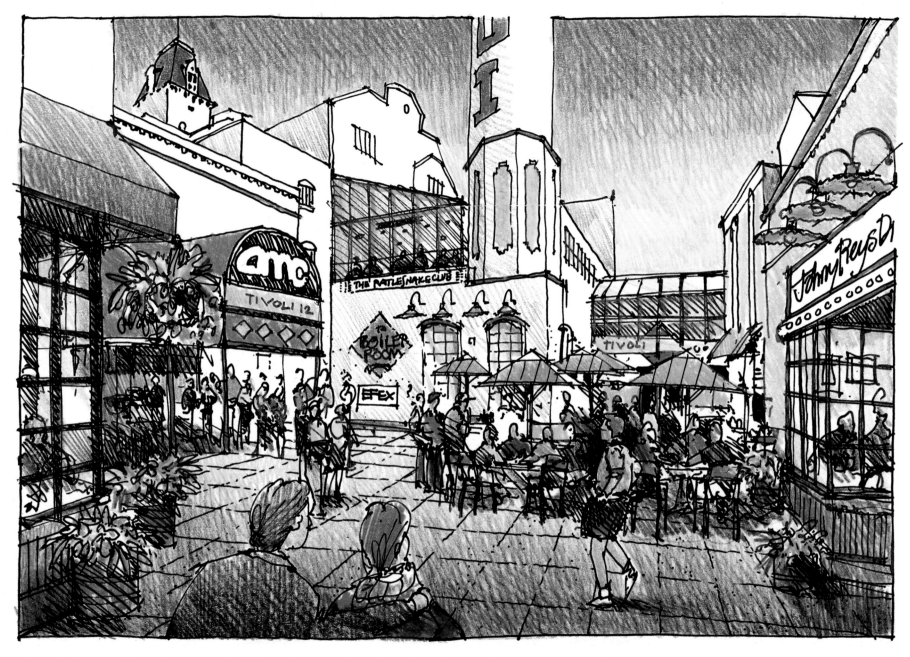

Fig. 6.36 Cross-hatching with color pencils. This drawing really shows the variety of intense colors that colored pencils can deliver. The hatching adds a rich texture that can't be achieved with color markers. Top and bottom of the drawing is darkened to focus attention on the center of the image area. Prismacolor pencils on a digital print made from an ink drawing.

Fig. 6.37 Coloring on original artwork. If you plan to use color markers on your original drawing, make sure the original has been drawn with a water-based ink pen. The solvent-based marker will not smear the ink lines. This 9 x 15" drawing was made with a Pentel Sign Pen on trace. Chartpak AD markers were applied to the original artwork. Several shades of gray markers were used to create shadows on the pavement. Green markers were dabbed in the trees to simulate leaves. Bright yellow and red colors were used to highlight small detail.

The Magic of Markers

Selecting the Right Markers

As with colored pencils, the best markers are the ones that offer the greatest color selection and are kept in stock at your local art supply store. Be sure to label your markers with a name or a mark in order to keep track of them. There are both water-based and solvent-based markers. The Chartpak AD marker is a great solvent-based marker, but the fumes tend to turn heads—you might even be asked to relocate away from pregnant co-workers or those who are sensitive to fumes. Visit your local art supplier and talk with the staff about marker choices and which markers generate fewer fumes. Never use solvent-based markers on a photocopy or directly on original artwork done with permanent ink! The marker will make the linework smear.

New markers tend to be very wet or saturated with liquid ink. These markers might "bleed" more than older markers, but they offer the best opportunity for full color saturation and blending. When using a new marker, always test it on a paper towel before applying it to your drawing. An old, dry marker will cause uneven color streaks on the paper and can ruin a drawing. The paper you use also has an effect on the outcome. All papers have varying ink absorption characteristics, and a single marker can produce entirely different densities of color on different papers. Even slight variations in paper color will also affect marker color. You'll need to explore how the markers you use work on different types and colors of paper.

Fig. 6.38 Coloring the front and back of an original. This small 6 x 6" drawing was done with a permanent ink pen on vellum. Most of the color was applied to the reverse side of the vellum to avoid any possible smearing of the linework. Accent colors were quickly dabbed on the front side of the drawing.

Fig. 6.39

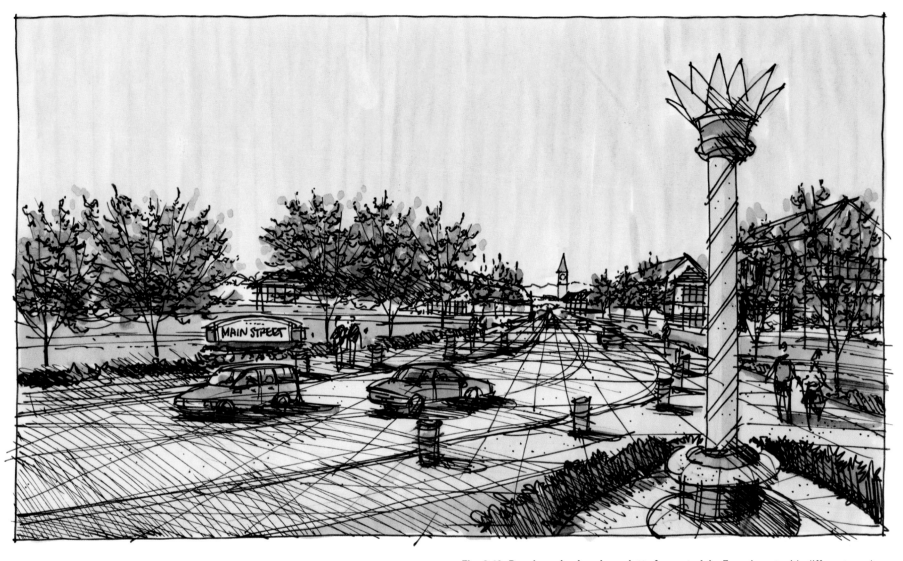

Fig. 6.40 Develop a basic color palette for materials. Experiment with different marker colors and write down which are ideal colors for specific elements in the drawing. For example, the Chartpak AD markers used in this drawing are Lilac for the ornamental trees, Sky Blue for the sky, Light Olive Green for the grass, Buff for the street, Pale Cherry for the sidewalk, Slate Green for the shrubs, and Cadmium Yellow and Red as accents.

It's a good idea to make a sample color chart of your markers using several different drawing papers. Take a sheet of tracing paper, bond paper, and any other drawing paper that you use markers on and color a one-inch square area with every marker you own. Label the colors, and use this color chart as a reference when you start adding color to your drawings (Fig. 6.39). Also keep a list of the markers that you find best for your work. Although there are hundreds of colors to choose from, I tend to do my entire coloring using the same three dozen markers.

Fig. 6.41 Option 1: No color. The line drawing has enough detail and tone to stand alone in a design presentation. The original was drawn with a permanent ink pen on vellum and digitally reproduced onto 30-lb presentation bond paper.

Fig. 6.44 Option 4: Combined marker and colored pencil. The ideal approach to coloring this drawing was first adding a base color of marker to the drawing, then adding colored pencil to delineate the brick patterns and add variations to the blue sky.

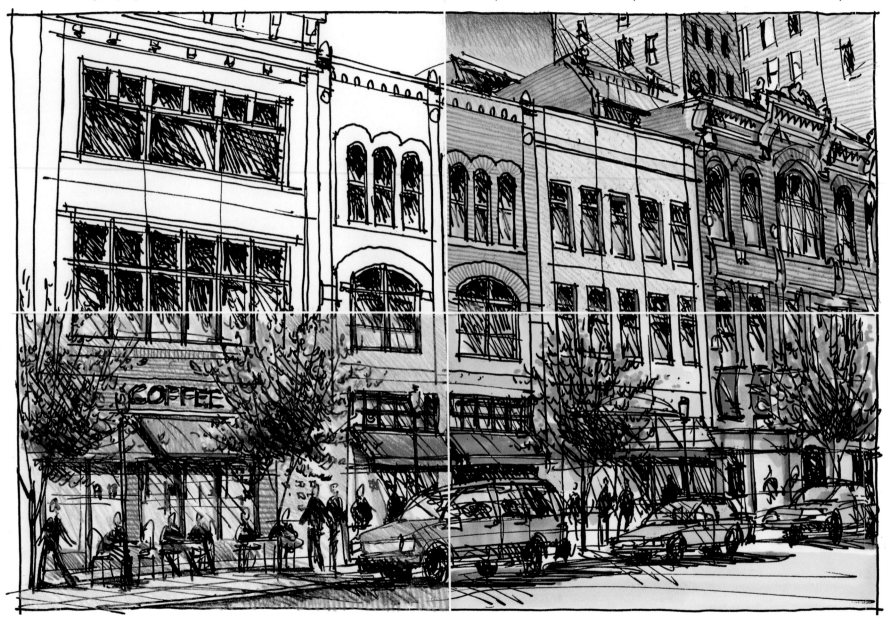

Fig. 6.42 Option 2: Colored pencil only. The bright colors and texture of Prismacolor pencils are ideal for coloring a drawing with a lot of visual elements such as trees, people, cars, furniture, graphics, and building materials. Pencil lines clearly delineate the brick walls of the building.

Fig. 6.43 Option 3: Color marker only. Markers are the quickest way to add color to a drawing. Because of their broad tips, it was too difficult to add brick texture with the markers. Notice how the marker in the street is an even tone and lacks depth.

Picking the Right Paper

There are enormous differences between the look of colored markers on different kinds of paper. When marker is applied to *vellum* or *tracing paper*, the colors appear much lighter than they would if used on white bond paper. Refer to your color chart for the best color markers to use on trace. Drawings in this book are about evenly split between being done on trace versus vellum. Trace is much thinner than vellum and is easier to see through when tracing over a drawing mock-up. Color markers can be applied to both sides and you can't notice the difference. Because this paper is so thin, tape your original to a white bond carrier sheet to avoid getting any folds in the drawing. Never draw on yellow or colored trace unless you are willing to live with the difficulties of scanning and reproducing the colored background.

When reproducing your drawing onto bond paper, consider staying away from the diazo process. This involves exposing light through your transparent drawing onto light-sensitive paper and developing the paper in ammonia gas. Very unfriendly for our environment. Years ago, designers made diazo blueline, blackline, and brownline prints, with different choices of paper finishes. The archival quality of the papers was unstable and drawings tended to discolor over time. The diazo process is quickly vanishing and being replaced by sophisticated "scan and copy" machines, led by the OCE 9800 machine. I reproduce my drawings onto a durable 30-lb presentation paper, which has a smooth finish that accepts Chartpak AD markers without smearing. This digital process is available at local copy and reprographic companies. I now use digital copies for all drawings that don't involve coloring the original artwork.

The standard office copier is an inexpensive alternative for copying and coloring artwork, but keep in mind that most office copiers aren't designed to reproduce continuous gray tones very well, and because they use a heat-set toner, you can't use solvent-based markers on the copy or the linework on the paper will smear. There are many paper options for copiers. I recommend using high-quality bond papers designed for inkjet printers and color copiers, with a brightness rating of 100 or more.

Fig. 6.45–6.46 Adding pencil hatching. This 9¹/₂ x 13" drawing was made using a permanent ink pen on vellum, which was digitally reproduced on 30-lb presentation paper. A base-layer of color markers was added and an overlay of colored pencil hatching gave the floor, walls, and clothing a strong texture and character.

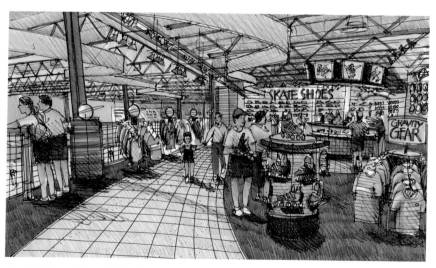

Fig. 6.47 Don't be afraid of color. Retail environments always are rich in colored graphics, displays, and items for sale. The techniques used in this drawing are similar to those in Figs. 6.45 and 6.46. Signage is even highlighted using a fluorescent colored pencil. 10 x 16" permanent ink on vellum, digitally reproduced on 30-lb presentation bond with Chartpak AD markers and Prismacolor pencils.

Combining Markers and Colored Pencils in Drawings

Drawings that combine both markers and colored pencils take advantage of what each medium has to offer. Markers can quickly cover large areas with color while color pencils can add extra detail, texture, tone variations, and character that markers alone can't achieve. When combining both, first color your drawing with a marker "base color" and then add the colored pencil as the last step. Figures 6.41–6.44 are examples of four drawing options with different combinations of pencil and marker. Remember that it is always an option to bypass coloring your drawing and simply present it in black and white.

Drawing Series: Grand Opening Celebration

This series of drawings was developed to help visualize a number of themed parties that were planned for the opening of a large sports arena. The rounded building is seen in the background of each drawing. Each was drawn at 8 x 10½" to easily scan and reproduce at a larger scale. The drawings were made with permanent ink pen on vellum and colored with both Chartpak AD markers and Prismacolor pencils. To create the festival atmosphere, each drawing was filled with people, signage, banners, and activities. Each drawing was made from imagination, except Figs. 6.50 and 6.51, in which elements were traced from a previous drawing (see Fig. 2.62).

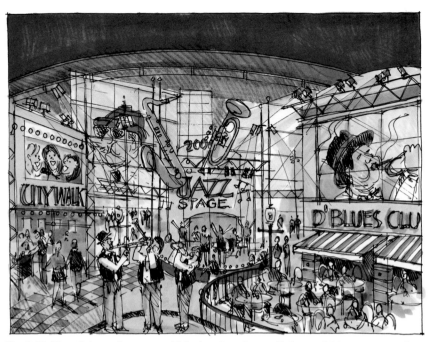

Fig. 6.48 New Orleans jazz party. This drawing shows dining activities, stage performances, and a large-screen projection of the performers. Signage, spotlights, and enlarged faces reinforce the nightclub atmosphere of this themed party.

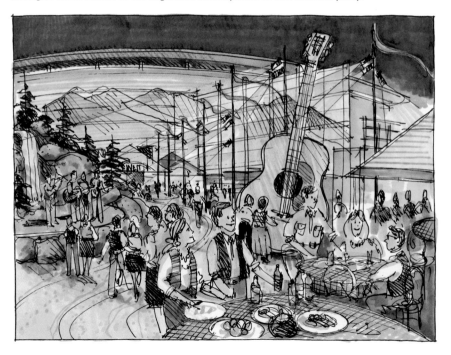

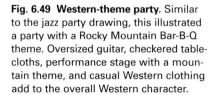

Fig. 6.49 Western-theme party. Similar to the jazz party drawing, this illustrated a party with a Rocky Mountain Bar-B-Q theme. Oversized guitar, checkered tablecloths, performance stage with a mountain theme, and casual Western clothing add to the overall Western character.

Fig. 6.50–6.51 Sports projections on the building. This drawing illustrated the capability to project large images on the building facade. The people at the bottom of the drawing give scale to the enormous projections.

Watercoloring Options

The quality of watercolor comes from a spontaneous blending of water, color pigments, and brush marks. Watercolor is a beautiful medium, and we all should take time to paint. But not everyone has the time or patience to learn how to paint watercolors like the one shown in Fig. 6.52. Figures 6.53 and 6.54 both explore applying Chartpak AD markers to trace and vellum in such a way as to simulate a watercolor effect. Experiment with this technique and develop your own loose coloring style as an alternative to techniques already discussed in this book.

Fig. 6.53 Landscape painted with markers. This 7 x 11" drawing was loosely drawn with a water-based Pentel Sign Pen on vellum, then dabbed with color markers to give the appearance of a light wash of watercolor. The color is quickly applied and purposely pale.

Fig. 6.52 Watercolor in Taos. This 8 x 12" watercolor was painted on site in Taos in about 30 minutes. The buildings were first sketched in light pencil and then colored with traditional watercolors and brushes.

Fig. 6.54 Foliage painted with markers. The leaves in these trees were dabbed on with markers in several shades of green. Color markers were applied directly onto the original artwork. The wet markers spread onto the paper and dried with a character similar to watercolor paint on paper. 9¹/₂ x 16" ink on trace with Chartpak AD markers.

Visualizing an Aquarium in Color

The following pages illustrate the process of visualizing exhibit concepts, site test fits, and visitor amenities in a proposed aquarium. Each image was generated to capture the "big idea" of a specific exhibit or public space. The drawings are grouped together representing early thumbnail sketches, exhibit concept drawings, and more elaborate interior perspective views. No single drawing format, style, or approach was repeated, although when a series of drawings was developed, each image in the series was consistently sized.

Fig. 6.55 Rain forest thumbnail drawing. This one-minute 4 x 6" thumbnail sketch simply tells the story of walking through a misty rainforest exhibit. Felt-tip pen on bond paper with a quick overlay of colored pencil.

Fig. 6.56–6.57 Pair of fish tank vignettes. These 5 x 5" drawings illustrate concepts of a large shark exhibit and a freshwater tank. People are added to the drawing for scale and orientation to the fish tank. These drawings were done with a Pentel Sign Pen on vellum and directly colored with Chartpak AD markers. Each took about one hour to draw and color.

Fig. 6.58 Quick sketch of a fish exhibit. This five-minute drawing was done so quickly that the frame around the image is extremely crooked. The fish (rays) are crude shapes, but the overall idea is successfully communicated with minimal time invested. Felt-tip pen on bond paper with color pencil.

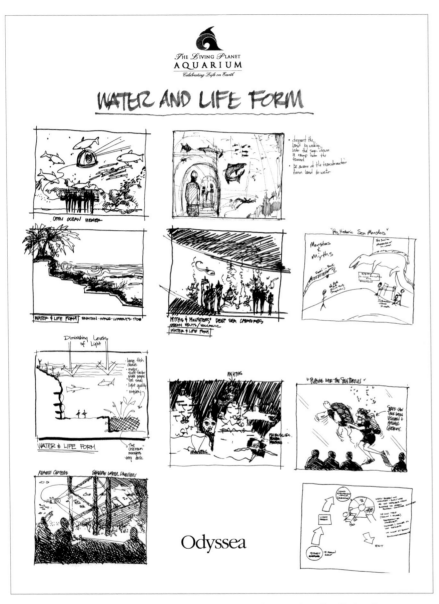

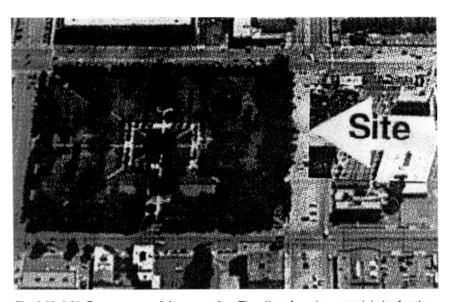

Fig. 6.60–6.61 Emergency aerial perspective. The client found a potential site for the aquarium and could supply only a crude aerial photograph pulled from the Internet. Although the photograph was extremely rough, enough information could be extracted to piece together a drawing of the existing park with a new building inserted into a portion of the property. The 10 x 15" drawing (Fig. 6.61) was done with a permanent ink pen on vellum, then OCE printed on 30-lb bond paper and colored with Chartpak AD markers and Prismacolor pencils.

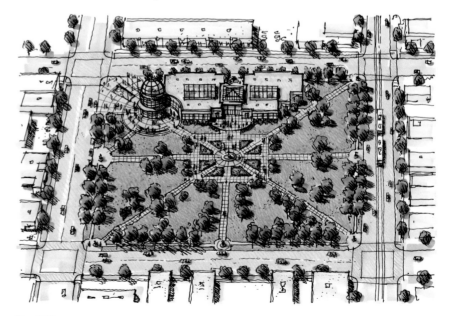

Fig. 6.59 Composite of exhibit ideas. This series of 6 x 9" thumbnail sketches was developed by a group of people during an idea-generating session for a new aquarium. Some are quite primitive, but each drawing captures an idea that could be discussed and further developed. Felt-tip pen on bond paper, taped to a 30 x 42" carrier sheet. Color wasn't necessary for these drawings.

Fig. 6.61

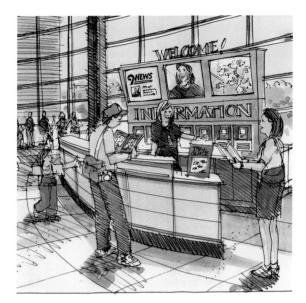

Fig. 6.62 Detailed Information station drawing. The orientation of this 9½ x 12" drawing dictated that more time be invested in drawing people and specific millwork design. Although the background is vague, the foreground is very detailed, including specific signage and detailed faces of staff and visitors. Ink on vellum with color marker on a digital copy.

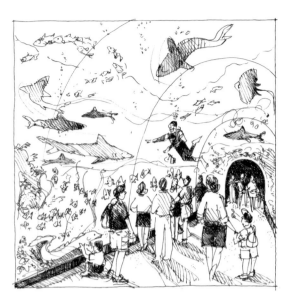

Fig. 6.63 First drawing: shark tank. The 10 x 10" sketch adequately shows an acrylic tube beneath a shark tank. After review with the client team, an exhibit needed to be included in the image and the people needed more refinement. Permanent ink pen on trace.

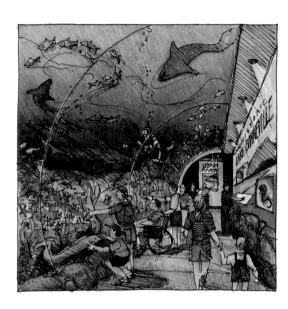

Fig. 6.64 Final drawing: shark tank. The acrylic tube was chang and an exhibit was placed on the rear wall. A wheelchair was added and the people were more carefully drawn. The drawing was digitally copied on 30-lb presentation paper and colored with Chartpak AD markers and Prismacolor pencils.

Fig. 6.65 First drawing: rain forest exhibit. This drawing had the same level of revisions as Fig. 6.64. The thatched "Exploration Station" hut was taken out of the exhibit. Because of the substantial revision, a new drawing was required.

Fig. 6.66 Final drawing: rain forest exhibit. The thatched hut was replaced with a fallen log and people were placed into a more natural setting.

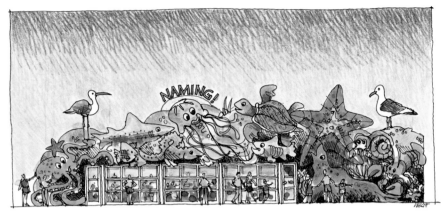

Fig. 6.67 High-impact color. The large-scale wall graphics are colored with bright markers and Prismacolor pencils. The 6 x 14" drawing was done on trace with a permanent ink pen and directly colored on the original artwork.

Draw It and Someone Else Will Change It

This series of drawings reflects the changes that normally occur in the design and visualization process. Drawing shortcuts can make drawing time shorter, but can't avoid the fact that during the development and review process of a project, there is bound to be change. If the change is minor, you can erase and modify portions of the drawing. If the changes are substantial, a total redraw is required. Fortunately, you can trace over the earlier version, save certain elements, and add new information to the drawing.

Fig. 6.68 Redline mock-up of the final drawing. Each drawing in this series was done from imagination and first developed in red pencil. This mock-up stage of the drawing allows for quick changes and visualization of the overall concept. The red pencil drawing can even be copied in black and reviewed with the client.

Fig. 6.69 First drawing: aquarium lobby. Sometimes a drawing just doesn't capture the design concept. This lobby drawing was rejected for not showing enough of the outdoor plaza in front of the building. A new drawing was necessary that would raise the orientation from eye level to bridge level so that more of the floor and plaza area could be seen.

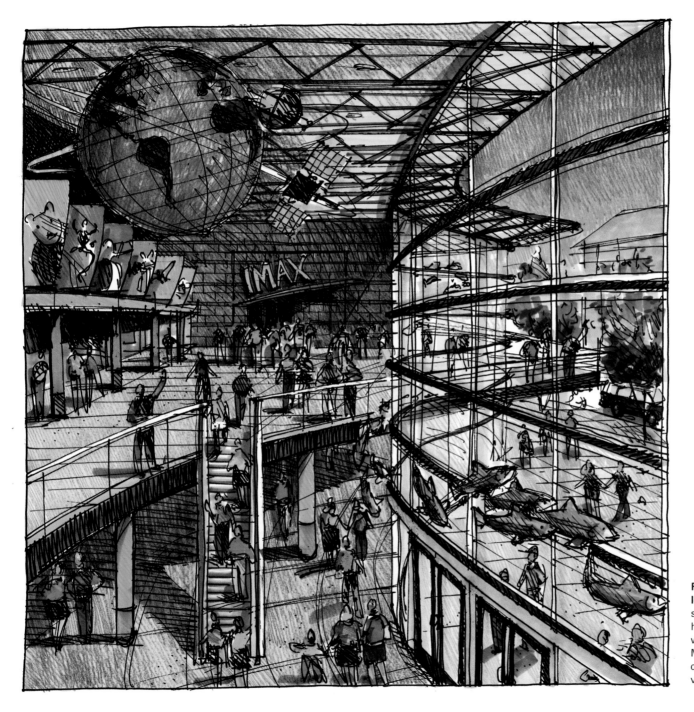

Fig. 6.70 Final drawing: aquarium lobby. The final approved drawing showed the lobby space from a much higher viewpoint. The outdoor plaza was in view as well as the second floor. Much more information was communicated with this drawing than in the first version (Fig. 6.69).

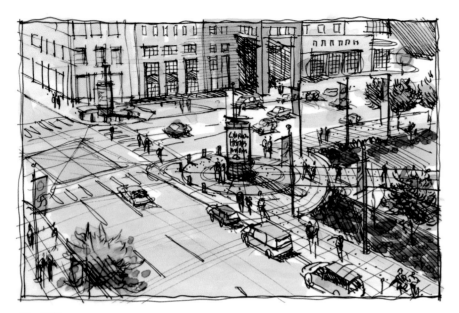

Fig. 6.71

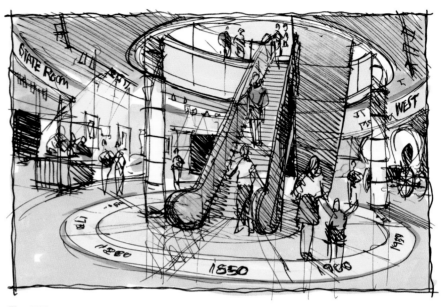

Fig. 6.73

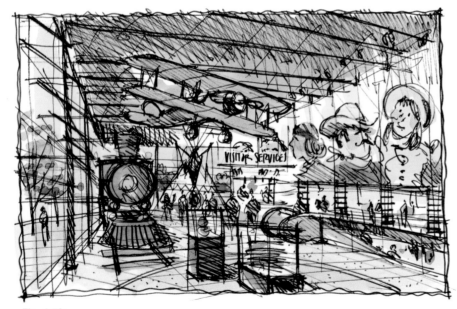

Fig. 6.72

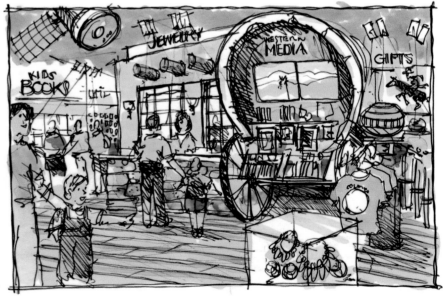

Fig. 6.71–6.74 Drawings of a proposed museum renovation. This series of 6½ x 10" drawings was mostly generated from digital photographs taken of the existing museum. Each was drawn with a Pentel Sign Pen on vellum and colored with Chartpak AD markers. The color was intentionally brightened because of the reproduction process. Each was scanned and printed on a large-format plotter along with other graphics and text descriptions (Fig. 7.4). The drawings illustrate various interior exhibits, signage, visitor circulation, and themed sales areas at the Western history museum.

QuickTip *Color Drawing*

- Markers are sensitive to UV light, and colors can fade if exposed to direct sunlight. Be sure to cover your marker drawings or locate them away from the sun to keep the colors from changing over time.

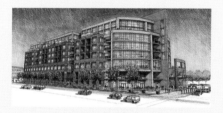

- When coloring a sky, make the area near the horizon light. Color the sky darker as you go higher on the drawing.

- When coloring against an edge of the drawing, use a ruler or drafting triangle as a guide to keep from coloring beyond the image area.

- If your original black-and-white drawing is bigger than 11 x 17", you can reduce it to fit an 11 x 17" format before adding color. The reduction can then be colored and copied.

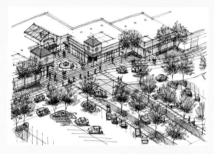

- It may not be necessary to color every square inch of your drawing. Be selective and you can save a lot of time by highlighting only the most important information with color.

- Have an extra copy or print made of your drawing before you start coloring. If you goof with the color, you have the extra copy as a backup print. If you're unhappy with a portion of the colored print, you can splice over that area with a piece from the second print and recolor the section without having to start all over again.

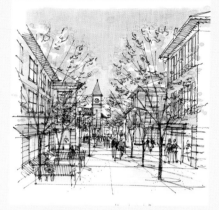

- There's no need to draw all the leaves on a tree if you plan to add color. You can create most of the leaves with your markers or colored pencils.

- Try drawing on the front of tracing paper or vellum with an ink pen, and then coloring the drawing from the back side of the paper. The color will be muted and soft, while the linework will have a strong and contrasting quality.

- You can add shade and shadow when you color the final illustration. Putting tone into your black-and-white original is an unnecessary time investment.

- Save all your color charts for reuse on future coloring projects. Keeping charts will also save you time, since you won't have to invent your color combinations all over again. If your chart is done with markers, make sure you store it in a dark envelope.

- Don't be afraid to use bright colors in your drawings. Bright colors are useful for highlighting objects in the foreground, while more muted colors create a sense of distance. The farther an object is in the distance, the more faded its colors become.

- Mixing media can improve drawing results. Add colored pencil to a marker drawing, creating highlights or textures. Emphasize edges with a black felt-tip pen.

- Apply markers and colored pencils with strokes going in the same direction for a more uniform appearance. Lines going in too many directions are confusing to view.

7
YOUR
COMPLETED
DRAWING

Save and File Drawings

Always, always keep a copy and file it away. Once you've created a drawing, either for a class, for yourself, or for work, there's a good chance that it will be given away or never returned to you. It's very important to make a record of your drawings, for future reference and for self-promotion. Start thinking about building a portfolio of your drawings and filling a flat file, box, or large envelope with either originals or copies of your work. Keeping a complete file of your drawings is an ongoing project, and you should always be aware of the value of maintaining good records of your work.

*"The best way to have a good idea
is to have lots of ideas."*

– Linus Pauling

Fig. 7.1 Saving drawings used for publication. These are but a few of the dozens of reports, proposals, and publications a typical design firm produces within a given year. Cover drawings, illustrations, and character sketches are generally scanned and inserted into the document. After you scan the drawing, label the original as to what project it was generated for and then save it in a flat file away from damaging sunlight. Avoid rolling any drawings. Make duplicate CD copies of the computer file with the image scans and keep one at home for your records.

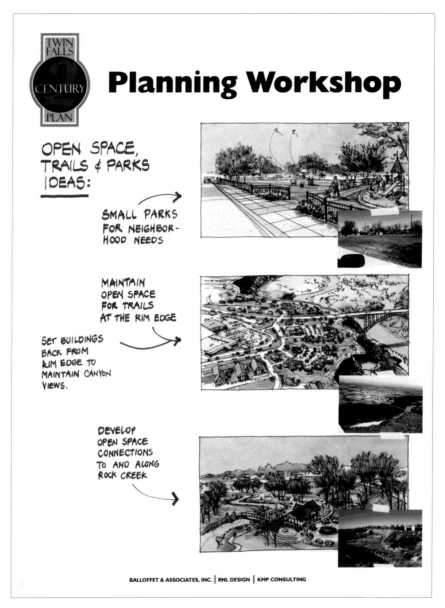

Fig. 7.2 Make color copies and duplicate prints. Avoid using an original drawing in a presentation, because it may get destroyed or lost in the process. The color drawings mounted on this 30 x 40" planning workshop presentation board were 11 x 17" color copies made from the original artwork. Original 4 x 6" color photos were mounted on the board. When the film was developed, a second set of prints was made as a back-up set for the project file.

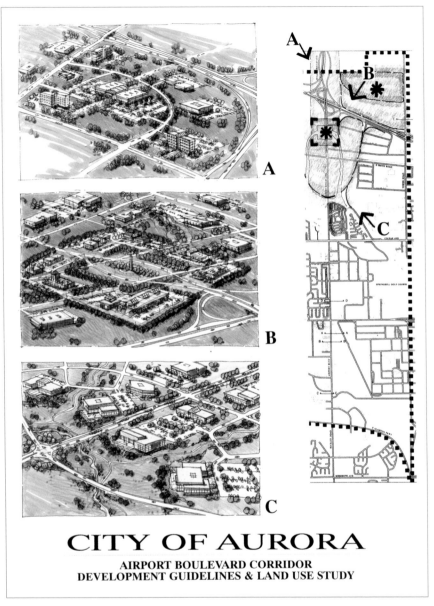

CITY OF AURORA
AIRPORT BOULEVARD CORRIDOR
DEVELOPMENT GUIDELINES & LAND USE STUDY

Fig. 7.3 Photographic print as a record. This 30 x 40" presentation board was assembled in much the same way as the planning board in Fig. 7.2. Drawings were color-copied, and copies were mounted to the title sheet. The presentation board was then given to a photo lab and photographed onto a 4 x 5" color negative. An 8½ x 11" color print was made from the negative and used to make additional color copies for the client.

Copy and File Your Work

There are three basic ways to record your original artwork: (1) a color or black-and-white copy made with a standard color copier, (2) a photographic transparency, print, or 35mm slide, and (3) a computer scan filed into a database.

The choices are affected by the size of your original. Remember that a standard color or black-and-white copier has a glass size of 11 x 17". If your image area is that size or smaller, this is the most economical and fastest way to reproduce your drawing. High-quality digital color copiers can reproduce originals almost perfectly, and are available while-you-wait at most copy centers. If you don't have access to a color copier, then at least make a black-and-white copy of the drawing. It's better to have a simple record of the drawing than nothing at all.

Photographing your work is a good option, especially if the drawing is larger than 11 x 17". You have the option of photographing the drawing yourself or having it photographed by a local photo lab. 35mm transparencies are the best choice, because slides can be turned into prints or used in slide presentations. Some designers keep duplicates of all their slides, so they can send pages of slides to prospective employers or clients while they keep the originals on file.

Flatbed scanners for computers are becoming more affordable to own. Standard color scanners are sized to scan 8½ x 14", but you can find larger machines capable of scanning 11 x 17" artwork. Once your drawing has been scanned, save the electronic file in several locations, including your computer hard drive, CDs, and any other storage device you may have. CDs are becoming an industry standard for storing data and are more stable for storing information than tape drives.

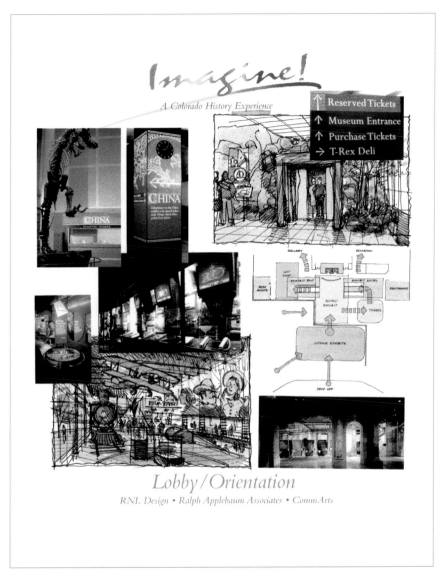

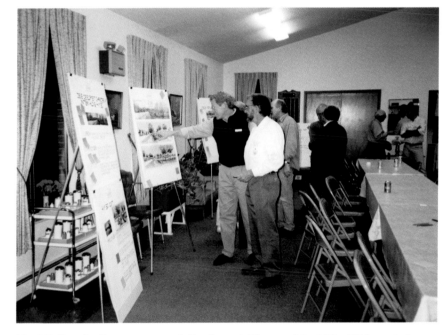

Fig. 7.5 Standardize your presentation format. The consistent 30 x 40" format of these presentation boards was ideal for the public meeting. Each page was clipped to foam core and set on easels around the room. Standard formatting of a presentation allows you to size your drawings and graphics to fit into the presentation, design carrier sheets with project titles, and develop a repetitive graphic standard for other projects.

Fig. 7.4 Computer-generated presentation. This presentation board was completely assembled by computer. Photographs, drawings (Fig. 6.72), and diagrams were scanned and assembled in a graphic document using Quark Xpress software. Text was inserted into the document and color manipulated with Adobe Photoshop. The final graphic was plotted on a large-format color plotter at 24 x 36" for the client presentation. Reduced copies were printed out at 11 x 17" on a color printer connected to the computer.

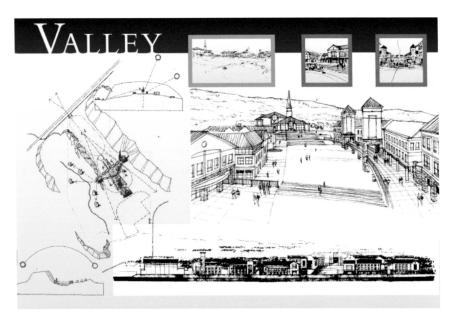

Fig. 7.6 Mounted and laminated on Gator board. This computer-generated image was assembled from six different scans of drawings and formatted in Quark Xpress. The image was plotted at 30 x 40" with a large-format color plotter and heat-mounted on 3/8" Gator board. The panel was then laminated with a glossy plastic overlay to protect the image. Gator board and foam core are two options for mounting presentations. Foam core is less expensive, but has a tendency to warp. Laminating both sides of the panel can diminish some of the warping that occurs with the mounting process.

The image of Denver is evolving. Unlike the older cities of America, where architectural tradition has developed from age-old buildings and a mature landscape, Denver is really an amalgam of diverse factors that has grown from its inception in the 1800's.

A City of Diverse Images

Denver is a city built upon transplanted values from mature eastern cities. Denver's wonderful parkway system, with its tree lined streets and stately victorian residential neighborhoods, is a legacy to the pioneers of the city who came to Denver during the gold and silver booms. The foresight of Mayor Speer has made Denver the city it is today.

Denver is also the treeless prairie, the juncture between the semi-arid plains and the rugged Rocky Mountains. As such, the ecology is very fragile. The landscape is harsh, windswept and barren, the architecture natural and functional.

Denver is the mountains. Clearly a challenge in the design of the New Denver Airport is to reinforce this image. With recreation and tourism as the state's largest industry, the airport must capture its presence at the gateway to the Rockies.

Today Denver and the Front Range are gaining a new image, that of a high tech, research-oriented community where "outer space meets the earth." With the highest per capita educational levels of any city in the country, Denver really is a center of clean industry, research, and advanced technology.

And, it is a city striving to create its own identity -- not a stepchild to the mountains, but a livable, mature city with its own attributes and attractions. The development of a new Convention Center, the creation of the 16th Street Mall, and their resurgence of Lower Downtown are all steps toward kindering a unique image for the city.

Denver is a city passing through adolescence, still searching for its real identity. Its image is very complex; a marriage of diverse physical environments -- mountains and plains; diverse culture; and a real contrast of values ranging from the old West to the new progressive high technology.

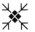

Fig. 7.7 Drawings reproduced using desktop publishing software. Producing documents with computer software is becoming easier and easier. An 8 1/2 x 11" report like this example can be done by either scanning the original drawing and inserting the image file directly into the electronic page, or creating a gap between the text paragraphs and pasting a reduction of the drawing into the space. This particular page was produced with the cut-and-paste method.

Presentation Techniques

The method that you choose for presenting your work can either distract from or enhance the drawing. Mounting drawings is the quickest and easiest form of presentation. This process involves your original drawing, a mounting board, and an adhesive. Mounting boards can be colored mat board, standard foam core, or Gator board, all available at art supply stores. For large drawings that are being mounted for a significant length of time, you can have the drawing dry-mounted. This process involves a sheet of laminating paper, heat-sealed between the original art and the board. Spray-mount can be used for less important drawings or a shorter timeframe.

Mounting onto a black board gives drawings a dramatic frame; carefully selected colored mat board can highlight important colors in the drawing. Try different types of mounting surfaces and techniques to establish which option works best for you. Once the drawing is mounted, it can be protected with glossy or matte plastic laminate. Check your local reproduction company to see if they have a heat press and laminating setup. If so, laminating your drawings will protect them and enhance their appearance. A clear sheet of acetate placed over your drawing and taped around the edges will achieve the same finished result.

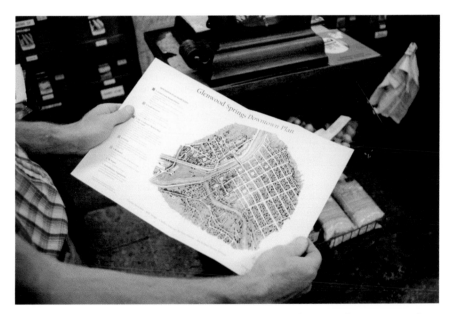

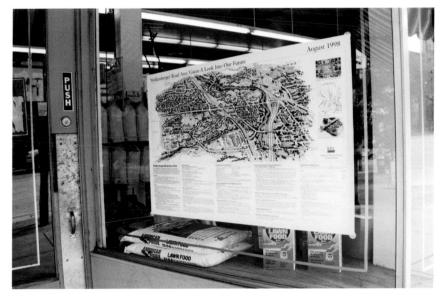

Fig. 7.8–7.9 Presentation posters for public distribution. Some projects may require the presentation material to be reproduced and distributed to the community or campus. The two options shown include (1) a small formatted publication in which the drawing and text are digitally printed at a standard 11 x 17" size (Fig. 7.8) and (2) a large formatted publication that required offset printing on 30 x 40" paper (Fig. 7.9). The drawing detail, amount of text, and budget for reprographics all affect the decision about what format is ideal for any given project.

Fig. 7.9

You Can Do It!

Now that you've learned some new methods for drawing, it's your turn to discover—or rediscover—and develop your own drawing identity. These methods, shortcuts, and design tips are the ones I use, and the ones that could fit within the limits of these pages. Many more are waiting to be discovered. If you find some great new shortcuts or have comments about the ones in this book, let me know! I love to learn new shortcuts, and I'd like to share them in upcoming books.

Let's put the technology of cameras, copiers, and computers aside for a moment here at the end of this book, and focus on the most important drawing tools of all—your imagination and creativity. They need to be constantly nourished and fed with new ideas and better ways to communicate.

Keep Your Eyes Open!

Great drawings are everywhere, but we hardly notice unless we look for them. Make the time to check out drawing books at the library. Visit your local art museum and study the drawing methods of the masters. Check out different sites on the Internet. Start filling your reference files with clippings from magazines and newspapers. Cover your studio walls with drawing examples that turn you on and ignite your creative enthusiasm.

Fig. 7.11 Creating drawings for publication. The original drawings shown in this page from a design guidelines document were drawn about 5 x 8" or twice the size of their final dimension in the report. When creating drawings for publication, establish the scale and format of the final drawings in the document and size your originals so each is reduced at the same percentage.

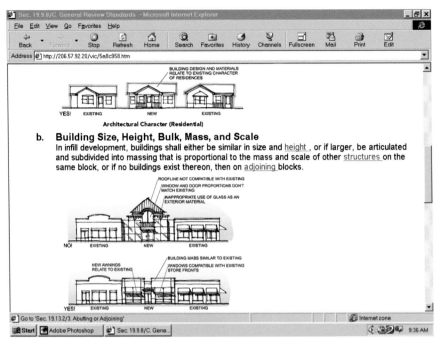

Fig. 7.10 Creating drawings for the Internet. These drawings were scanned, colored by computer, and inserted into a design guideline document that was developed specifically for the Internet. Requirements for creating drawings used on the Internet are no different from those for conventional print reproduction.

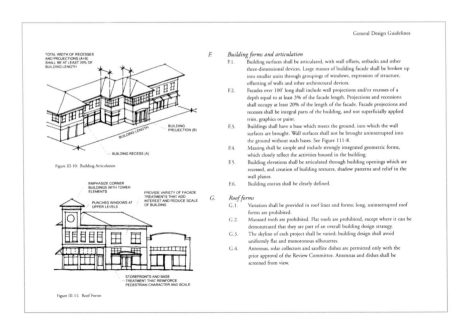

7.12 Presentation for an aquarium fundraising campaign. This 24 x 36" composite image incorporated a title block, colored drawing of a proposed flash-flood exhibit and additional photographs reinforcing the Southwestern theme. The image was one in a series of six mounted and laminated boards used for fundraising efforts.

Stay in Tune with Technology!

Industrial design is in a constant state of improvement. Last year's fast computer is an elephant today. Huge improvements in photography, reprographics, and computer hardware and software are changing the face of the average home, school, and business. Observe these changes, and figure out how you can take advantage of them to create better drawings. You might become a leader in computer-generated drawings or begin to mix multimedia into your work. You could merge different media into a single drawing that might incorporate photographs, hand drawing, and color copies. Technology will continue to present wide-open design opportunities.

Colorado Gateway Relationships To Urban Amenities

Proximity to Restaurants

One of the predominant activities for the conventioneer, tourist, and the local visitor is to dine out while attending an event. One of the foremost expenditures of the convention visitor is food. A key site determinant is the proximity of the convention center to a variety of restaurants of both high-end formal and low-end casual variety.

– The Colorado Gateway
 Convention Center 1987
 Consultant Team

Not only would the existing restaurants and retail stores experience more trade, but the need for new restaurants and new businesses would be stimulated. The site allows for, and a convention center would call for, the development of new and diverse business and retail malls and arcades. As a result, a convention center on the Colorado Gateway site would encourage economic growth in Denver simply by its location. Several interesting facts support the attraction of urban amenities to visiting conventioneers. First, a convention center delegate's dollar can turn over from four to twelve times, and secondly, fifty percent of all sales in the shops at Tabor Center are made to out-of-towners.

Potential Retail / Pedestrian Mall adjacent to Colorado Gateway

The Rattlesnake Club at Tivoli Brewery

Fig. 7.13 Size your drawings to fit the page. This document was formatted with two columns of text in which all drawings were inserted into the wider 5" column. Each drawing was created with the same 3¼ x 5" dimension for consistent presentation throughout the report. Other drawings from the same document can be found on page 67.

> *"What we have to learn to do,*
> *we learn by doing."*
>
> ~Aristotle

Practice and Participate!

Get involved with a drawing class or workshop. Set yourself some goals to experiment with some drawing shortcuts and different drawing tools. Share your ideas with other creative people and try some of their techniques. A great learning method is simply trading drawing ideas with others. You might show one person a shortcut that you've mastered, and the next day discover a new technique from a more experienced designer. Ask for feedback and criticism of your drawings, and learn from the mistakes you make—everyone does. Being discouraged is only human, but with practice and diligence, you can build your drawing confidence.

Have a Good Drawing Attitude!

In this complex era of machines, personal creativity can easily get pushed aside by the time and energy we spend with TV, home computers, video games, CDs, and other consumer products. Not only are we bombarded with relatively noncreative technology, we're constantly pressured into working faster, producing more, and spending less. Save high stress levels for passing a difficult test or balancing your checkbook; put away your anxiety when you start drawing, because drawing is relaxing, inspiring, and rewarding. Your creative spirit and drawing confidence will get stronger with every great drawing you make and every minute you gain from taking effective shortcuts. Drawing can be an amazing amount of fun. All you need is a positive drawing attitude. Enjoy!

Fig. 7.14–7.17 From preliminary idea to publication. The four drawings on this page show the step-by-step evolution of a drawing for an AIA Design Exposition. Early thumbnail drawings were first sketched on an 8 1/2 x 11" note pad (Fig. 7.14). The drawing was then blocked out in red pencil at 7 x 11", knowing that the final image would be scanned (Fig. 7.15). The final ink drawing was traced from the redline mock-up and developed with additional hatching as if it were only going to be reproduced in black and white (Fig. 7.16). The final image reduced to 2 1/2 x 4 1/4" on the cover of an AIA newsletter (Fig. 7.17).

Fig. 7.15

Fig. 7.16

"No [one] knows what he can do till he tries."

~Publius Syrus

Fig. 7.17

Drawing Resources

The following list gives you more specifications about the drawing materials and equipment I use, as well as different software programs that support the visualization process. I've also included addresses and web sites for many of the products. Reprographic equipment such as cameras, printers, and computers are constantly being updated and improved, sometimes as frequently as once a year. Many of the technical tools I've used to make drawings for this book have been updated and replaced with more current models. I've identified the original equipment and also name comparable models that are currently being sold.

DRAWING MATERIALS

Drawing Pencils

• **Sanford Col-erase Pencil**
Carmine Red
www.berol.com (Sanford/Berol Company)
Wood pencil for creating red pencil mock-up drawings (Fig. 4.18).

• **Berol Draughting 314 Pencil**
www.berol.com (Sanford/Berol Company)
Wood pencil with a soft graphite lead, deep black tones, ideal for sketching, smudges easily (Fig. 5.7).

• **Staedtler Mars Dynagraph Pencil**
www.staedtler.com
Wood pencil with a composite lead, variable densities (N0, N1, N2, N3), great drawing pencil that doesn't smudge (Fig. 5.3).

Color Pencils

• **Sanford Prismacolor Pencil**
• **Berol Prismacolor Pencil**
www.berol.com
(Sanford and Berol company names appear on different pencils)
Wood pencil, soft leads, light-resistant pigment, sold individually or in boxed sets of 12, 24, 48, 72, 96, and 120. Most of the colored pencil drawings in this book were made with this pencil.

• **Derwent Studio Colored Pencils**
Made in England by Rexel Cumberland; wood pencil, harder and drier leads than Prismacolor pencils, sold individually or in sets of 12, 24, 36, and 72 (Fig. 2.41).

Drawing Pens

• **Pentel Sign Pen**
www.pentel.com
Felt-tip (fiber-tip) pen, water-based ink, medium tip, easily found in art and office supply stores, ideal for quick sketches. Half of the drawings in this book were made with this pen. Solvent-based Chartpak AD markers can be applied directly over pen lines without smearing the linework.

• **Staedtler Lumocolor 318 "F" Pen**
www.staedtler.com
Plastic-tip pen, permanent ink, lightfast, quick drying on Mylar, refillable, available with different point options (F, S, M). Half of the drawings in this book were made with this pen. Will smear if it comes in contact with solvent-based Chartpak AD markers.

•**Staedtler Lumocolor 311 "F" Pen**
www.staedtler.com
Same pen options as the 318 pen, but has nonpermanent (water-based) ink. Linework not as black or dense as the 318 pens.

Color Markers

• **Chartpak AD Marker**
www.chartpak.com
This web site has a store locator feature that will enable you to find Chartpak marker retailers in your area. Best performing color marker I've ever used. All of the color marker drawings in this book were done with these markers. Sold individually or in different themed sets of 12, 25, and 100.

Minimum 24 colors: Cool Gray #2, #4, #7, Cadmium Yellow, Cadmium Orange, Cadimum Red, Salmon, Flesh, Mauve, Purple Sage, Willow, Apple Green, Moss Green, Slate Green, Ever-green, Turquoise Green, Sky Blue, Blueberry, Azure, Buff, Suntan, Light Sand, Pale Cherry, Mocha.

Recommended 36 colors: Colors listed above, plus Cool Gray #1, #3, #5, Naples Yellow, Peach, Deep Salmon, Pale Flesh, Lilac, Grass Green, Light Olive, Pale Indigo, Sand.

Tape

• **3M Scotch Brand Artist's Tape**
www.3m.com
Opaque, smooth, white acid-free tape that peels up easily. 60-yard rolls come in ½, ¾, and 1" widths.

Erasers

• Staedtler Mars Plastic Eraser
www.staedtler.com
Straightforward white plastic eraser, great for general erasing needs.

• Koh-I-Noor Electric Eraser
www.chartpak.com
Durable machine with a slip-chuck that holds 7" erasing strips. Use the standard white erasers. Beware of the imbibed erasers, because they can often leave an oily residue on the paper or Mylar surface.

Knives

• X-Acto No. 1 Knife
The industry standard knife with the number 11 blades. Purchase the blades in bulk packages, as they dull quickly.

Trace

• Bienfang Tracing Paper
This standard white tracing paper is available in 12-, 18-, 24-, and 36"-wide rolls. Inexpensive and quite versatile.

Vellum

• Clearprint 1000H Drafting Velum
This tracing vellum is a popular technical paper. It's transparent, smooth, and durable. I use this paper in both the 8½ x 11" precut sheets and standard roll sizes.

Mylar

• AZON Herculene Film
www.azon.com
Mylar is available in precut sheets and rolls, single-matte finish or double-matte finish, in 3- and 4-mil thickness. I prefer drawing with the thinner single-matte material because it is much more transparent.

EQUIPMENT

Digital Cameras

• Sony Mavica MVC-FD87
www.sony.com
Sony Mavica MVC-FD75 (updated)
This versatile camera's strength comes from its ability to store images on a standard floppy disk. The minimal 640 x 480 image resolution is marginal for most visual needs. I recommend using a camera with a much higher resolution.

• Sony Cyber-Shot DSC-S70
www.sony.com
Sony Cyber-Shot DSC-S75 (updated)
The very good 3.3-megapixel, 2048 x 1536 image resolution of this camera makes it ideal for taking quick images for drawings. The camera downloads directly into a computer and has numerous imaging options. This digital camera has now replaced the 35mm camera for all of my projects.

Polaroid Camera

• Polaroid Spectra Camera
www.polaroid.com
This camera model has been a standard for many years and uses high-quality Spectra film. It's a fast-imaging alternative that doesn't depend on any other accessory or processing.

35mm SLR Camera

• Canon EOS Rebel 2000 Camera
www.usa.canon.com
This fully automatic camera is very lightweight, durable, and affordable and uses a variety of interchangeable zoom lenses. A great camera for using on projects. Although it came with a 28–80mm zoom lens, I added a 28–200mm lens for greater range in taking pictures.

35mm Compact Camera

• Nikon Zoom Touch 400 Camera
www.nikonusa.com
Nikon Lite Touch Zoom 140 ED/QD (updated)
The compact "point-and-shoot" camera is useful in situations when a larger camera is too much to carry around. It's lightweight, affordable, and has a 35–70mm zoom lens. Newer models come with 38–140mm zoom ranges.

Computer

• Dell Inspiron 8000 Laptop Computer
www.premier.dell.com
I found this powerful and portable machine to be ideal for the demands of image processing and graphic production. It has a Pentium III processor at 850 MHz, 10 GB hard drive and 256 MB SDRAM, Microsoft Windows 2000. Work with the fastest computer you can possibly acquire!

Home Copier

• Hewlett Packard Color Copier 155

www.hp.com

HP Color Copier 190 (updated)

This digital copier was designed for home use and has detailed resolution and great color reproduction quality. The 25–400% sizing range is ideal. This machine is excellent when paired with a color printer.

External CD Burner

• Hewlett Packard CD-Writer Plus

www.hp.com

This external CD-RW drive is an invaluable tool for recording and saving all of your scanned drawings and digital photographs. An alternative to this would have been to incorporate an internal CD burner into my laptop computer.

Printers

• Hewlett Packard LaserJet 4M Printer

www.hp.com

HP LaserJet 4050 (updated)

This black-and-white 1200 dpi laser printer has been faithfully printing for over eight years. New models simply have more memory and better microprocessors. Great machine to have paired with a color DeskJet printer.

• Hewlett Packard DeskJet 720C Printer

www.hp.com

HP DeskJet 842C (updated)

This affordable desktop color printer is a workhorse for reproducing excellent colored images. Not ideal for printing black-and-white text documents. This printer is also semiportable for use outside the office (Fig. 4.9).

• Hewlett Packard DeskJet 350C Printer

www.hp.com

This lightweight mobile printer is designed for taking on the road. This printer, a digital camera, and a laptop all fit together in a carry-on bag. This printer is necessary to have when you do a lot of traveling for projects.

Data Storage

• Iomega Jaz 2GB Drive

www.iomega.com

File backup storage is critical when processing images. The 2-GB capacity of these disks makes this an ideal device for temporary storage of data. I routinely use three disks for moving information around my system.

Flatbed Scanner

• Epson Expression 1640XL Scanner

www.epson.com

This is the best flatbed scanner I've ever used! The high-performance machine has a 12.2 x 17.2" scan size, 1600 x 3200 dpi resolution, and 42-bit color. I found it extremely fast and worth the big investment.

35mm Slide Projector

• Apollo Kodak Ektagraphic III E Plus Slide Projector

www.kodak.com

Highly dependable projector backed with decades of Kodak leadership in the industry. A valuable investment, although it is being challenged by computer presentations and LCD projectors.

LCD Projectors

• NEC MultiSync LT100 Projector

www.nec.com

NEC MultiSync LT154 (updated)

This powerful projector is a general-purpose machine, perfect for large wall projection. 1100 ANSI Lumens. Considering the rapid evolution of LCD projector design, if you are looking for one to purchase, do plenty of research before you buy one.

• Compaq MP2800 Projector

www.compaq.com

This 1024 x 768XGA machine, with 1100 ANSI lumens, is lightweight and portable. Designed for travel use, it delivers great images in a very small package.

Opaque Projector

• Artograph DB-400 Tabletop Projector

www.artograph.com

Similar to Kodak slide projectors, the Artograph DB-400 has been a great machine for enlarging images for over 10 years. Timeless design, extremely versatile to use. Maximum size for the copy board is 10½ x 11".

Overhead Transparency Projector

• 3M 9100 Projector

www.3m.com

Reliable and easy-to-use projector that is available in offices, classrooms and libraries. There are many different brands of overhead projectors on the market, all fairly similar in design and performance.

Light Table

• **Porta-Trace Model 1824 Light Box**

www.gagneinc.com

This 18 x 24" 4-bulb light table is an optimum size for tracing images and sorting 35mm slides. The smaller models might not be bright enough or have the image area to trace large drawings.

SOFTWARE

Word Processing

• **Microsoft Word 2000**

www.microsoft.com

Basic word-processing program—updated, universal, the industry standard.

Graphics

• **QuarkXpress 4.1**

www.quark.com

This is the graphics and desktop publishing software that I've been using for about ten years and am very familiar with. There are similar programs, but this is the best.

Image Manipulation

• **Adobe Photoshop 5.0**

www.adobe.com

Most comprehensive and best image editing software. I've been using Photoshop as long as QuarkXpress and consider it a world standard and "must have" for designers.

Image Sorting

• **ACDSee 3.1**

www.acdsystems.com

This picture viewer, graphic converter, and digital image management tool is perfect for organizing your digital photographs and multimedia files. Easy-to-use thumbnail browser.

Presentation

• **Microsoft PowerPoint 2000**

www.microsoft.com

This standard software for creating a variety of electronic presentations is becoming a more accepted format than traditional 35mm slide presentations. Keep your presentations simple and avoid the stylized templates.

CAD

• **AutoCAD 3.3**

www3.autodesk.com

AutoCAD is a powerful 2D and 3D design and drafting platform that automates your design tasks, and provides digital tools so you can focus on the design rather than the software itself. Use it to create, view, manage, plot, share, and reuse accurate, information-rich drawings.

Computer Visualization

• **3D Studio VIZ 3.0**

www3.autodesk.com

This software allows you to create and communicate designs in a real-time 3D visualization environment. It is fast, intuitive and can create rich lighting and environment effects along with photo-realistic rendering. While AutoCAD is a highly refined and sophisticated design and drafting application, 3D Studio VIZ is one of the most versatile and powerful 3D modeling, rendering, and animation programs.

• **Form Z 3.8**

www.formz.com

The 3D modeling capabilities of this application are unlimited, and considering its complexity, it is surprisingly easy to use. If you can imagine a shape or an object, you can build it with Form Z.

• **Squiggle 4.0**

www.insightdev.com

This application allows you to create images from CAD programs (that output .DWG, .DXF, or .PLT file formats) that reveal a stronger degree of expression since the results are illustrations that appear to be hand-drawn. Users can choose from seven preset styles that range from "carefully sketched with a drafting pen" to "scribbled on the back of a napkin."

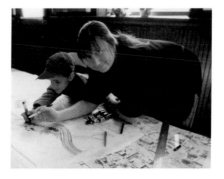 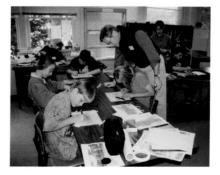

Project Credits

Advertising Poster, St. Anne's Episcopal School, Denver: 3.84–3.86

AIA Colorado Design Conference Promotion, Denver, *American Institute of Architects:* 4.61–4.63, 7.14–7.17

Airport Exhibit Study, Denver, Colorado, RNL Design: 3.3–3.4

Airport Retail Store Proposal, Denver, Frank Ooms Architect: 2.11

Alamosa Comprehensive Plan and Guidelines, Colorado, RNL Design, Clarion Associates, John A Humphreys, *City of Alamosa:* 2.39, 5.43, 5.50–5.52, 6.37

Aurora Land Use Study, Colorado, RNL Design, *City of Aurora:* 7.3

Aurora Planning Study, Colorado, RNL Design, *City of Aurora:* 2.57

Ballpark Infill Project, Denver, RNL Design, *Urban Neighborhoods:* 2.60, 2.73, 4.60

Beaver Creek Bicycle/Pedestrian Master Plan, Colorado, RNL Design, *MK Centennial:* 3.63–3.65, 6.5

CDOT Maintenance Facility, Colorado, RNL Design: 4.115

CDOT Sterling Rest Area, Colorado, RNL Design, *Muller Engineering:* 2.27

Chula Vista Civic Center Master Plan, California, RNL Design, *Highland Partnership:* 4.37–4.42

Clarkdale Downtown Revitalization Plan, Arizona, RNL Design, Clarion Associates, Sunrise engineering, *Town of Clarkdale:* 1.11, 4.17–4.20

Colorado Center Phase III, Denver, RNL Design, *Mile High Development:* 4.76–4.78

Colorado Christian University, Morrison, RNL Design, *Colorado Christian University:* 4.23, 4.70, 4.109–4.111, 5.8–5.9, 6.18, 7.6

Colorado History Museum Expansion Proposal, Denver, RNL Design: 4.13, 4.14, 6.71–6.74, 7.4

Colorado's Ocean Journey Aquarium, Denver, Odyssea Architects, *Colorado's Ocean Journey Aquarium:* 4.67, 4.79–4.81, 4.85–4.86, 5.53, 6.45–6.46, 6.55, 6.58, 6.62, 6.67, 7.12

Colorado's Ocean Journey Gift Shop, Denver, Odyssea Architects, *Colorado's Ocean Journey Aquarium:* 3.11

Columbine Hall, Colorado Springs, RNL Design, *University of Colorado:* 2.44, 5.31

Community Planning Study, Colorado, RNL Design: 4.106

Convention Center Hotel Proposal, Denver, RNL Design: 2.72

Day Care Center, Colorado, RNL Design: 2.5

Denver Convention Center Competition, Denver, RNL Design: 2.17, 2.21, 2.23, 2.25, 3.47–3.55, 5.21, 7.13

Design for Mountain Communities by Sherry Dorward, Van Nostrand Reinhold, New York: 2.9, 2.14, 2.40–2.41, 4.1

Design Guidelines, RNL Design: 2.18, 2.19, 2.22, 2.24, 2.50, 2.69, 2.71, 2.83, 2.85–2.88, 3.19–3.22, 5.41, 5.45–5.46, 6.21, 7.1, 7.10–7.11

DIA Bedrock Master Plan, Denver, RNL Design, C.P. Bedrock LLC: 2.74–2.77

Display Study, RNL Design: 2.91

Downtown Boulder Planning Proposal, Colorado, RNL Design: 3.30–3.31

Downtown Vision Plan, Twin Falls, Idaho, RNL Design, *Ballofet Associates:* 3.28–3.29, 3.32–3.33, 3.71–3.72, 6.1, 6.15–6.16, 7.2

Drawing Shortcuts Class, University of Colorado, Denver: 3.46

Drawing Shortcuts Workshop, Colorado, *BHA Design:* 1.6

Drawing Shortcuts Workshop, l. to r. Joseph Sacco, Jeffrey Yentz, Brian Smith, Lori Hunke: 1.2

Drawing Shortcuts Workshop, RNL Design: 3.1, 3.57

E-470 Land Use and Development Regulations, Colorado, RNL Design Clarion Associates: 2.89, 2.90

Eagle Area Community Plan, Colorado, RNL Design, *Clarion Associates,* John H Humphreys, *Eagle County:* 6.19

Everitt Foothills Mall, Ft. Collins, RNL Design, *Everitt Companies:* 1.13–1.16

15th and Pearl Parking Mixed-Use Facility, Boulder, Colorado RNL Design, Shears+Leese Architects, *Downtown Management Commission:* 3.68, 4.114

Florida Wild Development, Florida, *Bill and Judy Fleming:* 2.59, 2.67–2.68, 6.38

Fontana Civic Center Master Plan and Park, California, RNL Design, *City of Fontana:* 4.43–4.47, 4.102

Gart Sports Superstore, Colorado, RNL Design, *Gart Sports:* 4.22–4.25

Glendale City Center Master Plan, Arizona, RNL Design, Todd and Associates, *City of Glendale:* 4.4–4.6

Glenwood Springs Downtown Neighborhood Plan, Colorado, RNL Design, *City of Glenwood Springs:* 3.73–3.74, 3.77–3.79, 4.11, 4.12, 7.8

Gunnison 3-Mile and Urban Growth Boundary Plan, Colorado, RNL Design, *City of Gunnison:* 4.107–4.108

Hotel Proposal, Colorado, RNL Design: 2.37–2.38, 4.66, 5.2, 5.10

Interior Design Study, RNL Design: 2.16, 2.70

Interior Cafeteria Remodel, Denver, RNL Design: 2.26

From *Italian Hilltowns,* by Norman Carver: 3.80

Jefferson Corporate Center, Colorado, RNL Design, *Sunset Management Services:* 4.48–4.51

Lakewood City Center Master Plan, Colorado, RNL Design, *City of Lakewood:* 3.27, 4.21, 5.49, 6.7

Living Planet Aquarium Concept Design, Salt Lake City, Odyssea Architects, *The Living Planet Aquarium:* 6.9–6.14, 6.56, 6.57, 6.59–6.61, 6.63–6.66, 6.68–6.70

Lower Downtown Planning Study, Denver, RNL Design: 5.26–5.29

Manville Corporation, Denver, RNL Design, *Manville Schuller:* 1.7–1.9, 1.17–1.18

Mixed-Use Project Proposal, Denver, RNL Design: 3.69–3.70

Mt. Crested Butte Redevelopment and Transportation Plan, Colorado, RNL Design, *Town of Mt. Crested Butte:* 5.34

National Cable Center, Denver, RNL Design, *The National Cable Television Center and Museum:* 2.10, 3.5–3.6, 3.23–3.24, 4.58–4.59, 5.3–5.5, 5.13–5.20, 5.32–5.33

New Denver Airport Competition, Denver, RNL Design: 2.15, 7.7

NCAA Headquarters Competition, Denver, RNL Design: 2.46–2.49, 2.61–2.66, 5.11

New Store Concept, Colorado, RNL Design: 4.74–4.75, 4.102

National Jewish Medical and Research Center, Denver, RNL Design, *National Jewish Hospital:* 4.82–4.84, 4.103

Nevada State College Competition, Henderson, RNL Design: 4.121–4.122

New Classroom Building, Colorado, RNL Design, *Mount St. Vincent Home:* 2.53

Overland Park Design Guidelines, Kansas, RNL Design, Clarion Associates, *City of Overland Park:* 3.82–3.83

Palm Springs Classic Resort, California, RNL Design, *Senca Development Company:* 4.56–4.57

Park County Strategic Master Plan, Colorado, RNL Design, Clarion Associates, *Park County:* 1.19, 4.9

Parker City Hall Proposal, Colorado, RNL Design: 2.42

Parker Hilltop Retail, Colorado, RNL Design, Black Creek Communities: 1.1

Parker Town Master Plan, Colorado, RNL Design, *Town of Parker:* 2.7, 5.44, 6.54

Parker West Mainstreet, Colorado, RNL Design, Den Enterprises: 6.40

Pet Museum Proposal, Colorado, RNL Design: 2.2, 2.34–2.36

Planning Proposal, Colorado, RNL Design: 3.14

Planning Study, Central City, Colorado, RNL Design: 2.78

Planning Study, Mt. Crested Butte, Colorado, RNL Design: 3.2

Planning Study, RNL Design: 2.45

Promotional Drawing, Denver, SLP Architects: 2.6

Proposal For A New Aquarium, Denver, RNL Design: 3.88

Public Event Proposal, Denver, TTS Productions: 6.6, 6.48–6.51

Residential Loft Proposal, Denver, RNL Design: 2.80, 4.93–4.94, 4.116–4.119

Restaurant Interiors Study, RNL Design: 3.9

Retail Store Concept, Colorado, *Gart Sports:* 4.87–4.90, 6.47

Ridge Home Urban Renewal Plan, Colorado, RNL Design, *Arvada Urban Renewal Authority:* 4.28–4.36

Riverfront Development Proposal, Colorado, RNL Design: 2.28

RTD Light Rail Station Study, Colorado, RNL Design, *Regional Transportation District:* 2.84, 6.3–6.4, 6.29–6.32

Salida City Comprehensive Plan, Colorado, RNL Design, *Balloffet Associates:* 2.8, 7.5

Silver Triangle Urban Design Study, Denver, RNL Design, *City of Denver:* 2.3, 2.55–2.56, 4.7–4.8, 4.72, 6.41–6.44

Sioux City RU/DAT, Iowa, American Institute of Architects, *City of Sioux City:* 3.41–3.44

Stapleton Private Sector Redevelopment Plan, Denver, RNL Design, *Continuum Partners:* 4.112–4.113

Store Concept, Colorado, RNL Design, *USWest:* 6.26–6.28

Symbios Logic Corporate Headquarters, Colorado, RNL Design, *Everitt Companies:* 4.100–4.101, 4.104–4.105

The Sculptured House, Genesee, Colorado, *John Huggins, owner:* 6.17

Tivoli Retail Center Improvements, Denver Semple Brown Roberts, Architects: 3.87, 4.54–4.55, 6.35–6.36

Tropical Resort Proposal, Costa Rica, RNL Design: 6.22–6.25

University of Colorado Proposal, RNL Design: 2.13

Urban Design Competition, Denver, RNL Design: 1.3–1.4, 4.95–4.99

Urban Planning Study, Colorado, RNL Design: 1.12, 2.4, 3.61–3.62

Village of Five Parks Mixed-Use, Colorado, RNL Design, *Village Homes:* 4.22, 4.68, 4.71, 4.91–4.92

Wadsworth Boulevard Corridor Plan, Colorado, RNL Design, *City of Wheatridge:* 2.81–2.82

Wells Fargo Lobby Renovation, Denver, RNL Design, *Commonwealth Partners:* 4.69

Wolfensberger Road Corridor Plan, Castle Rock, Colorado, RNL Design, *Town of Castle Rock:* 2.51, 7.9

Women of The West Museum Proposal, Colorado, RNL Design: 4.64–4.65, 6.8

Yuma Riverfront/Downtown Plan Proposal, Arizona, RNL Design: 2.43, 3.75–3.76, 4.15–4.16

Zoo Kiosk Proposal, Denver, *Ecos Design:* 3.12

Index